HUNTER
HALVERSON
PRESS - LLC

2006

WAR
THROUGH THE HOLE OF A
DONUT

By Angela Petesch

Copyright 2006
Published by Hunter Halverson Press, LLC
Cover and layout design by Ann Christianson
Editorial Direction by Kristin Gilpatrick
Edited by Rebecca Wasieleski, Karen Bankston

All photos courtesy of American Red Cross and the U.S. Army Signal Corps.
Family photos of Angela Petesch contributed by Rutledge Hazzard and
Marjorie Carne

Printed by McNaughton & Gunn, Saline, Michigan
United States of America

First Edition

ISBN: 0-9744143-2-8
13-Digit ISBN: 978-0-9744143-2-4

The Hero Next Door is a registered trademark of Kristin Gilpatrick.

Hunter Halverson Press, LLC
115 West Main Street, Second Floor
Madison, WI 53703

DEDICATION

To Red Cross workers and volunteers who know

the joy found in serving others through mud and tears.

And, to the soldiers who know the sacrifices

of serving the cause of freedom.

May the service of one to the other

never be forgotten.

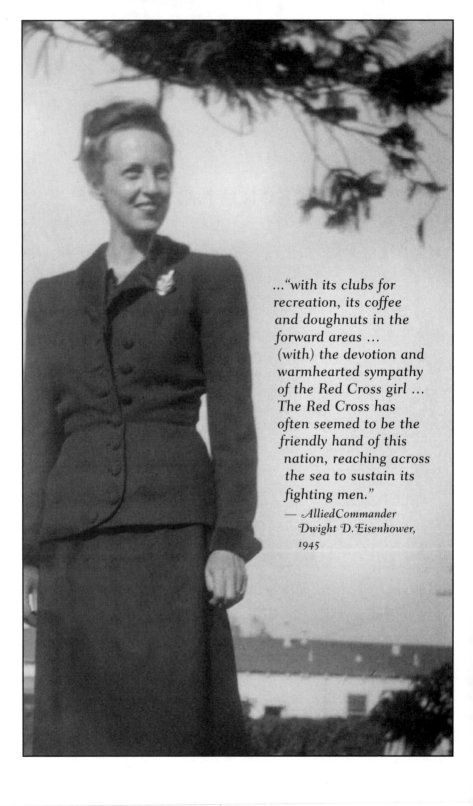

..."with its clubs for recreation, its coffee and doughnuts in the forward areas ... (with) the devotion and warmhearted sympathy of the Red Cross girl ... The Red Cross has often seemed to be the friendly hand of this nation, reaching across the sea to sustain its fighting men."

— Allied Commander Dwight D. Eisenhower, 1945

FOREWORD

By Angela "Angie" Petesch

*T*his is an account of my glimpses of Europe and of World War II as seen through the hole of a donut. On the fifth of May 1943, began the most interesting time of my life. With 68 other eager Red Crossers, we slid out of New York harbor, quietly and surreptitiously, on the ample Queen Elizabeth, double-loaded with American troops headed for England and the eventual invasion of the European continent.

Travel for me, up to that time, had been confined to the boundaries of the United States. The 27 months between May 1943, and August 1945, spent overseas with the American Red Cross, gave me the opportunity, either officially or on leave, to see parts of England, Scotland, France, Belgium, Luxembourg, Holland, Germany, Czechoslovakia, Austria, and Bavaria.

One of our organization's greatest accomplishments was bringing the Red Cross to the men in isolated areas rather than waiting until the men got to the Red Cross. The large cities and leave areas were well provided with clubs and recreational set ups for the men on leave. But there were still millions of men in outlying sections, either denied leave because of the

emergency or too far from leave areas to benefit from the club program. They were the ones stuck for entertainment, and who for that reason were even more important to reach.

Before going to the continent, the Clubmobile girls were organized into groups. There were 10 such groups, each consisting of eight Clubmobiles; four supply trucks; four little English Hillman utility trucks; a Cinemobile, which was the mobile entertainment unit; a jeep; and trailers for each vehicle to carry tentage, food, water, generators and other essentials.

Each group had 31 girls. A supervisor, 24 Clubmobile operators, two song-and-dance specialists on the Cinemobile, and four supply truck drivers who filled in as spare crew when girls were away on leave or were ill. The group formed an impressive convoy, when the 18 vehicles and trailers painted a dove gray with red and white lettering rolled along the road, all in order and spaced the regulation 60 yards apart.

Thus equipped and staffed, each Clubmobile had three American girls uniformed in Air Force blue battle dress, ready for a working tour of the continent. We followed the Army from place to place, served coffee and donuts with smiles and slang to the American GIs wherever we could find them. We earned the admiration of the men, who were proud as peacocks that girls from back home could drive a 2½ ton truck, live in tents when they had to, work outdoors through the cold and snow of winter without complaining too much, and listen to the big guns and wince only a little. Moreover, they could talk about tanks, airplanes and rifles with the same ease as movies, books or parties; could make good, strong coffee in the middle of a cornfield; and (on occasion) could still be feminine and dress themselves up to look pretty and glamorous.

We lived in small, uncelebrated villages, close to the people, getting to the cities only on leave. But it is the people rather than the places that seemed important. I saw them at

their best, more real, without artifice, with the problem of *living* the most important thing in their lives, strengthened by the lack of comforts and the necessity to work hard and get down to the fundamentals.

At the time I left this country, it was agreed among members of my family, scattered from Alabama to Chicago to San Francisco, that my letters would be saved for me until I got home. My plan was to write one big, fat letter to be sent to brother to father to sister. I knew I was not diary-minded, so my letters home were written in the form of a journal. Having been saved, typed, and arranged in order, I now have a complete record of my travels and my share in the war.

At the insistent encouragement of my friends, I have edited those letters and arranged them in the following pages, deleting such personal bits as "please send me sweaters and sardines."

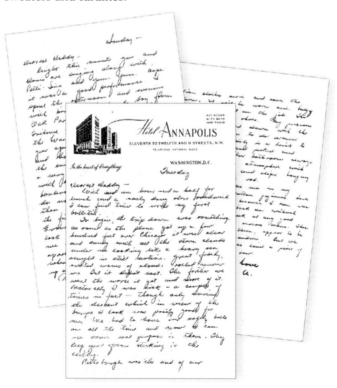

PREFACE

By Marjorie Carne

My friendship with Angie goes back a good many years, when we were both a part of the California fashion industry. Our paths crossed in the early 1950s when she was a market representative for Joseph Bancroft & Sons, and I was beginning my career with an association of designers and manufacturers. We shared several interests, and mutual friends. Her talents greatly impressed me, as did her adventurous spirit. A further link was our Midwest background as one time residents in the Chicago area—she in Oak Park; I in Evanston.

My high regard for her achievements as a *Chicago Tribune* feature writer, her artisanship as a jewelry designer, her prowess as a gourmet, and her indisputable good taste as reflected in her home, furnishings and garden only increased over time. Her courage in shooting the rapids of the Colorado River on a vacation, and her taking on the stint of working overseas with the American Red Cross, enhanced my estimation of her versatility and strength of character.

When I learned of her letters during her time overseas with the Red Cross, I asked if I might have copies, with the goal of having them privately printed so that they could

be enjoyed. She graciously consented. With the help of her nephew, Ed Tomaso, I edited and prepared them to fulfill that purpose. With the permission and guidance of her executor and relative Rutledge Hazzard, Hunter Halverson Press, LLC has updated and enhanced our work for this publication.

Letters begin with Angie's departure on the Queen Elizabeth on May 5, 1943. Prior to that, she had spent almost three months training. Trainees were assigned to various duties that included everything from dishwashing to hostessing and soda jerking to cashiering. For "Clubmobilers," more specialized training focused on motor mechanics and technical work.

There were many inoculations for tetanus, typhus, measles, smallpox, and more. Also in store were fittings for uniforms, plus purchase of size-regulated luggage, and shoes which were then rationed, along with gas and foodstuffs.

One notable experience, she wrote, was being invited to the White House. "There were 100 of us and it was quite an impressive sight as a stream of taxi cabs pulled up at the East Entrance and we poured out, dressed in uniform with spotless white scarves and white gloves. After a short wait, the First Lady appeared and greeted us all ... and now I can say I have shaken the hand of Eleanor Roosevelt. She really has a very charming manner, which is difficult to achieve when faced with 100 uniformed females staring at her."

Departure times and places were omitted for security. Her embarkation included another physical, more shots, dog-tagging, baggage inspection, final issues, and scrutiny by the FBI. "It took about 12 hours, after which it was up the gangplank, with each of us carrying our one big suitcase in one hand, musette bag over one shoulder, a haversack over the other, and a gas mask and tin helmet hanging around our necks."

The journey that started in letters on that haversack-filled gangplank begins with the "Diary of Days in Passage."

CHAPTER I

Diary of Days in Passage

On December 7, 1941, the Japanese bombed Pearl Harbor, Hawaii, and the United States of America joined the worldwide battle against both the Nazi Regime of Germany and the Imperial Empire of Japan. The American National Red Cross rallied to the fight as well, mobilizing quickly to offer aid and comfort to the American fighters and gathering supplies to help meet their needs.

By early 1942, thousands of American servicemen were heading overseas to Europe to fight the Nazis. American troops soon joined Allied forces gathering in massive numbers in Great Britain to train for the invasion of Europe. Most—including Red Cross volunteers and workers—made an arduous and dangerous journey by ship across the Atlantic, zigzagging their way to elude the German U-boat submarines that were determined to sink them. Angela Petesch recorded her journey across the Atlantic by writing a diary, supplemented with letters home, which begins with her departure from Brooklyn, New York.

~ *Diary of Days in Passage* ~

We were moved to Brooklyn to the St. George Hotel for last minute preparation before sailing. The week there was

one of getting our equipment fitted and a bit of drilling to make us look a little military. When on official trips, we all march down the street in a column of twos, trying to keep step and feeling terribly foolish and conspicuous.

Then there was the gas drill. We all got fitted out and practiced the routine with the help of an officer and two demonstrators. Then all 69 of us marched down the street at the Port, with masks adjusted, to the chamber. The first trip through the chamber we walked through with masks on, took a test sniff to get the sensation, and then out again. The second [time], we went in with the mask and took it off before we came out. The third [trip], we went in without it and had to put it on in the chamber as you would have to do in a real gas attack. The gas was tear gas.

Guessed wrong about sailing out during an air raid. Instead, we boarded the Queen Elizabeth about 8:00 at night. We sailed at 8 the next morning in broad daylight and in view of all the ferry riders on their way to work. Embarkation was simple. Everything was done in advance, and all that was asked of us was to wait a little, wearing all our rigging and then carry our hand luggage up the gangplank.

The Queen was as crowded as she has ever been before in her whole life, even her Army life. Her ample decks house at least 15,000 men on this trip. They are mostly (Army) Air Force. For the officers and us it is most pleasant and much more luxurious than a convoy or regular troop ship could ever be. Our cabins are crowded, of course, and I have 12 roommates in a cabin built for two, but we have a "private" bathroom, a washbowl in addition, plenty of salt water and some fresh water, a steward and a maid. Half a dozen MP's guard our corridor.

There are two meals a day—breakfast at 9:30 and dinner

at 7—very good and very ample. Breakfast includes a fruit, porridge, kippered herring, bacon and calves' liver with all the butter, sugar and coffee you can use.

The lounge on the main deck has been left intact and is now used for the officer's club. The Air Force is reputed to be the greatest drinking and gambling outfit in the Army. I haven't seen the drinking, since there is no bar on board; it is just as well if they drink like they play poker and shoot craps. The room looks like a Monte Carlo, smoky and crowded with happy young airmen. Every available table has a poker game—one with a $100 limit. Every square on the floor gives over to craps with more spectators watching the dollars change hands than players. They never play for anything less than a dollar. The enlisted men are quite as reckless as the officers, although they don't stay in the game as long, probably.

Those poor enlisted men have me worried. This is no pleasure cruise for them. The boat is so loaded that almost as many sleep outside on the deck as in. They rotate this so that each night another group gets the deck for a bunk. But you just don't walk out on deck after 7, because they have all bedded down without leaving so much space as an aisle to walk. I think, though, if I had a choice I'd take the deck. The lower decks and cabins smell like goats' nests and it is hot and breathless. The holds must be worse than that. They both sleep and eat in them in shifts. Meals go on all day and all night.

The poor darlings have to stand in line for hours to get food in their little tin mess kits, stand in line to get into the mess hall, stand up to eat, stand in line again to wash their dishes which they never get clean, and then stand in line to get back to where they came from ... when it's about time for them to start out again for the next meal. It's a nasty trip for them, but much shorter than by regular convoy. The boat is

well organized and controlled, though. Looks like there are as many MP's as soldiers. And even this may be remembered as luxury after they get where they're going.

We have been escorted a bit of the way. In the very beginning, a French liner was right behind us. A carrier came a little way out. There have also been two blimps and planes circling overhead. But for the most part, a boat the size of the Queen Elizabeth travels alone and never in convoy. She is so fast that she is considered quite safe and able to outdistance any attackers.

We keep zigzagging along. Have been told it takes nine minutes for a submarine to get its mark and fire its piece. So we zig just a little more often than every nine minutes, which puts us always out of position. We are also faster than submarines, so really are having as safe a ride as could be asked for.

All precautions are taken just the same—blackouts every night a half-hour after sundown, no smoking in the cabins, and boat drill once every day. The first drill came at 5:00 in the morning after we left N.Y. We were told about it and advised how to proceed. The point is to go to your nearest emergency station, which is a life boat on deck, and stand there until you are dismissed. That first drill was a flop, which is quite understandable considering the all-night confusion of loading those troops. All the women, for instance, were caught in one hallway and stairway and "drowned in a terrible death."

In the officers' lounge is an indefatigable piano player who goes at it all day and all night. There is always a small group around him, singing. But once in a while a song catches on and a couple of hundred voices take it up in as lusty a way as you ever heard. When that happens, the poor piano player might just as well give up because no one can hear him anyway.

Every night we get the ship's news over their public address

system. One night it was announced that a new law made it a criminal offense for laborers to strike while the country is at war. The cheer that went up would have made those miners crawl into their holes, preferably mine shafts, and never come up for light again.

The rumors during the trip were that we were down around Bermuda. Then as far south as the Azores, then 500 miles southwest of Ireland, then out to sea again to avoid a pack of subs. Wherever we were we'll never know, but we finally rounded the top of Ireland and glided into the Firth of Clyde to Glasgow. Landed on May 11. The trip may have had some dangers, but the Elizabeth, being faster, could get away. We were told later that subs did chase us one night. The only evidence was the severe zigging we did for awhile, sometimes so sharply that the ship heeled way over and obliged us to grab something solid quickly or be thrown to the other side of the room. Everyone had all the confidence in the world. There was not an anxious moment, even when we had the night alarm that was at a crazy hour and woke me up for the rest of the night.

We were taken ashore by tender at about 5:30 in the afternoon of May 11. On the dock a Scotch band met every tender, marching up and down the wharf. The native women did a little folk dance too. Gave us donuts and tea and seemed most delighted at our arrival. The Scotch people, all the way along, were friendly and cheered the American troops, waving American flags out of their little windows.

All the villages looked much alike—gray stone houses, crowded together, with no color except for an occasional red tile roof. The farms and the countryside were beautiful—green fields and pastures, snow-capped mountains. The little English train is something like Walt Disney might have

dreamed up—small coaches, a tiny engine, funny, squeaking whistle, with hands and arms flying out of every window as we acknowledged the welcome of the Scots.

There were a couple of stops en route to London at which time we all debarked with canteen cup in hand for coffee. One meal we used our K-rations—a new dish for us but one to be experienced more later. Breakfast was given us on the platform of another station—two cold meat pies, a bag of potato chips without salt, a hard-boiled egg and some Wrigley's gum.

The Red Cross met us at the station in London and transported us in buses to headquarters. We live at the Charles Street Club—I in the fifth floor half bedroom with four others. May 13, the second night in town, we had our first air raid alarm. Most of the Londoners pay no attention to them anymore unless they are out on the street when the anti-aircraft lets go—then it is wise to seek shelter from shrapnel. But the Red Cross made us get up with coats, blankets and helmets, and sit, stupid with sleep, in the living room just in case it should be necessary to go down the block to the shelter. There were some who wanted to get up and some were really frightened and worried. Such as Genevieve, who we caught a glimpse of tearing down the upper hallway, knocking at doors as she streaked for the stairway, wearing just a filmy sheer nightie and a steel helmet.

~ *Letters* ~

May 14, 1943

Dear Daddy:

Here I am "somewhere in England." Have been here several days but just couldn't seem to collect myself [enough] to write a letter. The Red Cross was supposed to send you noti-

fication today. I remember promising to send a cable myself, but were advised against it because the cable company has a nasty habit of saving these safe arrival notices for 10 days so as not to give information to the enemy.

Since we arrived here we have been given several days to rest and amuse ourselves. We were all more tired than we thought. Most of us have caught colds which seems to be the thing to do. And we were all as dirty as we were tired. Salt water baths aren't much good. Next week we will start some more clearing procedures, then some more courses and lectures; then our assignments that we have been waiting for so long. The Red Cross was terribly glad to see us arrive. Their workers here have been spread so thin. There is so much to do. I'm happier than ever that I joined the Red Cross and happy too, about the Clubmobile part of it. As one girl said— she feels so sorry for all the girls who are not Red Cross.

<div align="right">

May 22, 1943
</div>

ENGLAND

Dearest Family:

Somebody better write to me before I divorce you. Got two letters from String that were written before I left. They turned out to be carbon copies, a dirty trick. But I am following his advice and numbering my letters to you so you can figure out the mail service (though I fully expect to lose track myself and that will permanently confuse you). I suggest, if you haven't already been doing it, that you save these letters for me to peruse on my return. Will try to make them interesting and complete; they will supplement the journal I am also going to try to keep but am already two weeks behind.

Got my first assignment today and it kills me not to be able to tell you where it is, but that is military security for you. Have a feeling it is not too permanent a one, but none of them are. All the crews are shifted around from time to time, depending on the individual need for both troops and personnel. Nancy Brown, from Philadelphia, is to be my partner. She's a fairly new friend, but a solid one. Only met her on the boat, though she has been in Red Cross several weeks longer than I have. We requested to be allowed to work together and for this first assignment, at least, the request worked. An experienced Clubmobiler is going out with us to teach us the ropes. I will say this much—we will be stationed in a very attractive part of the country.

The past four days have been crowded with courses in donut making, air raid precautions, first aid for gas, coffee making and driving. The donut making is a job, even with an automatic machine. We have prepared flour and have only to add water, but it is made in 15-pound lots, which in itself is something to mix and hoist around. The dough container is a big upright cylinder, which fits on top of the machine. There is a disc, which fits inside to rest on the dough and force it down through the cutter, and then a rubber-lined cover clamped on top, which seals it and preserves the air pressure.

One of the crews taking instruction got their dough mixed and put it in the container all ready to begin operations, only to discover the disc hadn't been removed from the compartment and was snuggled under the dough instead of on top. Soooo—it had to be pulled out again and the disc recovered. Unless you know the stickiness of that dough, you'll never know the curses and mess that accompanied it. That dough is like a burr and you can only succeed in transferring it from one hand to the other and never get rid of it. Since it

wasn't our mess, we laughed loudly. On a normal Clubmobile schedule you make 600 sinkers a day. Believe me, our first tries were definitely sinkers because until you acquire a certain deftness you can't get it smoothly blended without overmixing the dough, which gives you a small, solid and indigestible ringer.

The driving tests were fun, aside from grinding the gears a little and driving down the wrong side of the road for half a block. I was all right. First, we tried a small passenger car. Then we had a small Clubmobile, which is built on a 3-ton Bedford truck. We each drove around Hyde Park, which is reasonably safe. Then the driver directed us right through the heaviest city traffic. I find judging the extra width of the truck the hardest job.

In the afternoon we tried country driving, and after the city, that was a breeze. We drove down around Windsor, saw the great Windsor Castle, the little Eton boys walking about in top hats and striped trousers, and skulling and punting on the Thames. Drove down sweet little English lanes, the countryside more green than ours, and the flower gardens and trees bright with color. The walks are right next to the streets with no parkway between and the houses are right close to the sidewalk. But they still manage to achieve all the privacy in the world with trees and walls and high hedges. Hope I get back there sometime; it needs much closer investigation than we could give it peering out of the lower half of the half-door of the body of our truck.

The weather has been perfectly delightful since we arrived, sunny and really warm. From reports we had before sailing, I don't think England has enjoyed such weather for years.

Last Sunday we went to church at the Guard's Chapel, that is, the Coldstream Guards. Now they wear their battle

dress even to church, so we were denied seeing them in all their color. But the brass band was there and I don't suppose there is another place in the world where a brass band furnishes the church music.

England is forcing many adjustments on us soft Americans. There is little meat, although we do get pigeon, rabbit and fish frequently. Wines and liquors are frightfully expensive so we stick to warm lager or ale. You don't see napkins except at the swankiest hotels. Coffee comes white or black, which means you can have it neat or with a dash of very thin milk. Eggs are powdered and are all right for baking, but most unattractive scrambled (and that's a gross understatement). Dried prunes and apricots are about the only fruit. Butter is noticeable by its absence, and flour is dark, so you munch on a hard black roll with your carrots and spinach and dream about thick, juicy steaks and roast beef and butter on your baking powder biscuits.

Desserts are terrible. I doubt whether English desserts were ever good, according to our standards. Now, made without sugar as they are, they are quite dismal. However, we get enough to eat even if it doesn't quite hit the spot. Cokes are plentiful at the Red Cross clubs, which explains why you can't get them at home.

In the directory I noticed the registration of Gladys Wagstaff, nurse, from San Francisco. There are also a lot of Oak Park boys listed, including Herbert M. Knight, which is a family we used to know.

The English don't do much in the way of outdoor billboards, but Bile Beans seem to be their best advertised product.

Love to all,
Angie

May 28, 1943

Dear Ede:

Am on the job now and from the first day's experience it looks like something of a job. We live in a small village of about 6,000 population. The town is more drab than most, but we have quite a nice hotel. This is new Clubmobile territory and the Commanding Officers are not yet completely sold on the idea, so we have a double job to do. Some of the officers think that our coffee and donut interlude is sissy stuff, and they don't like to have their work hours interrupted or the attention of their men diverted.

So we go around making good impressions or trying to. Will save more of the details for the family letter; also wait until some of the details develop. This was our first day on the job and was rather fierce. Between 1:00 p.m. and 6:00 p.m., we made up and served 60 pounds of flour, which is 1,000 donuts, enough to sink a battleship.

My principal purpose in writing is to report my first tragedy and give you another errand. When I un-packed my bedding roll the other night, I discovered that all my stockings had been stolen. About 18 pairs. The devils left me one pair of mismated nylons (old) and one pair of new cottons. It happened on the dock or on the boat, I suppose. It was easy for it to happen since there is no way of locking the thing and the roll can be picked from the ends without even undoing it. The stockings available here are pretty miserable.

So when you go to the city, will you get me about a half dozen pairs, size 9½ or 10, in a neutral color, and send them to me? We are allowed to get packages not weighing more than five pounds, though you may have to show this request to your postmaster to prove the necessity of sending them. Get some cotton and some rayon, the latter

reasonably sheer but fairly durable, if you know of such a combination.

There isn't much of importance in my trunk except my fur piece. Why don't you take it out and use it?

Am having a day off next Sunday. We hope to go on a little bicycle trip. I'll probably go over the bars trying to work the handbrakes on an English bike.

Love to all,
A.

May 31, 1943

ENGLAND

Dearest Daddy:

Enclosed is a copy of our official diary with all of the essential information deleted, of course. Am not sure that it will be especially interesting since you do not know the people about whom we are talking.

Mr. Kelly is a Red Cross Field Director and a stuffed shirt. Col. Hickman is the Commanding Officer at one of the camps that previously had a run-in with another Clubmobile crew and ordered them to stay away. So the situation was a bit touchy and we were sent off to clear it up, with much advice from Headquarters. On this first visit we were treated in a most friendly manner, so I guess it's again all under control. I hope so—our reputation rests on it to some extent.

One of my impressions of the English people is that they have such terrible teeth. Whether they are false or natural, they are terrible. In fact, one of the soldiers we were serving today said, "You know if we have a date with an English girl

we like, we don't say, 'Oh boy, I had a date with a Queen', we say, 'I had a date with a girl that had teeth.'" Pretty grim, but it is very nearly true.

Another thing upsetting is that I have never been stared at as these English stare. They are downright rude. When we are in a restaurant, or having a cocktail, all conversation seems to cease and the natives just sit back and look and listen to every word we say. It is most uncomfortable. Of course, we are foreigners and this is a small town, and our big van is quite a piece of curiosity. I can only hope they will soon get used to us, but until they do, it is painful.

Daddy, you have always been dreaming of living in a trailer. Well, I'm in it. This bus of ours is just like a trailer with every available nook and corner crammed with some essential. The kitchen, for instance, which is about 10' long and 6' wide, contains a sink and drain board with cupboards underneath, a big donut machine, a flour bin, a cabinet with a large Victrola and wireless equipment for a public address system. Also, six five-gallon coffee urns, racks for 15 donut trays (each one large enough for six dozen donuts), 11 or 12 drawers for the 280 coffee mugs, a long serving table on one side of the bus, a large 15-gallon vat for water, a Primus stove, brooms, mops and brushes. Besides, we store away a large box of cooking fat, two or three tins of coffee weighing 14 pounds each, and a couple bags of flour of 140 pounds each. "Conditions are a little bit crowded." as we remarked in the diary. Everything has to be strapped down, too. Only today we went around a corner and a whole tray of donuts bounced around on the floor.

Ran into a lot of boys from Chicago today. I say "Oak Park" and they seem to be a little discouraged, since they are mostly from Little Italy or Cicero or some strictly Polish neighbor-

hoods. Ninety-nine percent wish they were home. They all put out pictures of mothers and wives before you've been with them five minutes; there are ever so many of them who have new babies that they have never seen. They are especially eager to have it all over.

We tried to get bicycles the other day, since that seems to be the only way you can get around or have any fun. There are none to hire, however, and we can't decide whether to buy them or not. We were told that this would be just a temporary assignment lasting about six weeks. If that is true, it would be something of a nuisance to have to ship or resell a bike with such frequency.

We're having more typical English weather today—rain and cold. This is our first taste of it.

Love,
Angie

June 7, 1943
ENGLAND

My dear Daddy:

Are you getting my letters? So far your letters here haven't mentioned any. It does take a while to establish mail service from here. I've written every week, so they should be coming quite regularly now.

Finally got in touch with Doris' brother Bill, and he came down from Liverpool to spend the weekend here. I'm afraid it wasn't too lively a visit since this town offers absolutely nothing in the way of entertainment—except [for] a few pubs, and they close up at 10:00. The war has put the whole of England to bed at a very early hour. In London, for example, the theatres stage their shows at 6:00 or 6:30. Nightlife just

doesn't exist. And in this rural spot, it is even worse. We three usually come directly to our rooms after dinner and spend the evening writing letters and washing clothes. Having each other's company is certainly a blessing. I shouldn't like being stranded here alone.

A few days ago Mary Alice and I changed our hotel room and moved up next door to Nancy. We now call our corner of the corridor "Little America." The room is larger and brighter, much more pleasant. We also have an outdoor exit on the fire escape. We're just waiting for the day when there's a fire and the whole hotel files past our beds. It seems our room is the exit for the entire second floor and there's a bold sign on the door to that effect. Our door doesn't have a red light over it, which was thoughtful of the management at least.

As yet, we haven't come to any conclusion [about investing in bicycles]. English bicycles are a bit strange. They are built much higher than ours; you can't just tip over sideways when you come to a stop, but actually have to dismount. And they have hand brakes instead of our pedal brakes.

The Red Cross has just furnished us with a new uniform called our "battle dress." It is a pair of slacks and a short, bloused jacket made exactly like the English soldiers' battle dress; looks like a ski suit. Will be good for that very thing should I ever take up skiing when I come home. It's made of RAF blue and is very good-looking. A practical uniform, too, I might say, the way we have to climb in and out and hoist big coffee urns around. Also saves our regular uniform from spots of grease and gobs of dough and from smelling like a donut factory (which they soon do when they get permeated with the steam from the machine.)

Am getting to be a champion tea drinker, and with milk in it! Tea for breakfast even, instead of the horrible English

coffee that tastes like cocoa. We eat at least one meal a day in the camp's regular mess hall. If you don't see the food being cooked in 20-gallon vats, it tastes pretty good. One day this week we had steak, which was a real treat ... that doesn't happen often. The donuts are calling again. Will leave you until next week.

Love,
Angie

<div style="text-align: right">*June 14, 1943*</div>

ENGLAND

Dear Family:

The only excitement in our jobs lately has been a temperamental donut machine. When that starts bolting, it is the most frustrated feeling in the world, there being nothing else to offer in the place of the sinkers except a sick smile and a weak apology. One day, the biggest of the week, where we had 90 pounds of flour to make up, we kept blowing fuses, one after another. Yesterday, we had to cancel our engagements because the beastly donuts kept sticking and sinking to the bottom, coming out in the shape of pretzels, twins, and just plain wads of dough. The machine still isn't right, but we got through the day with a struggle from start to finish.

Spent a very pleasant afternoon and evening on our day off as guests in the home of a Mrs. Grindley, one of the town's better people, who lives on a nice country estate about a mile out. Until I met her, my opinion of the English people was fairly low. I was frankly disappointed in them and I'm afraid I still am in the general run. As one of our girls said, she "never saw people who could be so rude and be so damned polite about it." Mrs. Grindley was definitely very charming and served us

an ample tea and later a cold supper from her meager stores.

From her, we learned something of the problems of the English housewife living in the country in the fourth year of war. It is a terrific task. There are absolutely no servants, of course—they are all in war work. While no one is complaining about it, it's an almost impossible task for some of these women to take care of their tremendous houses and feed their families on such short rations. They are all extremely resourceful [with] all the tricks of making over clothes to fit smaller members of the family, of trying to be clever and dish up cabbage and potatoes every day of the year in some new disguise so they will be appetizing. Then, the tricks of shopping and making the points for everything come out even, of standing in a long queue for buses or to buy a loaf of bread or a small piece of meat, of finding a few spare moments to grow some fresh vegetables or preserving fruits without any sugar.

Everything has to be done the hard way, the long way and the cheap way. There just isn't time enough in a day or a month or a year to get it done whether you are smart or stupid about it. All clothes are rationed with coupons. Twenty coupons are offered each person a year. But it takes something like 18 to get a wool coat. Naturally, you study the situation pretty closely before you spend your wad on one garment. Those who didn't have a little reserve in their wardrobes are sunk. And clothing children, who grow out of their clothes before they wear them out, is quite an impossible task. Consequently, garment after garment moves around the community from a 12-year-old to a 10 -year-old until it is in shreds.

It is also true that if you are able to buy something new in clothing or shoes, the quality is so inferior that it breaks your heart. The natives are exporting all their good woolen textiles, probably to America. Besides that, the styles are the same as

they were four years ago, making it a completely unsatisfactory purchase. Consequently, everybody looks pretty dowdy. I'm glad I didn't bring much in the way of civilian clothes—I would be embarrassed to wear them.

They have little or no gas for their cars—about enough to drive to town once a week. The only traffic you see on the roads are trucks, Army cars and bicycles. This same Mrs. Grindley has four children who are away at school, and when she wants to visit them, she hitchhikes. The English gentry hitching seems pretty dire. They certainly are good sports about it, though. Her friends and neighbors are the Wedgewoods, of pottery fame. We hoped for a tour through the plant, but that doesn't look likely since that kind of fol-de-rol has been discontinued during the war.

I'm sending this letter to you first, String, because I don't know whether Father is there or still in Oak Park. If he isn't there, you'll know where to send it. I also wish the family would send me some snapshots of themselves. I went off with nothing but a mental image and would love something more tangible to look at and show my friends.

Love to everybody,
Angie

June 21, 1943

ENGLAND

Dear Family,

This is the longest day of the year; with that, plus the midnight sun, daylight-saving and the full moon, it is only a slight exaggeration to say that we have to keep the blackout curtains drawn all night to keep the daylight out instead of the light in.

In spite of its being officially summer, I have been wear-

ing my woolen underwear. It isn't the long-handled variety, but it's what I intended for winter use. I can see now it won't nearly do the job of keeping me warm. Took a look at myself in it the other evening and decided I looked just like Annette Kellerman, whose shapely figger used to (and maybe still does) grace our magazines in ads for something or other. Only her tights were black and mine are a lewd pink. I may have to ask the family to come to the rescue with something really warm when the time comes and we are not helping to invade the French Riviera by that time. Woolens are almost impossible to buy here, even if you have the coupons.

My newest addition is a pair of GI shoes. If you don't know what GI shoes are, look closely at the feet of the next enlisted man you see walking down the street. They are laced boots of heavy brown leather (cowhide, I think, [because] they are so tough), with half-inch soles and bulldog toes. Size 6C. They really are a man's shoe. Artie can wear them when I get home if I don't become too attached to them before then.

In this job, they really are wonderful. We frequently (all too frequently, I'm sorry to say) have to slop around in the rain and mud. And my uniform shoes, which at first I thought were such clumsy things, now feel like dancing slippers by comparison, and just wouldn't hold up under the beating we have to give them. The GIs don't look too awful as long as we are wearing slacks—they are fun to wear because the men are so tickled to think that by choice we would put them on. It seems to make us one of them. We're really in the Army now.

We got them from this Quartermaster. He and the Mess Sergeant are useful guys to know, by the way. We frequently get a quart can of grapefruit or tomato juice, always get our laundry done, and today were presented with a half dozen eggs which we are going to take down to our hotel kitchen to be

boiled 3½ minutes by the clock. One way you recognize a fresh egg in these parts is how it is served. If it is poached or boiled, it is fresh. If it's scrambled, it's powdered and very unappealing.

I think in my last letter I reported trouble with the donut machine. It has all been corrected now, but not without a near accident. It seems the difficulty was a loose wire in one of the control boxes. This day it was raining and the moisture on the wire made the short circuit complete, so that the whole outside of the bus was alive with electricity. We three girls were inside and safe because of the rubber tires (tyres in this country). But the driver, who was standing outside and in a mud puddle, made a good victim when he started to get in and got a shock that knocked him flat on the ground. Two hundred and thirty volts is quite a jolt. He wasn't hurt, but we certainly turned off the juice in a hurry and ceased all operations until the thing was repaired. Our dangers, you see, are not bombings. Now we are fixed up better than we were before and everything is running smoothly.

So smoothly, in fact, they keep piling on the work. We now have more camps on our list than we can possibly call on in one week and just have to keep teasing them along with an occasional visit until they can establish another Clubmobile and make two areas out of it instead of one.

Have been finding a lot of boys from Chicago but they seem to live on the wrong side of the tracks, because when I say Oak Park, they are definitely disappointed. Now, since Daddy has moved, I'm not sure what my address is. It's a queer feeling.

Was invited to tea again at another very nice English home. This was a very old house with the deed going back to 1720. The house, of course, has been done over some since then, but it still shows some signs of its antiquity. There's a little square paved courtyard in the rear with the servants' quarters, stables and coach house forming the walls. In the stable were

two cows and a new calf, a pony of questionable disposition, a cat family with ducks and chickens in the meadow. A gaudy peacock strutting through the flower garden, as well. There is also a red fox who lives in the hills nearby, but England does not have any fox hunts during war-time, so the marauder is getting away with pilfering chickens and sheep. Also, all the natives gave up their shooting irons to the Home Guard, so they are at the mercy of the fox.

This house also has a private greenhouse with tomato plants four feet tall. They are different plants than ours. They seem much taller in the first place, but maybe that is because we saw them in this small room. The fruit is definitely smaller, however, and grows in bunches on sprays. They also had peach trees in the greenhouse, pruned and trained in espalier fashion along the brick wall.

These English are incredible. All the property owners and gardeners, besides everything else they have to do, are busy collecting foxglove seed for digitalis, prickly nettles for the green dye they get out of them, and other tedious things, all of which add up to something when everybody does it.

Don't feel sad about your gas allowance, my friends. The average person here gets one gallon a month and that has to be used on some official business.

Love to all,
Angie

June 27, 1943

England

Dearest Family,

The bicycles arrived. So … I am the only one of the three with one in my actual possession because Saturday the girls

either didn't feel up to the trip, or had other plans. You see, the dealer was in the next village, a distance of seven or eight miles. So I hopped a bus, completed the transaction and started pedaling on my way home.

Nothing untoward happened except I never thought I'd make it. One difficulty was the two coats I was wearing: a jacket, and on top of that, my top coat that I had picked up from the cleaners on the way to town. I soon stopped and peeled off everything I could with decency, and wadded it all around the handlebars. The hand-brakes on the English bike confused me somewhat, too. All in all, it felt like an uphill climb all the way. I staggered up the steps to our room with perspiration glistening on me, my chest heaving, circles under my eyes, and my knees so weak they would scarcely hold my weight.

That evening, just to be silly, we took the bike up the fire escape and into our room and pampered it like a baby. Mary Alice rode it up and down the corridors of the hotel, three feet wide and 50 feet long. Today I did another five or six miles and came off a little better, but I still have a lot of work to do before my legs will stop crying for mercy. We should have a lot more fun when we all three get our mounts and can take our picnic suppers out into the country.

We had a very easy day today and hence, time for a bicycle ride in the afternoon sun. The reason was that six trays of donuts were left over from our last camp on Friday, which we overestimated very badly. Trying to be economical, we reheated the donuts in the ovens at the mess hall, but it was a mistake. You can save donuts all day, but two days are too much. The next time we'll just have to throw the overs away, I guess. And even though my frugal streak is small and undeveloped, tossing away 30 dozen donuts kills something fine in me.

Had fun going over the obstacle course at one of the hospitals we call on. This is a rehabilitation hospital, the only one of its kind in the American army and copied after the British, who have done a lot of experimentation and research along this line. It has been so successful that I believe many more will be established and the idea become a definite part of the medical program. Boys who have been wounded or burned, or suffered broken bones and whose muscles, tendons and joints have become stiff or atrophied through disuse or injury, are put through this physical training program until they are brought back to almost 100% efficiency.

This obstacle course is something that most able-bodied men can't do, and when I think of the weak ones and those lugging casts along with them, hobbling over bars, I shiver. First there is a 15-foot wall to scale. Then a four-foot bar to jump over. Then a broad jump with brush and a ditch like a steeplechase, a swinging bridge that makes you stagger like a drunken sailor, a slack wire (but with rope to cling to, fortunately), plus narrow trenches shoulder-deep that zig-zag at crazy angles, through which you are supposed to run at top speed. [Then, there's] a barbed wire tunnel which you maneuver by crawling on your stomach, a net hanging from a 20-foot crossbar which you climb up one side and down the other, and then more ropes from which you dangle like a monkey and swing across a yawning ravine.

Would you like to know how I scored? Well, I went under most of the things you're supposed to go over and around things intended to be crawled through. I did swing on the rope and felt like a trapeze artist. The whole thing is so strenuous, I should think they would double their list of casualties and never be able to discharge a patient.

The kids at this hospital are fun, though, and full of such pepper with outdoor life, they are nightly picking knock-down,

drag-out fights with the English soldiers, whom they call
Limey, by the way. They are all very eager to show us their
wounds, too, and take any excuse to bare their hairy arms
or legs where bullets or shrapnel or flak have produced their
ugly scars. The Army is certainly giving them beautiful care.
Everything that can be done is done, and more.

Have you found that any of my mail has been censored? I
was just interested to know. I do censor my own, as you have
noticed, and as all Army officers do. But it also passes through
a base censor's office where a few pieces out of every hundred
are taken at random, and given an official reading.

We have worked out a brand new perfume on this job of
ours. It is a rare blend of donuts, hot grease, tobacco, coffee
and exhaust fumes, guaranteed to last indefinitely, or until
washed out with strong soap and hot water. And it has been
christened "Fuelgue Clubmobile" by Nancy. I am sure she
will make her fortune because after the war all nostalgic
Clubmobilers will be enthusiastic customers.

It is now 12:00 again and time to stop and get some shut-
eye. We never seem to get to bed before midnight.

Love to all,
Angie

July 5, 1943

Dear Daddy,
 Your letters are coming through in fine style. No censoring
and not much delay. Ten days seems to be the average time
required to reach here. Straight airmail seems to give the best
service right now. Have been getting quite a lot of mail from
family and friends at home. Our breakfast is practically dis-

rupted each morning because we dive into the letters much more avidly than the porridge.

Another breakdown has interrupted our service and wiped the professional Red Cross smile from our faces. It started Friday, when the machine became shorted again. Afraid to go on under the circumstances, we admitted complete defeat for that day, hoisted our white flag and limped home. Mechanics came in from all directions and soothed and caressed the "IOWA" into what they thought was submission.

But Sunday she pulled a new trick and we were from 8 a.m. until 12 getting the first donut. And on the Fourth of July, too, when we were expected to furnish the music and the refreshments at the celebration in the afternoon. We made it—two hours later than scheduled—and even that was all right since it was a very informal afternoon of baseball games. We made a most dramatic entrance on the baseball field—the big truck surrounded with cheering donut-eaters and guiding hands as she crept over the bumpy, stubbly ground, scraping her bottom all the way. The body of the truck clears the ground by only 5 inches, so when you get her off a paved road, you immediately run the risk of being grounded with the middle hung up on a high spot and the wheels dangling helplessly off the ground.

Time out here for a bike ride. We found some wonderful tiny country roads. A couple of times had to glide off into the ditch to let a car go by. Some terrific long, steep hills which we had to walk up. But what goes up must come down. Our village is located down in a little valley with both a river and a canal running through. No matter which direction you start cycling, it is upgrade. Coming home you coast in magnificently with your ears pinned back and your hair flying.

~ Official Diary of Clubmobile Iowa ~
June 27 to July 6
Mary Alice Sturdevant, Angela Petesch,
Nancy Brown, A. Sears, Driver

With sincere affection, faint though the praise, the boys now call us the "Motorized Mess."

A Mexican version of the rhumba, homemade ice cream, another mechanical breakdown and the Fourth of July were the highlights of this week's circuit.

The ice cream, we felt, was a very worthy swap for donuts and coffee. Even though it was made from dry milk and water, it was definitely reminiscent of the Auld Countree, and made the day a real party. The boys arranged their daily menus to have it on Tuesday, because they knew that was when we were coming.

At the hospital this week, we got off to a bad start because of the time wasted in trying to find some diesel oil for the engine. That had been ordered for our use at the usual base, had failed to arrive, and so we were given instructions and a special permit to stop at an RAF station to fill up. Which we did. But either the irregularity of our request, or the red tape, brought about a considerable delay. Consequently, we were late in arriving. Only by rationing the donuts more stringently than usual, we managed to reach all the patients and the staff at the customary hour of 3:30. Al, our friend in the mess kitchen, cheerfully related the results of his latest difficulty with his military superiors, [including] all the details of his having been caught sending a letter through the British mails, the Court Martial proceedings and his being "busted from a Staff Sergeant down to a Private." He hopes the next time to "bust" into civilian ranks, he says.

Beginning with Friday, our performance has been impeded by a temperamental donut machine. At the Air Corps train-

ing base, we admitted complete defeat for the first time, when a few shocks were registered via the metal handle on the big front door. By slightly changing our routine for the week's work, we had managed to squeeze this camp into our schedule and were anticipating a great welcome after having been absent for several weeks. The warning from their civilian electrician that someone might be seriously hurt decided us to quit in the middle of operations. We left the few trays of donuts we had made up to that point with Mr. Kelly to distribute (we knew not where or cared less), and limped home.

Saturday was the regular day off for the crew. And electricians seemed to arrive from all directions to put us on our feet for the big day of the season—the Fourth of July. They spent hours … and left thinking all was well. Not so. Sunday, the IOWA reverted again to her English heritage and just seemed determined not to participate or want any part of the celebration marking the independence of those colonial upstarts—the Americans. Not until 12:00 did the first donut slide down the ways and launch us on our days' work.

For those first four hours we had the feeling we were all dressed up and no place to go. It being Independence Day, we had spent hours the previous afternoon and evening conniving suitable decorations out of meager material, trying our best to make an American out of the IOWA. Red, white and blue streamers, an Uncle Sam's hat, a large V for victory, and the sign "Happy July Fourth" cut out of cardboard in 4-inch letters, eventually came into being through our combined efforts and the resourceful use of a bolt of blue crepe paper, some white wrapping paper, and a generous smudging of Elizabeth Arden lipstick (which worked beautifully and is more "kissproof" than we realized!)

So at 3:30 in the afternoon we made it out to the ball field where a small tournament was in progress, dressed to the

hubcaps in our homemade decorations. It was something of a dramatic entrance, having to squeeze through a very narrow gateway, all of us, plus a dozen or so GI's walking to lighten the load and waving frantic directions to the driver to avoid what seemed like an imminent possibility—the embarrassment of getting the IOWA hung up on a 6-inch hummock. We were spared that humiliation, at least. It all developed into quite a happy afternoon after a morning of dire misgivings flavored with a few choice cuss words spoken in unison.

Early the next morning, and I mean early (5:30 to be specific), we rolled out of the fluff to serve at the railroad station where a detachment of about 70 men were being shipped to join various operational units. The men had been bugled out of bed at 4:30. Some had not had breakfast. All were brought to the station an hour and a half before train time and [were] required to stand around in little huddles, bowed with backpacks and tin hats. We had a noisy welcome and I'm afraid jolted the staid natives with American jazz and dancing in the street at 7:00 in the morning.

At 9:00 Sears drove off in the IOWA to take her to Hanley for her monthly servicing where she will be confined for 48 hours. I hope she gets her ears pinned back because she has been in high disfavor with us for days.

By Angela Petesch

~ *Letters* ~

July 13, 1943

Dearest Family:

The Red Cross has just issued us a new typewriter, which overjoys me. It will doubtless make your reading time a great deal shorter. I sit propped up in bed, covered with a downy

comforter, and the little portable resting on my knees, cigarettes and candy within arm's length. Solid comfort. It's an English typewriter, but much like ours with the addition of several symbols such as # and =.

Having been to London since I last talked to you to spend our regular monthly weekend. Previous plans I had made I thought had fallen through, but I went anyway, mostly because I didn't want to stay here and rot by myself. Was mighty glad I did. Found a lot of the girls in town that I came over with. Also found Doris quite by accident. I had been led to believe that she had been sent on assignment two days before. Consequently, I spent most of the time with her. She was still recovering from a bad cold—the same cold that everybody seems to catch the moment foot is set on English soil.

London seemed much more gay than I remembered it on my first visit two months ago. Then, I'm afraid, I was comparing it to America, and finding it a little dingy. Now I compare it to the provinces and it is something else again, with lots of smart people dining and dancing and going to the theater— pretty women and handsome, snappy officers.

Traveling in England in wartime, however, is like mapping a military campaign. In this case it wasn't too bad since all roads lead to London. But I'm not at all sure that I want to do much of it at night as we did coming home Sunday evening. With the whole country blacked out, including the railroad stations, you just never know where you are. Even if you do sneak a little peek through your window curtains, all you see is a miserable lonely red light down the platform. And the railroad companies here are so understaffed, you never see a conductor to find out if you are where you think you are.

We got off our train at 2 in the morning on a dark night in a drizzling rain and marched down the middle of the black

streets without a light showing from any window or street lamp, singing as we paddled through the puddles, and almost not recognizing our hotel when we came to it. (The same principle as whistling in the cemetery.) The hotel was, of course, locked up tight at that hour, but we had left instructions for our fire escape entrance to be left open. With the aid of a measly pencil flashlight, we finally stumbled into our "Little America" in the Crown Hotel amidst whispers and stifled snickers in what I feel was a vain effort to keep from waking up the entire building. We are now settling down for another month hard back at the donut machine with steadily increasing numbers to serve. Met a boy from Oak Park today [who lived at] Cuyler and Harrison Streets, two blocks from home.

Just had a phone call from headquarters tonight that we are about to lose our precious driver, Sears. He is about the best driver they have and we were pretty lucky. But he really is too good a man for the job and there is a better one waiting for him. We are sorry to lose him, though. He was a former contractor, builder and plasterer, and there was nothing on that old London bus that he couldn't fix. I'm sure he saved us many working days when we might otherwise have been sitting around waiting for repairs.

The Army gave us three steaks today which they said were cut off a beef tenderloin. We smuggled them home and then bribed the cook in the kitchen with candy, to broil them for our dinner. You know the answer. They were so tough that the waitress had to bring us a butcher knife from the kitchen, which we passed around the table, carving off a few small bites on the way, before handing it over to the next one.

Another diary enclosed. 'Bye til next week.

Love,
Angie

Chapter II

Serving the Women Who Served

Donut Dollies, like Angela Petesch, were just a small number of the thousands of American women who volunteered for the Red Cross in overseas duty. In July 1943, her Clubmobile helped serve another special group of American women, 557 members of the Women's Army Corps (WACs). WACs were first group of women to serve in the ranks of the U.S. Army besides nurses and this contingent of 557 were reportedly the first group of WACs to reach the European Theater of Operation (ETO). Many of these women were previously serving in the Women's Army Auxiliary Corps (WAACs) until their auxiliary designation was changed in early July 1943 and officially became part of the U.S. Army.

About 150,000 women served in the Army alone during World War II in noncombatant jobs. Additionally, some 60,000 American nurses served in the Army Nurse Corps (ANC). American women also served in groups associated with other branches of the U.S. armed forces, such as the Navy Nurse Corps (NNC), U.S. Marine Corps Women's Reserve (UWMCWR), the Navy Reserve's WAVES (Women

Accepted for Volunteer Emergency Service), and SPARS (Women's Reserve of the Coast Guard). About 1,000 women took to the air in World War II as pilots with the Women Airforce Service Pilots program (WASPs), 38 of which died in service. The British had similar female military groups, such as Women's Auxiliary Air Force (WAAF) and Women's Royal Naval Service (WREN), all of which Petesch encountered during her Clubmobile service.

Clubmobile women were a special group too. According to *The History of the American Red Cross (Vol. 13)*, a Red Cross woman was to have a "pleasant personality, good appearance, tolerance, sympathy, conscientiousness, courtesy, adaptability, originality, poise, cooperation, and good health." The typical Red Cross girl in WWII was 28 years old and "knew a little French, played piano and had a degree or was a teacher. ... Clubmobile workers had to be sensitive to the particular mood of the men they were serving ... If companies have taken a terrible loss, the men are apt to be preoccupied, depressed, surley ... too much levity and they resent it; too generous with supplies and it irritates them; too sympathetic and they feel more sorry for themselves."

~ Diary ~

Clubmobile Serves the WAACS

Saturday, July 17 was a colossal one in the life of the American Red Cross Clubmobile "IOWA". For-merly the IOWA was a London bus. She has known cities and villages, counting lanes and Army camps by the dozens. But today, she met and served the WAACS, 557 of them, just arrived from America. There was a complete battalion of these smart young women, dressed in olive drab, a showpiece in anybody's country.

The crew of the IOWA, consisting of Mary Alice Sturdevant of Washington, D.C., Nancy Brown, Radnor, Pa., myself, and Joni Jean Ford of California (who joined us later) had been harassed for weeks by official reports and unofficial rumors that "those American beauties were about to move in on our private hunting ground." In general, the men and officers seemed to be of two minds about the whole thing. First, they would say ecstatically, "When are they coming?" with a wicked glint in their eyes. Two minutes later when faced with some new problem heretofore unheard of in their man's Army, they would mutter and grumble, "Why don't they stay home?"

Our first glimpse of this Army of women was from our vantage point behind the kitchen where we could see them file into the mess hall for breakfast, wearing GI fatigue coveralls, knitted GI caps of khaki, and carrying mess kits and canteen cups like any other soldier. Sopranos shouting out in cadence, "Hep, two, three, four" as they marched along, I must say that in this drab costume they didn't look too glamorous. But the KPs gazed at them starry-eyed, while the Mess Sergeant swore a little under his breath at having to operate his kitchen and dining room in a little daintier fashion. The Adjutant beamed boyishly at his new charges, feeling that Fate had smiled on him at last. And the MP in charge of the guard for the camp cheerily reported having caught four adventurous youths from the neighboring camp crawling under the fence at the Commando Entrance at 4 a.m. the night before. It was also he who had the purely masculine pleasure of going around the whole encampment rapping on brightly lighted and uncurtained windows to remind the scurrying females indoors that England was in a blackout.

The Clubmobile IOWA was on the spot to serve these girls their first American Red Cross donuts and coffee. It is

something of a coincidence that the IOWA was the one to do the job, since most of these WAACs had their basic training at Des Moines, the first and still the principal WAAC camp in the United States. At first we were requested to serve at 10:00 in the morning. This meant our forcefully brushing the sleep out of our eyes at 5:00 a.m. in order to be ready for the onslaught of 557 dunkers. At 9:00 we received the shattering news from the Commanding Officer's office that 3:00 would be better, that being the time just before they would have to "fall in" for their parade. The loss of three hours' sleep means nothing in the Army—God bless 'em.

Naturally, we prepared for this group as we would have for any other, though Mary Alice did admit she felt a few faint whispers of uneasiness without knowing why. As it happened, the girls did fool us. Their tastes in coffee and donuts are quite different and not the least bit GI. They eat fewer donuts, for one thing, though that is not too surprising. The blow was the universal request for black coffee. The average soldier wants his coffee with all the milk and sugar the law will allow. The average WAAC wants her coffee black—and the blacker and stronger the better. We discovered too late that our coffee urns, four out of five which were prepared in advance with milk and sugar to hasten the serving, were not the popular ones. We realized the next time that plans would have to be varied a little.

The parade late that afternoon was definitely an impressive ceremony. Several companies of men led the way onto the parade ground and also brought up the rear, marching to the music of the Army band and a WAAF band imported for the occasion. When they stood at attention facing the reviewing stand, the women were flanked on either side by the regular Army. Captain St. John of the WAACs gave the commands. Then, if never before, those men took orders from

a woman. On the reviewing stand were many guests including high-ranking officers of the British Navy, the WAAFs and the WRENs, as well as our own officers on the permanent staff. Everyone, particularly every American, was pleased at the sight of those girls. They looked good, were well-dressed and marched smartly. Better than the men, in fact, so far as posture and erect carriage were concerned. Their pictures will doubtless be seen in newspapers and magazines all over the country. Reporters, correspondents and camera men were around all day getting the news from all possible angles.

Work seems to be going on briskly at the WAAC camp. The men are not allowed on the post, of course, unless on official business. Suddenly they are finding numerous reasons (557 of them) why they should run up to "B" Hall. Trucks and cars that have been sitting around for weeks unattended, now find themselves swarming with master mechanics who have one eye on the carburetor while the other keeps a steady lookout by wandering over the landscape for a winsome WAAC.

Within the week following their arrival in camp, the WAACs have begun taking over some of the duties for which they were trained back home at Mrs. Hobby's (Oveta Culp Hobby) school for girls. The entire battalion has been assigned to the U.S. Army Air Force. In time they will be sent around the country to the various bases where their talents are most needed. They perform such tasks as jeep and truck drivers, secretaries and office workers, telephone operators and the like. Already they have relieved the regular Army detail of KPs in the kitchen at their present headquarters … pushing heavy mops around the tile floor, polishing the stoves until they mirror their own curly heads, peeling potatoes and preparing other vegetables, and the worst job of all—cleaning

the big 50-gallon steam cauldrons and the heavy metal baking pans with wire brushes, steel wool, plus GI soap which, I might add, is not made of gentle palm oils. Dishpan hands is the very least they can expect.

The climax of their first week in England was Saturday, July 23, when they were inspected by General Eakers. They and the permanent staff buzzed around for days planning the day's program. Even though these WAACs have been inspected many times before by the great and the illustrious, the whole neighborhood was thrown into a tailspin, including the Clubmobile crew who had been invited to serve donuts and coffee and was spending the day on the post. On the chance that the General might like donuts or be inquisitive about a Clubmobile and wander over in our direction, we were inspired to polish up in our best military manner so that we too might face his critical eye if need be.

The parade of the WAACs at 11:00 in the morning, which General Eakers and other celebrities reviewed, was another beautiful spectacle. It will probably be a long time before we see its equal. The Air Corps badge this contingent is now privileged to wear had been sewn on the sleeve of every uniform. Conscious of their new insignia, the WAACs marched proudly, all heads facing right as they passed the reviewing stand. I am frank to say little quivers shook my spine. I was proud too.

At 3:00, under a warm summer sun, parked in the middle of a large paved court, with the amplifier sounding out solid jive, the American Red Cross came in for its share of praise. With 1,400 crisp brown donuts and 25 gallons of the best American coffee we knew how to make, plus cigarettes and candy, we played the host for 2½ or 3 hours. The girls are every bit as enthusiastic about the Red Cross Clubmobile service as any soldier. Many of them didn't know there were

Clubmobiles on the road. They were all frank to admit that our being there gave them a nice warm feeling. One girl said, "I don't know why, because you're as far away from America as we are, but your being here is like holding hands with someone back home."

~ *Letters* ~

July 25, 1943

Dear Daddy:

We had a big week with the WAACs in town; a lot of pictures were taken and it is possible we may break into print.

Have received my first orders to move to another territory. This moving from one area to another is a general practice in Clubmobile circles. It not only keeps you from getting stale in one place, but also gives everybody a chance at the good as well as the not-so-good assignments. So now the old crew is split to ribbons and I am moving today to another territory about 50 miles from here, and a new crew. Have been appointed Acting Captain of another Clubmobile. If I can hold everything together properly, perhaps the temporary sounding adjective "Acting" will later be removed. There is a problem involved in this new place. It is to keep my thumb on a girl who has been criticized for too much drinking and is being given one more last chance.

Will write again the first of the week when there should be lots to say about new friends and new places.

July 28, 1943

If I said I was living in the country before, you should see me now. This town is about 30 miles east of Stone, my last

station, but since you don't know where that was, this isn't much information. At home we would call it a crossroads. In England, however, the roads seldom cross. The Spread Eagle Inn is our home. Alongside it runs a little brook … no name, just "the brook." Across the bridge which spans the brook, now green with weeds and watercress, is a tiny post office. A block down the road is a general store which, in truth, is made out of the parlor of the storekeeper's home and it has coffee, tea, and toilet paper and other stuff arranged in the bay window. That's all of the village. They boast of a couple thousand population but that is spread out for miles in modest country houses.

The Moseley estate is in the neighborhood. We have been invited to use the pool there whenever we want to. The whole countryside uses it, since the house is not occupied. Moseley is the man of Fascist leanings and I believe he is now being "detained" somewhere else.

This place is strictly rural. You walk a block and find yourself in a lovely green pasture with broad, fat trees and bright yellow buttercups. And it is so quiet. Even the cows seem to tip-toe when they shuffle past our windows every morning, their cloven hoofs making a soft, whispering sound on the black tar roadway. A little boy rides behind the herd on a bicycle … pokes them with a stick every now and then. Sometimes his little brother accompanies on a tricycle.

This hotel is much more like a boarding house. You have the feeling you're eating with the family all the time, though actually that is not true. They do take a sort of parental care of us, however, and leave bread and cheese or a bit of salad for us when we work late in the evening. It is also the only local pub and consequently the gathering place for all. The beer is very handy, as you can see. We have nice clean rooms, though the beds are hard and the floors list, so that the doors will either not stay open or not stay closed, depending on which side they

are hung. Out in back is a sweet, quiet garden with a red brick wall. Beyond that, a grass tennis court. The dog, a foxhound, lives here. On the other side of that fence is a pasture where the hotel keeper has his house.

The camps we visit in this territory are ugly things. Drab Nissen huts for the men to live in. No grass or plantings of any kind. The kitchens are a mess and that is no pun. They have great coal rangers about 15 feet long and 8 feet wide that make the room so hot the men get cooked before the hash. Our coffee is always made in the mess kitchen where we have to stagger and slop around with big 15-gallon vats. About the only way to make the coffee in sufficient quantity is to make it double strength and then dilute it, which doesn't make too good a brew.

Our bus gets hitched up behind the mess kitchen where water, heat and electricity are convenient. But equally convenient is the sooty smoke from their coal fires and acrid fumes from the incinerators which burn all day long.

None of the camps here have facilities for women. So when we or anybody wants anything so banal as a bathroom, we have to ask one of the men to convoy us. He goes on ahead to make sure the coast is clear and then self-consciously stands guard outside—latrine duty, he calls it. It is all very funny, but if anyone has a notion that this job is glamorous, their minds should be changed for them. We get dirty, messy and tired; smell of donuts; our hair gets oily and stringy from the greasy steam of the machine, and there are no hairdressers. I've been cutting everybody's hair since I left London. But I can't find anyone to cut mine. It has already reached the spaniel stage.

CHAPTER III

Plushless, Blushless, Flushless

*T*he people of Great Britain had been feeling the direct and devastating effects of World War II since 1940, and German bombing raids across England had taken a deadly toll. Rationing in Great Britain was stricter than anything Americans experienced after the United States entered the war in late 1941. And, its people were faced with feeding not only themselves but millions who had escaped Germany's Nazi Army and came to fight for their captured countries. Great Britain was teetering on defeat—its people down but its resolve not nearly out, when American troops began arriving in England in 1942.

During the next two years, millions of U.S. troops poured into the island nation. Great Britain soon became one crowded island. In fact, by early 1943, more than 45 million people were in Great Britain, an island nation the approximate size of, the state of Minnesota. By the end of 1943, some 50 Clubmobiles had served 1.5 million donuts to servicemen in Great Britain.

Clubmobiles traversed the crowds, terrain—and what Americans considered "the wrong side of the road"—to reach

the millions of soldiers soon calling England home. Life for Clubmobilers wasn't always comfortable in Great Britain. Journeys were often made through fog and rain. Conditions could be downright cramped, cold, and inconvenient. Living in close proximity to, and visiting so many Army facilities in areas not cut out for modern living, much less for women, made personal hygiene extra adventurous.

~ Diary ~
Plushless, Blushless, Flushless
The Army Latrine

A wit recently remarked that the Army must think all Red Cross girls have had their kidneys removed before coming overseas. Needless to say, the wit was a Red Cross Clubmobiler who, by deep suffering, had achieved this great wisdom. We now look upon her as a sort of Patron Saint, so deep are her powers of perception.

You must understand the problem clearly. Three of us in our faithful Clubmobile, named "The Oklahoma City," leave our home base every morning about eight o'clock for No Woman's Land, and return at dark about five-thirty. In the interim we have traveled anywhere from 40 to 100 miles, and have visited all sorts of out-of-the-way groups of men, bringing them donuts, coffee, music and company. We bounce and jolt over shell-torn roads, seas of mud, forests, mountains. All along the way the signs read, "Mines Cleared to the Hedges," "Mines Cleared to the Hedges," "Mines Cleared to the Hedges."

I don't want to harp too much about hedges; in fact I've never been even slightly interested in hedges. But it's amazing how one's sense of values changes. It's like the Captain who told me that after being in the ETO (*European Theater*

of Operation) a few months, he began to think kindly even of his mother-in-law. Well, in the same way, I have become acutely interested in hedges. I don't care about their color, shape, type, beauty; only their existence, and their availability. But that is the hitch, because all the time those damned little signs keep up their endless bleat—"Mines Cleared to the Hedges," "Mines Cleared to the Hedges," "Mines Cleared to the Hedges," and War is Hell. As time goes by one gets to the reckless point and thinks, "Oh, to hell with the signs. If I don't try it, I'll blow up anyway."

But that isn't really very convincing, so you sit a little more tightly, a little more stiffly. The theme repeats and repeats itself and falls happily into the rhythmic roar of our big 2½ ton truck. Finally, one's mind becomes furry with frustration. Hedges, hedges, everywhere and none worth a good God damn. And that, friends, is frustration. Think of it and weep. So inevitably the time comes when we have to throw ourselves at the mercy of the Army, which is interesting because the Army is most peculiar about certain things. They wine us and dine us; they shower us with gifts and souvenirs; they wait on us hand and foot and treat us like queens. They tell us there is nothing in the world as wonderful as an American girl. Then from our pearly, shiny pedestals we have to spoil it all by asking for a latrine!

At first, I was slightly reticent, having once been a civilian. Later I took myself firmly by the hand and humming, "Birds do it, Bees do it," I picked out a nice-looking lieutenant, very much like my brother. I waited until he was aside from the group and then asked him very quietly. With horror, I watched him turn a tomato red, and he retired to a group of officers with the unbelievable news. He whispered to a Captain who scratched his chin and turned to a Major who raised his

eyebrows and turned to the Colonel who said, "Oh dear me. Dear, dear me," and coughed a couple of times while the very chickens on his shoulder shriveled up with confusion.

Meanwhile, we were looking out of the window very, very hard and were listening to our little problem develop in a long table conference. It took me some time to figure all this out. Now, of course, I know. It's that divine protective streak in the American male. They always want to protect us from the Army latrine. I love to be protected, but oh, dear God, the price I have sometimes paid.

There may still be some mortals who do not know what an Army latrine is. Basically speaking, and I mean basically, it is a ditch dug in the ground a few feet deep. That's all. You've had it. Next, the usual, but not at all necessary procedure, is to enclose this ditch by a latrine flap which is a piece of canvas, three or four feet wide, anchored at intervals to posts in the ground.

From then on the lucky GI who has pulled this particular duty is on his own and can let his imagination run riot in delicious abandon. He can paint pornographic murals on the flap, scatter flowers here and there, make cute boxes for the toilet paper, but if he is smart, he will simply pray like hell that the damn thing stays up, because it rarely does. The winds blow the flap out in great billowing bulges and the rains come and churn the ground into soupy mud, and poles sag until complete collapse is inevitable.

Actually, the worst thing about these contraptions is that they always seem about to fall, long before they do. It's a paralyzing experience to be straddling ye olde trench and have to watch the flap, the only thing between you and a whole Army division, sway back and forth in the wind and sag more and more. Of course, hurrying is out of the question because it's when you want to hurry most that Mother Nature pulls her

rottenest jokes. It's a wonder we haven't all developed acute kidney trouble, or at least some sort of Latrine Neurosis.

Having been overseas for over a year and a half now, I have the deepest respect for the ingenuity and humor of the American GI. It turns up in the most amazing places. Just as the medieval sculptor expressed himself with such wit and humor in carving under the choir seats of the great cathedrals, so the GI may express himself in Army Latrines. And that brings me to the story of the three Bears … the part that was always omitted from the nursery tale.

At one camp, our request dropped like a bombshell amidst a rather undynamic group of men. They immediately went into a huddle and while we looked through some magazines with deep concentration, we heard emphatic snatches of conversation such as "Hell, no," or "Okay, you can. Not me." Finally, the Colonel called the Top Sergeant. I have a deep-rooted passion for all top sergeants, but this poor creature looked as if he were going to his execution as he led the way for us. The latrine was the most beautiful we had seen. Over the ditch was a long wooden seat painted startling white and looking as chaste as a newborn babe. In the seat were three holes. One great big hole for Father Bear, a medium-sized hole for Mama Bear, and a little wee, wee hole for Baby Bear. Over each was printed in red, in old English script—LARGE ASS, MEDIUM ASS, SMALL ASS.

My most disastrous foray into the realm of Army latrines occurred one evening when we had joined an armored division that was spread out in a tremendous valley. A little cross-eyed GI, whom we named "Tangle-Eyes," was assigned to dig our latrine. An officer apologized that he had no flap and asked if we had anything we could use. The best we could produce was a pup tent, and amid much discussion, this was

set up as the shades of twilight closed in.

Fate, or rather Nature, ordained that I should be the first to use it. A pup tent, you know, is only about three feet high at its highest point, which is carefully obstructed by the pole from which it slopes down rapidly to the ground on either side. The correct approach to it is by a sort of slithering movement on one's stomach. That was impractical, so I gingerly entered on hands and knees, little suspecting that "Tangle-Eyes" had done such a noble job. Perhaps his sight deficiency made him see double. I will never know.

Anyway, he had dug the trench almost as wide as the pup tent, and I fell in flat on my foolish face with such a jolt that my rear tried to follow but somehow got impaled en route. No booby trap could have been more effective. It was like trying to get up after your first fall on skis.

Just then the ack-ack opened up and I heard the enemy planes coming in low. Panic-stricken, I writhed and twisted. My knees came up and bumped all my shins and it was hell. I thought of myself arriving at the Pearly Gates labeled "Latrine Lulu," and I prayed hysterically. From the outside, the pup tent writhed and twisted and looked like a little snake that has swallowed the big frog whole. Eventually, the churning ceased and with quiet dignity, a battered lump backed out on hands and knees, rose painfully, and through the glow of falling flares and streams of ack-ack, carried the warning to the others.

I suppose it is fitting to close this with a glimpse into the future, since everyone is so preoccupied with programs of rehabilitation and stuff. Everyone in the ETO has nightmares. I had my worst the other night. I dreamed I was home. I was elegantly dressed and was cocktailing with the "elite" in ultra-civilized surroundings. As the waiter bent over and suavely placed our drinks on the table with a few flourishes worthy of

a ballet dancer, I tapped him on the shoulder and said gaily, "Hi, Top Kick, where's the latrine?"

~ *Letters* ~

August 8, 1943

Dear Daddy:

Just got your letter—the first one from Birmingham. I feel so much better knowing you are not rattling around Oak Park without the drug store and without a bed. That was a good letter, too. Give me more. Sounds like you're having a good time with a Tom Collins in each hand. We don't get Tom Collinses over here—the nearest equivalent is gin and grapefruit juice, the latter the canned variety which we chisel from the Mess Sergeant now and then. And that has no ice and no cherry and no orange slice, so it isn't the same. My favorite drink here is rum and lime or gin and lime. It's a short drink like a cocktail and very pleasant to the taste buds.

[I] like my new crew very much. The American girl who got into a little trouble with the Red Cross and is now on probation, is fine—all my anticipated problems are non-existent. At least so far. She's a cute blond and very popular with the soldiers. Accomplishes miracles with the boys in the mess kitchen and gets them to do all sorts of KP jobs for us. Her "Mess Appeal," we call it.

The other girl, Vera Pitcher, is British. I like her immensely. She is married, but her husband is off in Nigeria in the Army. All English women have to work—are conscripted, in fact. They are usually given a choice of munitions work or one of the services. But unless they have small children at home to take care of, they are

obliged to do some type of war work. Vera is very well liked by our American boys. In fact, she sometime has trouble convincing them that she *is* British. I thought at least it might be a little embarrassing having a British girl aboard. The men talk so rudely sometimes about England that a native who was the least bit sensitive would have her feelings hurt every day. Vera has too much sense for that, and usually manages to hand it back better than they give it.

It isn't really England that gets these boys, because they are treated well. It's the Army life, but because the Army is in England, they mistakenly put the blame there. I can't say I blame them for hating the Army. It looks like a miserable life to me. The men live in these nasty, little dingy Nissen huts. They have to stand in line to eat, to wash their mess kits, to buy supplies at the Post Exchange, to get their pay, and queue for everything they do.

Lots of 'em have miserable jobs like scything and cutting grass or hauling garbage or shoveling coal. It just doesn't make sense to them that they are helping to win the war with such jobs. Every last one of them wants to go home. And they promise they'll never complain again about the Little Podunks in America where they came from and will go back to.

The days are noticeably getting shorter now. [On] the 15th of August, one hour of daylight saving time will be knocked off, which will make quite a difference. Don't see how these Clubmobiles do the job in winter when it gets really black at 4:00. We work 10 or 12 hours a day which means that a lot of that would have to be done in the dark if the same schedule is maintained.

August 15, 1943

Artie in his last letter asked me if I had sat on an English hillside and heard the church bells chiming in the distance. I wish I were on a hillside with the bells echoing from the valley. Instead, the little village church is right next door. On a Sunday morning and evening they go quite mad for 60 minutes at a stretch. Sometimes the bell-ringer gives us eight notes of the octave in straight do-re-mi sequence, then he mixes 'em up—it drives me crazy trying to anticipate the next note. Just when my ear gets tuned to one order he goes off on another sequence. Bell-ringing here, you know, was discontinued for a long time when England was fearing invasion. The church bells were to be rung only as a warning to the people that the enemy was at hand. Now that that danger has passed they have resumed their tinkling to the great joy of the entire island. I didn't know that church bells were so great a tradition here. Maybe the English didn't know it either until they were silenced for such a long time. I would still like to put a muffler on these scale-runners next door, however.

The airplanes are roaring overhead tonight. There must be an unusually heavy raid on somewhere. The sound of the motors is never lost. As soon as one fades in the distance another one comes up. Except for noticing action of this kind, I really don't feel any closer to the war than I did in Chicago. In fact, I know less about what's going on than you at home. We have no radio and we don't keep up with the newspapers.

On our present working schedule, Monday is our heavy day. We start from here at 8:00 in the morning. Drive 35 miles which is a long haul in our leviathan. There we serve a large hospital. The time between our arrival until 2:00 is

spent just cooking the donuts. Then the other two girls stay on the truck to dish 'em out while I do the wards with 500 donuts and 10 gallons of coffee balanced on a little hospital cart. It takes me two hours of walking to get back to where I started, after which time I am plenty pooped. Then, on our way back we stop at three more small MP stations with just 10 or 20 men each. Even though they are small groups, they do take time. Usually we get home about 9:00 in the evening.

Tuesday we do a bunch of warehouses and another stop for some black engineers who are working on a construction job. We park in a great big cinder lot and all around us little English freight trains (which are miniature in comparison with the freight cars we know) are tootling up and down the track. Great cranes are hoisting and chugging, bull-dozers are churning up the dust. When they see us coming, all the war-winning wheels stop turning as if cut off at a main switch. A double-quick stampede to the donut wagon is launched. The men are allowed a 30-minute break for our benefit. It is at stops like this that we really eat dirt ... the wind whips it up across the cinder yard if the trucks don't; it comes in and settles—in our hair, in our mouths, in the donut machine, and in the cups. Cups that were washed two seconds before are coated with black cinders before we can get them put away in the racks. It's enough to make you cry, but instead of doing that, we pour out more coffee and hand it over the counter, hoping they'll think it's just a few coffee grounds.

One thing that England has bigger and better than America is draft horses. Guess I've talked about them before, but I was reminded again when I saw a big fellow tonight wearing slip covers on his ears to frustrate the flies.

August 24

In Ipswich I had my first experience walking about a busy, crowded downtown in complete blackout. London has a few dim lights and traffic lights, and even if they are shaded, you can tell where you're going. Up here it was terrible. The sidewalks are as curly as the streets; they are extremely narrow, have lamp posts right in the middle, and are completely cluttered with thousands of ribald soldiers who nudge you and jump out of doorways at you and make themselves generally objectionable. We had no flashlight at the time, so both Doris and I held a lighted cigarette out in front of us which helped a little—at least it warned others of our presence. The blackout terrifies me. I don't see how the police manage to keep any kind of order. It seems to me a criminal or a marauder could get away with anything with never any danger of being caught.

CHAPTER IV

On Board the Kansas & Oregon

*D*onut demand soared as millions poured into Great Britain, the staging area for the massive invasion plans the Allies began developing to rid Europe of the Nazi occupation. Plans for the invasion of the European continent were mapped out and the build up for D-Day was underway by the time the majority of Clubmobilers had arrived. Clubmobilers joined in the invasion preparations, stocking 15 days of supplies and adding personal hygenie items, such a razors, combs and bootlaces, to the list of soldier's supplies.

For Clubmobilers, the Great Britain build up also brought big challenges. As men who used to drive Clubmobiles were transferred to invasion units, Donut Dollies had to learn to drive the 2½ ton trucks. Angela Petesch remembered the hectic build up and her truck driving lessons in letters home.

~ Official Diary ~
Clubmobiles Kansas & Oregon—August 22-29

Angela Petesch, Vera Pitcher, Harriette Atkinson, George Boehm, driver

For four weeks now the new crew on the KANSAS has
been slugging away serving donuts and coffee and getting
acquainted with its new surroundings, with little or nothing
interesting happening worthy of an official diary.

The fireworks started last Sunday when the KANSAS
broke down and scattered herself all over the road. The crew
and driver had been to London on a long weekend vacation
during which time the Clubmobile was left in [site blacked
out] for the periodic oil change and greasing. We met there
Sunday evening to take the big gray monster back to her berth,
a little courtway beside the Spread Eagle Hotel in Rolleston-
on Dove, Burton-on-Trent.

Before we were out of the city limits, there was a clang and
a clatter as bits of gears, fragments of the engine and gallons
of oil bounced off the under-carriage onto the pavement and
off the Clubmobile again. They were bits and fragments of the
Clubmobile, fortunately, and not some unseen bicycle hit in
the blackout.

After inspecting the damage and gazing open-mouthed at
the hole in the engine where the connecting rod had uncer-
emoniously crashed through, the well-known tussle with but-
tons A and B began. The garage we had left a half hour before
didn't answer—closed for the night. The next choice was to
get in touch with the nearest American camp to plead for a
tow truck. This was accomplished. After a wait of half an hour,
instead of a tow-truck, a small ambulance skidded to a stop and
three eager doctors armed with flashlights jumped out looking
for the broken bodies. We were sorry to disappoint them after

breaking up their card game and getting them out in the black of the night, but since there was no tow available, we parked the stricken KANSAS along the curbstone with the blessing of the local Bobby, and gave the medics the secondary pleasure of driving us home—in a vertical instead of a horizontal position.

They put on a good show, though, and to create the proper atmosphere, one of the men screamed up and down the scale emulating a siren in first gear. We weren't stretcher cases when we started, but thought we might be at any moment. In less than due time, we were home and I might say glad to get our feet firmly planted on the safe and sober soil of [site deleted].

Monday and Tuesday were spent telephoning again and transferring stores and equipment to the relief vehicle, the OREGON, which itself was jerked out of the repair garage and paint shop at headquarters to pinch hit for its more badly off sister. So Wednesday we got down to business again. Our largest camp in this neighborhood is a big QM (*Quarter Master*) depot. The men worked in warehouses, on open storage and at railroading.

We were making the rounds there with the traditional refreshments, driving down one of the camp roads, when we were spied by a crew of four or five men shuttling up and down on a steam engine. In order to be quite sure they would get their share, they parked their little English locomotive on the crossing so that we couldn't proceed. A big thing like the Clubmobile can bluff most of the traffic off the roads, but even she couldn't argue with a steam engine. So we traded places for the moment—the men took over the Clubmobile and served themselves coffee and donuts while the girls climbed into the cab of the engine to inspect the various throttles and toot the whistle.

Then a second engine puffed up, and a few seconds later, a third. Transportation on that line ceased for a while. Viki entertained with an old-fashioned railroading song sung with a good hillbilly twang. As we pulled away, the little huddle of English engines reminded me of something Walt Disney might have created; [and all] joined their adolescent voices in as wild and noisy a chorus of tootling and whistling as you have ever heard. They were last seen going back to their prosaic pastime of hauling freight.

I suppose every Clubmobile crew has at one time or another lost its flour sieve. Our acceptance into the club was solemnized Saturday. We heard something clatter down from the rack up in front of the Clubmobile as we were driving home, tired and irritable from a day of frustrations. Two blocks later we discovered the sieve was missing. After stopping the driver with a heavy finger on the "Push Once" [button], Angie took off at a slow dog trot (retriever), waving and calling to a group of small boys who had picked it up and were passing it around for individual scrutiny. Either they didn't see her or didn't recognize her frantic gestures, because before she had covered half the distance, they started down a side street with our more-precious-than-jewels sieve.

Everybody else on the street heard her, though; heads were poked out of windows and cyclists stopped in their tracks and smilingly watched the scene with no one doing anything to nab the kids. Angie accelerated to a sprint, and when she finally overtook them they were about a block away from the scene of the crime and were just about to step into a doorway—doubtless to show their trophy to their mothers. Puffing like a porpoise, Angie arrived back at the waiting Clubmobile with the recovered sieve firmly [grasped] in her hot little hand, and slumped down in the lounge to catch her poor breath, while we traveled the rest of the way home without further calamity.

September 13, 1943

Dearest Family:

The weather has been bad, particularly on the weekends, so that we have had to spend our precious day off huddling around a gas fireplace to find a little cheer and warmth. But those days I seem to have slept through, putting off the weekly bulletin 'til some other day. I've told you how ugly and dirty our camps are. You should see them after a couple of days of rain with the trucks and tractors churning up the mud and clay. Oddly enough, it always seems to clear up when it comes time to serve donuts though, so the crowds are as big and hungry as any other day.

We expect to be moved again in another couple of weeks, probably to the airplane country which will please all of us. I feel we have now done our time, up in this neck of the woods, and should be due for something better. The English girl I like better every day. She's wonderful. And takes such a lot of guff from these fresh Americans who think they are God's chosen people. You have no idea of the conceit of them.

My health has been excellent. Haven't had a cold since I've been here which is rare for an American to say, most of whom get one when they step off the boat and never get rid of it. My old backache hasn't murmured. And something about the English climate has also cured my dandruff—an unpretty subject but a happy riddance.

Accepted a "rich" gift the other day when a little Lieutenant jokingly offered me a pair of woolen, long-legged "drawers". He had bought them for himself and they didn't fit. He assured me they were form-fitting, but he didn't have my form in mind. However, they are wearable. Fifty percent wool and a lovely gray color like the old scraps of underwear Mother used to fasten into the old mopstick. I'll have to find somebody

now who doesn't want the top half so I can have a complete uniform. Then I will really look like the old time prize-fighters who used to pose for photographs with their muscles rippling under their long skin-fitting tights.

People warned me that in England cabbage and Brussels sprouts would be the main diet. They weren't kidding. But what is really getting me down are plums—stewed plums and plum tart, which is nothing more than the little, sour Damsons, stewed, with a square of pastry (baked separately) sitting uncomfortably on top. Custard along side, of course. Where so many plums come from I'll never know. Or how they get so sour. The plum tart always brings up the old argument as to whether it is a tart or a pie. Vera says it is a tart if it has no top crust, no matter what the size. When there is a top and bottom crust it is a pie. Yet stewed plums with no bottom crust at all and a square of pastry balanced on top is a tart when really it is neither.

We have lots of fun educating each other though I'm afraid Vera is becoming more American than I am English. She lives with and sees nothing but Americans all day long, and months ago decided it was less wear and tear to say it the American way to avoid a lot of subsequent explanation. She says when she first took this job with the American Red Cross she was more lonesome in her own country than the Americans who were 4,000 miles from home, because she never saw an Englishman. She has picked up a lot of Americanisms ... so much so that her family is horrified when she goes home for a visit.

Sept. 26, 1943

Dearest Family:

There's a real chill in the air tonight so I am sitting up in bed with my knitted pajamas on, a woolen bathrobe, bed

socks, and over me, four thicknesses of blanket plus a comforter—and with the gas fireplace going besides. They tell me it's healthier without central heating. I had no idea we were such an unhealthy race of people. Am very glad I got here in the summertime and can get conditioned to it gradually. To arrive in the middle of winter and be plunged into this cold and damp suddenly, would surely put you in bed with pneumonia.

Have just returned from a week's leave which I spent in Edinburgh. It is without a doubt one of the loveliest of cities. It is lovely even now after all the deprivations of war, though they haven't suffered nearly so much from blitzes as some other places.

The shops on Princes Street, which is the main avenue of the city, are beautiful with lots of pretties to buy (for them that have the coupons). The shop windows are so attractive, whereas in London, they are all boarded up for protection or have only a little square of window 3' x 3' without blackout in which to display merchandise. The Scotch people, too, look so much better off; better and more tastefully dressed, and better looking. The hats are something you wouldn't be ashamed to put on your head. And the girls who don't wear stockings have pretty legs. English legs unfortunately are purple.

On my way up there I met another Red Cross girl headed for the same place and with the same purpose, which saved the day for me. I had started out alone because I was notified so late there was no opportunity to make plans and join up with anyone else. We did the city pretty well in the five days I was there—saw Edinburgh Castle, shopped on Princes Street and along the Royal Mile, which is the main thoroughfare of the old city stretching between Edinburgh Castle and Holyrood Palace. [It] is full of historic spots such as John

Knox's house, plus a succession of curio and antique shops. Also went down to the Firth of Forth bridge and had a ride on a ferry boat. Someday some enterprising person should dredge that spot because it is the habit of tourists and natives alike to throw a penny and make a wish as you cross over the bridge. It was cold out there that day, with the wind blowing in from the sea and throwing up a fine spray. We had to wait an hour for our ride back, having missed the ferry by just a minute or two.

We stayed at the Red Cross club in Edinburgh which was set up for soldiers, but they do have one room with six beds for women such as the Red Cross, nurses, WACs, etc. The club part wasn't too comfortable. This room for six did have an adjoining bath, but no closet space for hanging clothes—only two hooks on the wall.

One of the room-mates snored, another talked in her sleep, a third one had a cold and did as much coughing, snorting and sputtering, with head cleaning of the jolly consumptive variety, as she could do without showing us her adenoids. In addition to that, the beds were iron Army cots with mattresses that felt like rock piles, and springs that squeaked every time anyone turned over. In spite of it all, we managed to sleep because we were so dead tired with all the walking up and down hill. The hills are almost as bad as San Francisco. It was a good week, and I have come back pleased and impressed with Edinburgh.

When I got back I discovered the Clubmobile had broken down in my absence so the girls had to spend a couple of days changing over to another one and cleaning them both up—one to send back for repairs, the other to make fit to work in. We now have the KANSAS back again ... which has been fitted with a new engine. It isn't right yet, however, and is leaking oil badly, so the mechanics have to come back tomorrow. The word "mobile" has once more been removed temporarily from

our vocabulary. The old bus is now parked in a spot where we can make donuts, but we will probably have to serve by Jeep. It seems to me we have put in an awful stretch here. There has scarcely been one normal week. But maybe that in itself is normal—we do hear of a lot of catastrophes, and they all make better stories than going along peacefully day after day.

Have a new permanent wave that I got in Scotland—"perms," the natives call them. I needed it so badly that I've had an inferiority complex the past few weeks. It was most fortunate that I got an appointment at all, since hairdressers here are booked three and four weeks in advance. And the poor hairdresser. There just aren't any replacements for their equipment—especially the metal parts. In this case his little key was broken—a key he uses to tighten the curlers after he has the hair wound around them. So he had to go after each one with a large pair of pliers which had a way of slipping off the little stem and bouncing off my skull. He would grit his teeth and try so hard. Naturally, it all took a good deal longer. But it was worth it. Now no one knows me, which shows the rejuvenation that has taken place.

October 5, 1943

Have just finished polishing my boots. The English soldiers use a spit-and-polish method. First they rub in the polish, then shine with a brush and cloth. The last stage is to drool a little on the shoe for the final rub-in and high polish. Being of a more delicate nature, I used tap water instead. The results were all right, but not as good as pure, unadulterated spit.

Have I ever told you about Robert Lee, a patient in one of the hospitals and [who is] a colored boy with strong white teeth and a strong stomach. Robert eats razor blades. He

entertained the bug-eyed Clubmobile crew recently—between donuts. We had heard about his sharp talents and so had him brought around to demonstrate. Finding a razor blade to waste on his digestive tract was a problem for a moment or two, but we produced, and he obliged. He also likes light bulbs, but we thought that a little expensive.

The razor blade was a thin, double-edged one. He casually snapped off a piece and with an expressionless face, chewed it up into small bits, making a noise like one eating celery, licked the little scraps off his lips, swallowed it and started on the other half. His friends said he ate a lieutenant's bars the other day.

Robert was hospitalized for a bad cold.

Our Clubmobile crew has become amphibious. Last week we took to the water. At this camp some of the men were on one side of a river and some on the other. So we loaded donuts onto a boat and were punted across to the other side, throwing a few to some isolated soldiers perched on a pier mid-stream. Only one or two of the throws were not dead-ringers; one boy retrieved one of those from the chilly waters and ate it with as much relish as if it had been dunked in coffee. Am thinking of designing a little cannon to be mounted on a radiator cap.

We have a new girl in the crew—Joyce Farnham from New York. A young girl, cute, lots of fun, and a good worker. She's just recently arrived in England. This is her first assignment and, poor kid, has had a rather rough introduction, considering all the trouble we've been having. Besides that, I ran over her foot the other day and put her out of commission. I had been driving a little finger truck—a tiny thing about six feet long that has a hoisting arrangement in front for lifting and moving freight. After I had my little spin and was still sitting in the saddle, Joyce came over so that the men could explain it to her. Without my knowing what they were going to do,

they slammed it into gear—my foot wasn't far enough down on the clutch, so it jumped backward about six inches but just enough to catch her big toe. It was a hard rubber tire and it hurt. The skin was broken a little, and she will have a black nail, but thank goodness no bones were fractured.

Then today, another kind of a ride. We were running short of time this afternoon. So while the other kids stayed back to wash up the cups, I commandeered a big hoisting crane to take me down the road a half mile with my two trays of donuts. We roared away with chains clanking and black smoke pouring out the little exhaust chimney in the rear. A half mile of that, sitting on a metal tank as I was, was just about enough of that mode of transportation. But it served the purpose.

Business is getting better and the days aren't long enough. Your days are getting shorter about now, too, and I'll bet you have nice bright fires in your fireplaces. I have an old gas fireplace with a vulgar shilling meter along side—the only source of heat in the room. Have to dream pretty hard to make believe it's warm or real.

October 27, 1943

Dearest Family:

It is cold now and there is a lot of fog lately—sometimes all day long—that keeps you in one prolonged shiver. Am now at the stage of wearing a sweater under my white cotton blouse. The next degree will be sweater under and one over. Also, the Brussels sprout season has opened and is well underway.

Tried to do some Christmas shopping last trip to London. Am really quite unhappy over that, I must admit. My boxes will be sent off next week, rather uninteresting and too late to

be insured for Christmas delivery (the deadline for that was Oct. 15). But what normal person can have her Christmas shopping done, wrapped and mailed at such an unreasonable time. If it doesn't come, you know it is on the way and will get there by the grace of Uncle Sam, the U.S. Army and a little bit of grace from God.

This past week we have had a relief driver helping us while the regular one was on vacation. He was an older man and said he was a former London bus driver, which should be enough experience for anyone. But he scared us to death. He had a quick, jerky way of handling the big bus, barely missing obstacles and barely making corners. Because he didn't know the route, I had to stand in back of him with my head poked into his little box to give directions about which I was none too sure myself. Besides being jerky, he didn't see or hear too well.

The first day was the worst, because it was the longest drive. We started out in a heavy fog and came back in a black-out. Almost home, I discovered just in time he wasn't seeing the crossing lights where the railroad lights were down, but my shrill shouts to STOP brought us up to within an inch of the barrier. We three girls were limp when we finally got home.

Another day, he put a dent in the body of the Clubmobile, parking too close to a wall. And Sunday he gave another wall a real smack by not looking when he was in reverse and smacking right into it. The wall swayed back about a foot, shivered a little and finally settled back in place, well-cracked and with another dent in our body. The wall was the property of the local vicar. So last night I had the questionable pleasure of calling on him to apologize and find out the damages. He turned out to be a cute little fat man, so it wasn't nearly the ordeal I had anticipated.

Today was another mess. The truck was loaded with donuts and hot coffee; while going over a bumpy road, a coffee

urn (capacity 5-gallon) hopped off the counter and bounced on the floor, breaking the urn and flooding us in two inches of coffee. Besides that, two trays of donuts left their berths in the rack overhead that was formerly the baggage rack when we were a London bus, and dunked themselves in the coffee on the floor.

November 11, 1943

Dear Family,

The thing uppermost in my mind tonight is my chilblains. 'Member how I had them when I was a kid? My poor old toes haven't gone black as they did then, but they are red and swollen, tender and itchy. At night when we sit by the fire they really start to blaze. Last night Joyce went out dancing and Vera and I stayed home and scratched our itching feet. It was delicious.

We three girls have moved our quarters from upstairs to the first floor where we have a little suite consisting of two double rooms and a private sitting room. Plus a private bath. We have chrysanthemums, holly and fir branches stuck around in a variety of jugs and jars, and it is all quite cozy. Matey, as the English would say. Next week we will get us a little tea kettle to set on the hot coals of the fire, so we can brew us a spot of tea. Now we can do a little entertaining without having to sit around a frosty public lounge, and enjoy each other's company a great deal more. For heat we have gas plates in the two bedrooms with meters. The sitting room has a real fireplace. And the bathroom has none, though it does have an automatic water heater. However, the hot water running into the bath in the cold room raises such a steam as to cut off visibility entirely. Even when you get into your 5

inches of bath water, you shiver like a leaf with most of you exposed to the cold moist air and the rest of you sitting on the icy porcelain.

November 19, 1943

When we moved downstairs to our little apartment a couple of weeks ago, we inherited a small portable radio that had been left in the sitting room by an RAF man and his family. The radio he had found in France when he was there at the time of Dunkirk, and he brought it back with him. He was one of the two or three of his entire squadron that came back at all.

It's a funny little cheap radio, quite old, with a three-point plug that we have to fit into a two point socket; has wires on it the size of a single hair that keep breaking. So that as one repair job follows another, we inch along getting closer and closer to the end of our rope. The machine squeaks and squawks and sometimes fades into nothing at all, but it is such a treat to have it, and it has such a noble history, we feel very wealthy.

We're going to see if the Signal Corps boys in the Army can fix it up for us. The Army gives us every-thing else, including shoes and socks, long underwear, pineapple juice, with now and then, a steak ... so that fixing a radio should be a mere nothing. This morning we heard a rebroadcast from New York and last night a program from Hollywood with Ingrid Bergman, Edgar Bergen and Charlie [McCarthy] among others—the first time I've heard little Charlie since early last Spring.

A rather distinguished visitor is in our midst this weekend. He also spent the weekend here two weeks ago. Col. Charles Hicks is his name, on the Australian General staff and in England on a diplomatic mission. He is a friend of our Joyce

Farnham's and it is she he has come to see. He is a nice little man, quiet and retiring, about 45 to 50 years old, young for the position he holds but too old for our Joyce. He's on his way back to America for six weeks, back to Washington, D.C. and then maybe return to England. He says he will bring me a big fat oyster packed in dry ice. I haven't mentioned it to him yet, but will give him Ede and Art's address and ask him to telephone on his way home. If weather should interrupt Clipper sailings, he might even have a chance to see them. Wouldn't that be fun?

Lady Dill has given String the right information. I could see right through your censorship, String. Now look on your big map exactly two miles straight north and you will have it on the bean.

Vera Pitcher, our third member, had a most interesting experience last weekend. We were all in London on a holiday. In the house where she was staying was also another guest, a Canadian officer recently repatriated from a prison camp in Germany. He got back a couple of weeks ago with hundreds of others on the Red Cross exchange ship, the Atlantis. [His name is Lt. Woodcock.]

Two years ago at the time of the Dieppe raid, he was taken prisoner along with practically every other Allied soldier who lived through it. His ship was blown up a few hundred yards off shore. The blast blew his shoulder to bits, blinded him (he could feel his one eye dangling on his cheek), and also deafened him. In spite of all that, the shock and fright and agonizing pain, he clung onto bits of wreckage for several hours in the icy waters before he was finally rescued.

The Germans pulled him out of the water but did nothing in the way of first aid for his wounds—just left him lying in a row boat on the beach. Some of his buddies managed to

tie up his shoulder. After two days of that exposure they were piled on a train for Germany and the prison camp where he finally received medical supplies. His shoulder has been pretty well mended, though it is still misshapen and weak. His hearing has returned in one ear. He is still blind, though the doctors here in England are going to operate on the one eye with the faint hope of restoring the vision partially.

When they arrived at their prison camp, this man and the others with him immediately organized themselves and appointed a mess officer to take charge of and distribute the boxes of food sent by the Red Cross. It was on these boxes of food that they subsisted. The German menu consisted of a bowl of potato soup and a couple of pieces of black bread—the soup revolting and unedible.

Then they took on the job of re-educating themselves. Each man had to lecture and teach everything he knew about his own peace-time profession. This man studied law a great deal in camp because he thought it would be something he might be able to follow after the war, though blind.

The British and American Red Cross were wonderful in getting supplies to them such as books, equipment for learning Braille, handicrafts. For a while, they were housed in dirty cellars in retaliation for what they thought the British were doing to German prisoners. During another spell they were chained (more retaliation) and their hands tied behind them. Those who weren't chained were made to work in the salt mines. The Germans didn't seem to care who was chained, because the men used to change off and swap jobs with those in the salt mines now and then—it just pleased the Germans to have some of them in chains. Lt. Woodcock said, however, that nothing ever got them down—they were always laughing and gay—partly because being so made the Germans mad. That in itself made the prisoners feel better. They used to

yearn so for news. When they heard British or American air raids going on over Germany, they would hope that any airmen taken prisoner would be interned in their camp. New arrivals were their only source of news.

My two days in London were spent going through Hampton Court which is where Henry VIII made love to his six wives. Parts of the building are still occupied by some of the royal hangers-on. It would not be my choice of a place to live, but I must say it is the most livable castle or palace I have seen up to now—much less cold and grim than most.

The gardens are beautiful and appear to extend for miles though they are not at their peak in November. Joyce and her Colonel and I went together; got there about 4:00 which was closing time for tourists. But we were not disappointed because one of the guides spotted us and took us on an off-the-record tour. He tried so hard to impress us with the special privilege he was giving us by talking in a hushed whisper all the time, having us walk on tip-toe through miles of corridors so the occupants wouldn't hear us below, and by snatching us through open doorways into shuttered, dimly lit rooms so that we would not be detected on our sub rosa visit.

The trip was fun because of this old guide and his lecherous hands that were forever squeezing our arms and tilting our chins to see the murals on the ceiling, or leading us through a dark passage. I found the interior of the castle a little disappointing because all the old furnishings that are normally there and intact had been removed; the really fine pictures had been stored away for safe-keeping from the blitz. It all looked like an art gallery with room after room full of inferior pictures and hideous murals with a corridor running straight through them all. There were some fine bits of wood carving, magnificent fireplaces large enough for a man to stand in, and

majestic staircases where you had no trouble visualizing velvet-robed and white-wigged royal personages swooping down the stairs. The Colonel tipped the guide handsomely (which was what he was after in the first place).

Sunday I bought myself a ticket and went alone to hear the London Philharmonic Orchestra conducted by Fistoularis with Myra Hess the soloist. This was held at the Adelphi Theater, in case Artie is interested. We lunched at La Coquille in St. Martins Lane. Don't know how old the restaurant is or whether Artie has any memory of it, but the Lane is an ancient and famous one he may recall.

The statue of Eros in Picadilly Circus, which is one of the landmarks of London, has been boarded up with planks and scaffolding to protect him from bombs and prankish Americans for the duration. It looks just like an old wooden pyramid as it is. Hope I see the little cherub before I leave these parts. Wouldn't it be wonderful to see London and Picadilly with lights on, and bright as in peacetime. Think of it … there are children six and seven years old who have never seen a street lighted at night, (assuming they weren't interested in such at the tender age of 1 or 2). England has been blacked out for almost 5 years. These same children don't know what a bright, gay Christmas is—have never seen the toy windows or had decent toys. Maybe next year.

December 5, 1943

Dearest Family:

This letter should reach at least the first half of the family circuit before the holidays and in time to wish you a happy Christmas. At dinner time on Christmas Day I will raise my glass of sherry and toast a hearty "Cheerio" to you all. That

will be 7:30 English time, so if you feel any gentle vibrations, you'll know what it is.

Our Christmas promises to be a very busy one, professionally speaking—much too busy to allow anyone to feel lonesome or homesick. We've just had word from headquarters about the Christmas stuff they are going to send us to distribute to the men ... sweaters, mufflers, sewing kits, ocarinas ... amounting to a total of 750 individual pieces, all of which should be wrapped, in my opinion.

We're also getting a few hundred balloons and thousands of pieces of candy and cigarettes. It all has to be divided for distribution to about four camps. Since there won't be enough for an individual present for everyone, we have to figure out some amusing scheme of giving them away so that the unlucky ones won't feel offended; such as a raffle, or a present for the man with the baldest head—and then have a big argument and end up by counting the individual hairs, I suppose.

We also have to decorate our Clubmobile for the week preceding Christmas. Besides that, we may be expected to address and mail 1,000 Christmas cards to the men who have signed their names in our state register. The latter was my idea, so I can't complain too much if it materializes. Weeks ago, I wrote to headquarters and proposed that they furnish each Clubmobile with inexpensive cards to be sent to the names in the register. They liked the idea and promoted a contest for the design of the card among the Clubmobile personnel. Now the boomerang is about to come back and hit me in the head. Then we are going to try to have a Christmas party of our own here at the hotel, providing we can manage to buy a bottle of something and chisel a few snacks to eat. We won't be too lonesome, as you can see.

We were "honored" the other day at the officers mess when

a mock investiture was held and we three girls were decorated with the D.D.C. A cute little Lieutenant, a smart little hillbilly from Paducah, stood up at lunch and in stentorious tones read off the long citation about how these three girls had made so many millions of donuts and how they had exhibited unusual bravery by going directly and unhesitatingly into thickly infested GI territory. A boy was there with a large camera and flash bulbs to catch the scene of pinning the decoration on the blouse and kissing each of the giggling girls on both cheeks. The D.D.C. is the Distinguished Donut Cluster.

In return, the three donut benders made a lei of stale donuts by stringing them on a rope (pardon my modesty, but our fresh donuts are too tender) with a big red cross dangling from the bottom; this we draped round his neck like the winner of the Kentucky Derby.

Army slang—the GIs refer to the Chaplain as "GI Jesus."

December 17, 1943

Dear Family:

It is now just one week before Christmas and the first hundred packages are wrapped. We started last night by painting a lot of white tissue paper with green ink Christmas trees and red ink blobs. Also, dyeing a few hundred yards of paper ribbon ties. Only 900 more parcels to take care of.

At first, we thought we would have to make only four stops on Christmas. Now it develops that our problem is a little more complicated than that. One camp, for instance, is divided into a number of smaller units, some white and some black; the officers believe that all or none should be visited, so our Christmas parties for the men have grown from four to nine. We start Wednesday with two calls in the evening.

Three on Thursday and Friday nights, and one Saturday, Christmas Day.

The donut business will be suspended from Wednesday on, fortunately, so we can spend all day getting ready for the evening shows. The Special Service officers have been fine and are building their own parties and entertainment around us. We can only spend an hour in each stop, but with that, the extra beer rations, their own talent and a few Christmas carols to weep over, I am confident a good time will be had by all. The results will be reported.

Had a very nice weekend with Doris. They have a most comfortable house to live in, the three girls plus the club director, with several additional beds to sleep visiting Elks like myself. A housekeeper too, to prepare meals and keep them tidy. Doris is the manager of the house, in addition to her club duties, and was a most charming hostess. As manager she has to handle all expenses and the ration cards. Learning the latter is a job in itself.

In order to get back here, I had to catch a 9:30 train to London Sunday evening. That meant leaving Ipswich at 6:30. Normally, it should have worked. But there was nothing normal about it. The train was two hours late getting into London, so I missed connections. Then when I got over to the Red Cross club, they had no room for me, so I slept on the floor. That wasn't really as bad as it sounds. A whole row of feather bolsters were put down for me in the writing room, with sheets and plenty of blankets—I slept warm and comfortable.

Monday I declared a holiday for myself and spent the day to good advantage in London because there were lots of bits of shopping to be done for the Clubmobile. The girls picked me up at the station in Derby on their way home from hav-

ing done a terrific day's work (that is hard for three of us and a merry-go-round for two.) On Mondays, with the bus full of people and in the way, we try to make donuts, serve them, wash up cups, make coffee, keep the Victrola wound up, send out carts of coffee and donuts to the wards, pack up other little bundles for officers that can't leave their work—all of it going on simultaneously all day long, in a space as large as a kitchenette.

Here's a new Thanksgiving toast that some soldier composed:

"Here's to the turkeys that grace our tables.

We love their breasts and legs –

And also Betty Grable's."

January 4, 1944

Dear Edie and Art:

Hope I haven't waited so long as to have forgotten some of the Christmas fun. I'll begin with the week preceding and give a play-by-play report. Monday and Tuesday can be covered quickly because we worked our regular stops as usual with donuts and coffee, but were just a little more dressed up than usual with holly dripping from the ceiling, a wreath encircling the clock, red satin bows at the windows and sprays of holly tied onto the donut trays.

At night we worked like beavers—Joyce dyeing string and ribbon to look like Christmas ... and Vera and I wrapping bundles until our backs ached. ... We also painted two of our big cardboard boxes to look like red brick chimneys, glued cotton wool around the upper edge for snow, tied red bows on them, and put our parcels in them to take to the parties. ...

Wednesday, we gave up donuts for the rest of the week

and spent the day packing. Each day we would just manage to be ready for that evening alone—just one jump ahead of the sheriff. We did the work at home so that for about 10 days we looked like a bargain basement. But as one day followed another, the stacks would gradually decrease and daylight would glimmer through. At 6:00 in the evening the truck furnished by the Army would come and pick up the stuff and us and trundle us all off—the three girls, our driver and John and Lewis Wood—all dressed up with red mittens and holly pinned to our lapels. …

However, the two stops on Wednesday were complete flops. They were both colored camps, and the officers had done nothing to help. They had a Christmas tree standing there without a single bit of trimming except the dust it came with. The piano players were there drumming away, but when we asked for something a simple as "Jingle Bells" to sing, they couldn't comply. The men all stood around with deadpans, waiting for us to put on a show and we had none.

And because it was a colored camp, everybody was more than a little self-conscious. It was most painful. After we had made several fruitless attempts to work up a little party spirit, we gave up and distributed our lucky numbers, gave away the presents and candy and finally wound up in the Officers' Club to drown our sorrows. I was sick about the whole thing at that point. I wasn't expecting too much either, because I realized it was several days before Christmas and that much harder to stir up enthusiasm that wasn't there, since nobody felt too happy about spending Christmas in an Army camp in England.

Thursday was better, however, so our hopes began to rise. At least they tried to help. But there again, a bad taste was left because at the third stop of the evening there were so many men and so out of hand that a near panic resulted. An

officer started the difficulty by making the mistake of throwing the candy to the men. It just flew out over their heads in great handfuls. The great crowd started crushing toward us where we stood in the middle of the room around the ping-pong table. They pushed each other around trying to retrieve candy from the floor, and I thought we would all be pinned under the table.

This party was the other extreme … too much enthusiasm, all for a chocolate. But it was not hysteria and not Christmas spirit that drove them. It eventually had to be stopped with a series of sharp commands and threats of punishment. We went home feeling like a limp Hershey bar that had been set in front of the fire. Having Army commands shouted out over the party, of course, spoiled it. We had so wanted to keep away from Army routine because the men get enough of that seven days a week.

Friday was the best of all. One camp had entertainment planned for the entire evening with microphones, search lights, Christmas decorations, music, a GI Master of Ceremonies (rather than an officer), and donuts and coffee for refreshments—their donuts and coffee, not ours. A great treat for us.

The last party on that night was another colored camp and they were wonderful. They had a good hot Negro band on the platform, with a bass player who slapped his big fiddle around until I thought it would fall into splinters. Also, a soldier dancer who used to be an entertainer at the Cotton Club in New York. He shuffled and tapped and squirmed in true Harlem fashion. The men, 300 of them, sat everywhere but on the ceiling and were perfectly orderly. They laughed and smiled, hollered and clapped, and had a good time.

But the real treat so far as I was concerned was when they all joined in singing spirituals. … They sang beautifully, had

an excellent leader, and it was something I won't soon forget. Their wonderful sad faces. We could have listened to them for hours. When it came time to give out the presents, they were happy as children if they discovered they had a lucky number. They came up to the platform rather shyly because all their friends were hooting at them in the rear of the room, and their faces wore a sheepish, self-conscious grin as they selected a package from the red brick chimney ... and they were so polite.

On Saturday, Christmas Day, we were scheduled to make our last call. We got there at 4:00 in the afternoon, prepared to join in the fun and have supper with them at 6:00. But what we found were about 50 men out of 400 who had been drinking beer since the night before, and not caring whether school kept or not. After standing around about 15 minutes to see whether something more favorable might develop, we took our stuff and went home with the promise to come again Wednesday. They didn't miss us—I think they didn't even know we were there. The second performance was better planned. They first had a little service by the chaplain, then a movie, then presents from the Red Cross, and finally donuts and coffee.

Sunday we collapsed and didn't go out of the hotel all day.

Our own Christmas Day was fine. We had a specially nice breakfast with canned grapefruit (the first I've seen) and a fresh egg. Dinner was roast duck with the usual trimmings, mince pie, and Christmas pudding for dessert, with real cow's cream on it. Buried in the plum pudding were little silver thrupenny pieces. Also a glass of wine on the house.

Sunday we were invited to have tea with the family, and a proper pre-war tea it was. The table was laden with cakes and cookies, candies and puddings, many of them saved

from better days. There were paper hats to wear and crackers to snap. To top it off—snap dragons. That is an old English custom. The lights in the room are turned out and raisins and almonds, soaked in brandy, are set alight and brought into the room. Everybody stands around the table and snatches the fiery raisins in their fingers and pops them in the mouth while they are still aflame, with squeals of delight.

January 22, 1944

Dearest Family:

At last the move we have been expecting for months has come about. We had notice of it about two weeks ago. Then the day of departure was postponed twice because our new accommodations weren't ready for us. Finally, on Wednesday we piled everything into the bus—trunks, suitcases, bedding rolls, bicycles, and a few oddments that wouldn't fit in anything—and the entire Clubmobile crew moved off 130 miles to its new base. We felt both glad and sad about it when the time came—glad of a new territory since the old had become a little tiresome, and sad to leave our comfortable apartment because we knew we would never find anything so good.

The last hunch was correct. We now live in a small residential hotel (more like a boarding house) that is the house where Thomas Gainsborough was supposed to have been born back in 1727. Downstairs the rooms are attractive and gracious, but the bedrooms are the most antiquated with a marble-topped wash stand on which is arranged a bowl and pitcher, jug and soap dish, and a pot in the cupboard underneath. In the morning there is an enamel pitcher of hot water on each doorsill.

These bedrooms are all tagged with little signs bearing the names of famous Gainsborough paintings. I live in "The

Baillies." Next door is the "Duchess of Devonshire." Then there is "The Blue Boy," "Lady Siddons," and "The Wagon Cart." The last is the attic bedroom where poor Joyce is billeted temporarily. It is so small, the furniture is practically juvenile size and the gables so steep and low only a midget could stand up erect. The attic stairway is so low-ceilinged Joyce has to come down backwards, bent double to avoid cracking her head. My room is all of 6' x 10'. When these present guests move out, I'll see if I can improve my quarters to something a little better than a fox pit.

And speaking of the guests—it's like a movie. There's one old lady who has lived here about three years—lost her home and husband in the blitz. She is a tartar and a jealous old thing—the kind that won't allow anyone else to sit in her chair in the sitting room, and the kind who turns out the lights in the dining room when she leaves, whether anyone else is still eating or not.

Then there are a set of English Army wives who have come to visit their husbands, stationed in this town. They do nothing but sit around the fire all day gossiping and looking like Rosalind Russell. There seems to be a feud on between the old lady and the young ones, which you can well understand. Another inhabitant is a single young man whose business I haven't discovered. And three Red Cross girls round out the picture. The menu is quite good, I'm glad to say.

The town looks pretty good—a great deal larger than the last village we just left, with lots of shops and at least two movies.

So far, we haven't worked, although we have been here three days. But since this is a new base, we found things not too efficiently arranged for us, and have spent the time ironing out the wrinkles with the electric company and the bil-

leting officers. Tomorrow we start donut production and start looking for more wrinkles. We have a few airmen to serve in this territory, which should be fun. Great formations of planes roar over our town night and day. They are beautiful to see.

Before we left the Spread Eagle, the Woods gave a little party for us—invited in several of the local gentry. The party began about 10:30 in the evening after they had closed the pub, with sherry in their private sitting room. Then we had supper, and a spread it was, for wartime. Baked ham and cold roast beef, chutney, mashed potatoes, several vegetable salads, plum pudding, celery, cheese, coffee and beer throughout. Port was served with the dessert.

Following dinner we reconvened in the lounge where I gambled and lost, playing Napoleon and Slippery Sam. Mr. Wood was the principal winner, so I figured we helped finance the party. Whiskey and beer flowed abundantly. About 2:30 in the morning we had a cup of tea. Around about 4:00, another nightcap of whiskey before we said good night. It was a good party, but I got so tired and was so heavy with cold, I lost interest about midnight.

Joyce left last night for her week's leave—a few days in London and the rest of the time in Edinburgh. My second leave will be due in a few weeks, too—just as soon as the job here seems to work smoothly enough to leave it. My plan is to tag along with one of our Clubmobile supervisors and drive through Wales with her as she goes on her rounds. It sounds like a busman's holiday, doesn't it?

I would like to see Wales while I am here, however, and driving through would seem to be the ideal way to do it. Since the Army and the Red Cross are the only people with cars these days, I'm lucky to arrange it that way. While the "Snoopervisor" is off snooping into Clubmobiles, seeing if she can find dirty cups or something else to point an accusing

finger at, I can be doing the villages. Doris may go with me. I am located only about 20 miles from her now, so frequent visits should be arranged quite easily. Called her today on the phone but she was in London.

Confusion still reigns in the donut business. You think you have seen all the angles and experienced all the problems, when a new crop is born. I think I explained that this is more or less a new base. Some of the camps have been served before, but most of them have not. I rather like that, however, instead of following in the footsteps and trying to meet the precedent set by someone else. But it means a lot of organizing, meeting commanding officers, having the plugs and electric hook-up installed ... always the first day cooking at a new base we blow out all the fuses, put the camp in darkness and the potato peeler out of commission. We lose an hour's work ourselves and become generally unpopular. Should you be working at a camp where the maintenance work is under English supervision, more time is wasted. They are naturally not quite so sympathetic toward the ARC as the American Army. Every time you look for the English electrician, he is nowhere to be found—frequently because he is having his morning cup of tea.

With all apologies to Art, I sometimes wonder how the English get anything done. It is true, of course, that they are short-handed; all the good workmen are in the Army, leaving the English equivalent of 4-Fs and old men to do the job at home. However, it gets done eventually ... though I don't understand why they won't permit the Americans to do the work at camp that the English are too busy to handle. The

American electricians are not permitted to touch a simple plug installation and just stand around and tear their hair at the lack of efficiency of the whole thing.

I must say again there is nothing like the unlimited generosity of the American Army. We are like their little sisters, and their acts of kindness on our behalf are sometimes overwhelming. The Red Cross is making a splendid reputation for itself in this war. Thousands of men who formerly thought the drive for funds something of a shakedown are now being personally touched by the Red Cross overseas and they are impressed. We have heard so many of them say that at last they have seen where their donations have gone and they think it's wonderful. The sight of an American girl still moves them.

The first week here at Sudbury we did almost nothing except call on electricians and workmen in the village. It has taken five or six visits over a period of two weeks to get some of that work done. Now we have engaged a woman to assist us; for the next two weeks we'll be working in the evening to teach her the mechanics of making donuts. Her hours will start after we get home in the evening, and the donuts she makes at night will give us a head start on the day following.

Our latest problem is with our driver. His landlady wrote me a letter telling me he drank too much beer, kept the whole boarding house awake by going to the bathroom all night and ultimately ruined her feather bed. So I've had to give a little motherly advice to our 40-year-old George.

Wasted another week in London. When I say "wasted," I mean the fault lies with me and I don't do the things I plan to do. Saturday morning I spent at headquarters and shopping. Tried to buy some shoes to replace those that were stolen on the way over. But it seems that that weekend was the tail-end of the rationing period and any and everybody who had a shoe coupon left was out spending it. At each shop I stopped there

was at least an hour's wait before I could be served. Finally gave up. There are some shoe stores that carry shoes made on the American last. In general, however, English shoes for women are quite ugly and badly fitting, according to my judgment. They still show the funny pumps and strap slippers with the long, narrow pointed toe and the squashed French heel like you see in the museum or on Queen Mary.

Saturday evening I spent with Vera and several Canadian officer friends of hers. Had a few drinks first at the Park Lane Hotel and then had dinner and danced at the Chesterfield Club. Sunday I had planned to sight-see. Actually, I did nothing—didn't even move out of the hotel until I had to catch the train back here. Stupid.

The West End of London is quite a fascinating place these days. You can see Polish officers with their funny square caps, Scotchmen in kilts, Czechs, French officers with bright red on baby blue hats trimmed to the top of the crown in gold braid, generals, spit-and-polished Britishers, and Americans with so many insignias, shoulder patches, arm flashes, ribbons, you can't identify them. Tried to go to a movie while I was there, too, but could only get into the newsreel theater. The rest had queues blocks long lining the walks. London still has the street entertainers. A fiddler pumping his bow up and down while a little gray-haired lady danced a jig. Another was a foolish man standing on his head right in the middle of the street, cabs and trucks flying past in both directions, waiting for coppers to be thrown at him.

Am going to London again Sunday evening to take truck driving lessons on Monday and Tuesday. This time it will be an Army truck, 2½ ton GMC variety. This is in preparation for an assignment on the continent where the girls will have to do their own driving instead of having a civilian to drive and

keep up the bus as we now have. There will be a new style of Clubmobile, too, built on these American truck chassis. It will be important to have the new powerful 6 x 6 on the badly war-torn roads of France, and also its being an American Army truck will make the maintenance and the replacement of parts simple.

February 21, 1944

Dear Family:

Last week I took you up to the point where I was going to London to learn to be a truck driver. I have now been through the first stages. They first give you a two-day test at the driving—just ordinary, straight driving—then, if you qualify and seem to show promise, you are called back for four more days, during which time you learn more of the intricacies such as the front wheel drive and low range, and you become acquainted with the miracles of the bogey assembly. On the second test they also take you—or you take them—over the obstacle course, a tank course. They bog you down in the mud and you get out. These Army trucks are wonderful bits of machinery. I should think they are the pride and joy of the Allied nations. There seems to be no obstacle short of a brick wall that is too much for them. They have wonderful power and still are very easy to handle.

I feel sure I performed all right on this first visit. Wasn't too sharp at first on the double clutching, especially when shifting back into lower gears, but we had plenty of practice in those two days and succeeded in building up my confidence. Will probably be a menace on the roads if they give me a chance. Used to play games with myself in my little Ford at home, bluffing people, cars, taxis and even trucks on the Chicago

streets. With a truck under me, they will really run for cover.

We had a very good time doing this driving, and saw parts of London we might never have taken the time to see otherwise. The trucks were parked out at Wimbledon dog track. We were taken out there from Grosvenor Square by truck. Then each of us—about 10—was assigned to a truck, and we started by going round and round the parking lot, shifting from 2 to 3 to 4, then 4-3-2, again 2-3-4 and back again 4-3-2. When the instructors were satisfied that we could manage that, they took us out on the road in groups of twos and threes, up and down and 'round the Wimbledon hills. The favorite trick was to stop us halfway up a steep hill and then get going again with a big roar of the motor so as not to let it stall.

That was a lovely residential section and reminded me more of our suburban towns that anything I have yet seen in England. Saw the famous tennis courts and Wimbledon golf course when we could take our eyes off the winding roads long enough to take a peek. In the afternoon, three of us had to go on a little errand to pick up some trucks in Hackey (north London) and drive them back. I pulled the straw to do the driving over there. So with the instructor and guide beside me, and two other student drivers rattling around in the back of the truck, we set off, asking directions every half mile and getting a different answer each time—always followed up with "You can't miss it." We could miss it and did for some time. Coming back we had a little convoy of three. That jaunt took us all afternoon.

The day's work made us plenty sore, tired and bruised. Felt like I'd been riding a horse. The foot pedals were so stiff and we had to change gears so much, driving through the traffic, that my knees seemed to feel the strain more than any other part of me. And such appetites! Guess the jouncing and the

vibration shook everything up to a fine pulp. Several of us had dinner together that evening, and all the others ate two full dinners and two desserts. Slept well, needless to say.

Though I would have slept if I hadn't seen a truck, because I got in so late the night before. The train pulled into London at 2:00 a.m. instead of 12:00. I got more and more worried during that train ride about getting transportation from the station. The underground closes up tight after 12:00 and taxis are so scarce and in such demand, you can't be sure of getting one. We did, however. Five of us, all strangers, rushed for the taxi when we saw it coming down the ramp, until I thought the little taxi would rock off its wheels—they're so top-heavy looking anyway.

All five of us got there at the same moment and there being no acknowledged winner of the competition, we all piled in and had the driver deliver us one by one. London taxis are so cute and so comfortable. There's an old world grandeur about them and they are terribly old-fashioned looking. A design suitable for London streets and London traffic having been found, the pattern was frozen right there. So the little black motorized boxes go whipping around corners and skittering in and out of thundering buses and clanking street cars on the narrow London lanes. I love the little London taxis.

But I digress.

The second day of driving was even more interesting. We had graduated from the boring fundamentals and went right out early in the morning and stayed all day driving around the city. We had a convoy of 10 trucks on Tuesday—each girl with her own vehicle. We were frequently separated, getting hung up on traffic lights and at one stage, the last half actually got lost. Felt very fortunate that I was up front with the guide and no chance of having to find my way back to Wimbledon alone.

The tour started at the dog track, from where we proceeded to the West End and Grosvenor Square headquarters. After a short business stop there, started again down Oxford Street toward and eventually right through the financial district where we saw lots of debris from blitzing, not recent, but not cleaned up and left pretty much as it happened.

The afternoon found us at Hampton Court. We all pulled up and parked in front of the castle; I couldn't help thinking how strange it was to see 10 modern Army trucks lined up in formation in front of Henry's Tudor palace where he played with his six wives so long ago. While we were there, we took a little tour and saw, among other things, the famous grape vine. One vine [was] trained and latticed to occupy an entire greenhouse—with a trunk as large as a tree. It's hundreds of years old and used to produce 600 bunches of grapes, or some such figure as that.

Had a little excitement in Sudbury one night after I got home. There was an alert, to which none of us paid much attention. Then we heard the local guns, and finally machine guns. At that we rushed to the front door, contrary to all safety regulations, just in time to see a German plane burst into flame and come spinning to the ground. It landed about 4 miles from here. It was a wonderful and terrible sight, with this flaming thing turning and twisting end over end—sometimes lost in a bit of cloud and then coming into view again.

So today, it being on our way, we stopped to view the wreckage, and wreckage it was. There in an open field it lay, about 100 yards from a peaceful little farmhouse—just a mass of metal burned black and quite unrecognizable. We were not allowed to get close to it, of course. But there was no special point in getting close anyway. We just stopped, got out and asked the guards a million questions—questions they

had been answering all day long from other curiosity seekers like ourselves. [We] gave the soldiers some donuts and then came home. The crew of the plane had bailed out, of course. But all had been found—one dead and four alive though badly shot up.

March 5, 1944

Dearest Family:

An interesting angle to our job over here is serving the missions when they come back from their raids. We transfer our donuts and coffee, cigarettes-and-candy tray, cups, Victrola into the briefing room a few minutes before the planes are expected in. After it is all arranged, we sit and fidget with our eyes on the skies, waiting to see the formation appear out of nowhere.

It is a thrilling sight when they are first sighted. Everyone feels it, even the old-timers and the men on the ground who have watched the same sight day after day for months. When the weather is fine, everyone is outside with field glasses spotting the numbers on the planes to find out who came home and who didn't. In bad weather we sit inside, with our noses smashed up against the window pane. When they are overdue, the minutes are painful. I remind myself of Grandmother sitting on the window seat at 2824 Cambridge Avenue, nervously announcing that Angie is five minutes late getting home from downtown and wondering where she can be.

They do come, finally, steady and graceful, flying fairly low, roar over the field, make a wide circle—so wide they get out of sight for a while. By the time they get back, the lead squadron has peeled off and formed a single file preparatory to landing. As they come in just a few minutes apart and taxi off down the

line to their respective parking spaces, the rest keep circling overhead until it is their turn to come in.

Trucks pick up the crews and trundle them up to the briefing room; finally they come in laden with impediment, looking like men from some other planet. The clothes they wear require a blueprint to get into. Their first job is to take all this stuff off—all this special equipment is checked in one large room. Life preservers, parachutes, flying suit, electric flying suit which is a baby blue flannel thing that looks like Dr. Denton pajamas. It has a quilted look about it where the wires are sewn in. Out of the side seam comes the cord and plug attachment for hooking into the socket. "Animated waffle irons" we call them. It gets as cold as 50-60° below zero upstairs. Even with the electric suit they sometimes freeze their hands and feet.

They're a pretty rough-looking bunch when you see them come in—dirty and tired, their faces blotched and creased with wearing oxygen masks. This is where we come in— donuts with hot coffee. The mess hall sends up good, rich, hot chocolate, but terrible sandwiches. The birdmen are hungry when they come in, if they aren't too tired. They haven't eaten since they took off, which might have been since early morning, depending on where their target was. They do take a little box of hard candy and gum with them, but they either eat it before they leave or don't eat it at all—it doesn't provide real nourishment anyway. Consequently, our donuts get a heavy play. As the men begin to warm up and fill up, they begin to talk with each other and with us. They tell us about the flak, the hits and the misses, the cold, the injured. It is wonderful to hear their stories now, but when we know them all better, the tales will mean so much more.

This particular briefing room is small for the numbers that

crowd into it. It's like a pool hall after an hour or so of smoking. It takes nearly that long for the men to clear—one crew at a time being called in for interrogation by the intelligence officers to whom they divulge their bits of secret information. The coffee and donuts are consumed to the last crumb about now, so after we have scurried around the room retrieving dirty cups from under benches and off window ledges, we pack our tired selves off and go home, comparing bits of information gathered here and there, feeling very important and as if we had been on a mission ourselves.

The crew has enjoyed a weekend leave yesterday and today. Vera and Joyce went to London. I stayed home to entertain a nice corporal who traveled all the way from our last station up here to see me—a matter of 8 or 10 hours, including late schedule, trains waited for and trains missed. He used to live in Indianapolis; has had a checkered career, having left home at the tender age of 12. [He] worked his way ever since doing truck driving, bus driving, steeple-jacking, Salvation Armying—traveling all over the world, more or less. [He's] now the owner of two small restaurants in Indianapolis.

We spent Saturday by doing a little sightseeing up in this section of the country. There's a little village close by which is supposed to be one of the good examples of a medieval village [still] remaining in England. Quaint, no end. It was settled at one time by the Flemish weavers; weaving has ever since remained one of its principal industries.

It is all old, terribly old, needless to say—beautiful examples of half-timbered architecture, the timbers bleached and weather-beaten, with the roofs and floors sagging dangerously. Several of them have been carefully and faithfully restored in an effort to preserve the village and its antiquity. They have quite a wonderful church, dating from 1450. Flint rock is one of the native elements of the soil here, and is used for much of

the construction. ... There are lovely pieces of wood carving, some of them lost for a few hundred years and found again in a blacksmith shop. After that, a cup of tea with scones and thin bread and butter with jam, served in a little tea shoppe with a thatched roof. Home by bus.

I didn't see him, in fact, didn't know about it until after it was all over, but the King—the King of England—was in our town one day last week to inspect the 8th Army. The station master wore a tailcoat, and the station and platform were spit-and-polished practically down to the road bed. The royal train arrived about 9:30 in the morning and they left again about noon. The local gentry was in a dither as you might well imagine. The English love their King and Queen. The royal family makes a tremendous number of public appearances these days—including the whole family, the number runs into thousands during a year's time. As the King himself has said, "they are no longer a family but a business."

The week before that the town entertained General Montgomery. So we are on the map.

Will now play a game of solitaire while I wait for Vera to knock on the door. She's long overdue and is probably sitting on a cold platform waiting for this miserable train that plies between here and the mainline whenever the engineer seems to feel like it.

March 18, 1944

Dearest Family:

This is Saturday, and I'm just rounding out a week's leave in Bournemouth on the south coast of England. I remember telling you some weeks ago that I hoped to spend this leave ... driving through Wales. That idea, which I still think was a

good one, got scotched somewhere between here and then, so new plans had to be made in a hurry. This is what evolved.

Doris was included in the Wales scheme, too. She, however, has been in the hospital again. Just discharged last Monday. So she couldn't have taken that kind of a holiday anyway. After a few hurried telephone calls, we finally decided on this place which is a good place for Doris to recuperate and good for me, too, I guess, since I discovered I was more tired than I knew.

It is a very restful resort town, very fashionable in peacetime. We are staying at a Red Cross club for women officers. Can't seem to get away from the Red Cross, which gets to be a little tiresome. But hotel rooms are terribly hard to get. I'm sure there are advantages to each which the other doesn't have, although I could have done with a softer bed than this iron cot. Most of the girls here are nurses and such a buxom, ordinary lot I never saw.

Bournemouth is lovely, but the most un-English city I have yet seen. That is probably because it is quite modern in comparison to the rest of the country, having been built up from a tiny village to a city of 140,000 since the last war. It is strictly a resort town with a good location and a warm climate to account for its popularity. It reminds me very much of a California resort—on the sea, built up on high, sandy cliffs, [with] gardens and trees very similar to northern California modern architecture, and a nice, refreshing smell to the warm gulf stream breeze. The place is simply full of small hotels. They line the cliff road. Before the war there were said to be 3,000 hotels and rooming houses. Now a lot of the Army is enjoying it—the warm sea air, the wooded hills and the miles of rhododendron hedges. The latter are not in bloom just yet, worse luck, but we did see a white camellia blooming its head off today and looking a little foolish and lonely.

There hasn't been a lot to do since we've been here, but enough to put Doris, whose pins are a little weak, in bed every afternoon for a nap. The first afternoon we took a tour by taxi and saw much that would have been out of range for walking and not on the regular bus runs.

Have had dinner out several evenings, hoping to run onto something special. But for the most part, here as everywhere else, the food is quite disappointing. In the first place, no restaurant is allowed to charge more than 5 shillings for a dinner. That roughly is one dollar. And it doesn't allow for anything special. The hors d'oeuvres which commence every meal are so sour, that's about all that can be said for them. These bits of salad and raw vegetables are seasoned only in vinegar, since olive or salad oils are not to be had. Sweets are not sweet because sugar is so scarce. So you eat and get filled up, but get up from the table bored with it all, the dinner having tasted just like the dinner the evening before and the evening before that, and feel unfed and unsatisfied.

Another day we bussed out to Christ Church, the one piece of antiquity in the near vicinity. Today we drove to Branksome Hotel for tea. By reputation it is the best hotel in the neighborhood; it does have a beautiful setting, but it is full of stuffy old people, rich but common. ... The tea they served was shameful—a couple of tiny, thin pieces of bread with a film of butter and a dry, powdery, tasteless bun. This, served with a lot of foolish airs and extravagant service. Some of these places, I'm convinced, take advantage of the emergency and get by with murder.

Bought a few bits of old silver while I was here. Mean to do more of that from now on. Wish I knew more about antiques, hallmarks and values. These dealers see an American coming, take him for a chump, that conclusion usually being the right

one. The Americans have too much money and will never get over spending a pound like it was a dollar.

Next week I'll have another vacation from donut bending to do some more truck driving. Six days of jouncing my liver should fit me for another leave in Bournemouth. If you don't hear from me for awhile, you can guess that I'm mired in the swamp and had to stay there until I get me and my truck out. I haven't very suitable clothing with me for this driving or for crawling under the hood to see what makes the wheels go round, or for greasing the joints. Getting out and under will surely be required of me in the motor mechanics part of the course. Tire-changing, too. Maybe I can borrow a monkey suit of some kind from one of the soldiers who do the instructing. Am told they spend a lot of time and concentration on these mechanics. We are not expected to know how to repair major breakdowns, but should be able to keep the machinery in running order. Will give you the greasy details later.

April 1, 1944

Dearest Family:

After two weeks away from donut making, it was really quite a pleasure to get back. The first week was spent in Bournemouth. … Doris went back to work and I went to London to learn about distributors, carburetors, transmissions, high and low range gears and front wheel drive. We had a whole week of that with lots of driving besides.

One evening we did blackout driving, and while we were out in the country, had to stop because of an alert. The convoy parked along the side of the road and we all got out and sat under our trucks to protect ourselves from the flak, if any. The raiders never got to us, however, so there the story fades out.

Another part of the driving was going over the tank course—perpendicular hills, ruts, bumps and tree stumps. It was not so difficult as I had anticipated, however. The purpose of it was not so much to test us, as to show us what those wonderful trucks would and could do. I should hate to have to go over such terrain when the truck is converted to a Clubmobile, however. I can see all the cups and trays and coffee in a scrambled heap on the floor.

We had a bit of excitement here the other day when we were on hand to see a crippled fortress come in. It was long after we had served the mission and were just getting ready to go home, when people started running and shouting and pointing overhead. There was the big plane circling above with a hole in the fuselage big enough to drive a Jeep through. The plane had received a direct hit and there seemed almost nothing holding the tail to the body. Yet that pilot had nursed it all the way back and was now getting instructions from the control tower as to what to do with it.

Landing it would surely have snapped off the tail and further risked the lives of the men on board who still had lives to risk. Finally, they started bailing out. It was the first time I had actually seen a parachute jump. Altogether, five men jumped over the field—one landed in a tree. Then the pilot took off on a straight course, and the two who were left jumped at the coast and the plane with three dead men aboard was set out toward the sea.

Tonight we go on another hour of daylight saving—and lose an hour's sleep. Am enjoying a two-day weekend. Stayed home, since I have only so recently come back from London. Had hoped the weather would warm up a little to allow a walk in the country. Instead, we had some flurries of snow.

Vera and Joyce went to London. Lucille is here with me

... she is a recent addition to our crew. She's a cute, quiet, modest little rebel from North Carolina. That southern sweet talk certainly sends those boys for a loop. She wasn't with us two days before they were all asking for her. Having a fourth member makes our work a great deal easier. Now we can send one girl out in a Jeep to serve the ground crews on the line without leaving the bus shorthanded.

Of course, when we're all trying to work in the Clubmobile, we about fall over each other or trip over George as he tries to mop the floor. Don't know why he doesn't throw that mopstick someday. There are so many obstacles such as pails, 50 pound tins of fat, 100 pound sacks of flour, four girls and soldiers with muddy shoes, in and out, in and out, on his wet floor. Try as he will by putting down papers or sacking, nothing works. But every day he sloshes through the motions again, mumbling to himself, "And I pay people to do this for me at home."

Forgot to tell you a funny incident on the driving course. We had a driving test at the end of the week in addition to a written test. Ten girls piled in the back of the truck with another one in the driver's seat beside the instructor. He gave each of us 15 or 20 minutes. One of the tests was to stop on the side of a steep hill, set the emergency brake and then start off again without killing the engine.

The kids in the back always knew when this was coming and would brace themselves against the lurch they were more than likely to get as the driver raced the engine and jerked into motion. All went fine until one girl made a mistake—put the gears in reverse and went boiling down the hill backwards. Braced the wrong way, as they were, the girls in the back landed in a huddle up at the front end—their slide broken only by the partition between the truck and the cab. Only casualty was an embarrassed driver and a few split sides.

April 9, 1944

Dearest Family:

It's Easter, but there is no egg rolling contest here. We giggled this morning over the idea of sprinkling a few powdered eggs around to help out the Easter Bunny. And there have been cartoons of soldiers painting the tin and cardboard egg boxes in Easter colors in the absence of a real shell egg. Personally, we haven't done too badly with fresh eggs.

It's embarrassing, though, to come down to the dining room in the morning and have special delicacies like eggs served at our table while the other guests hungrily look on. The normal egg ration in England is about two per person per month. The meat allowance is half a pound per week, which is about 25¢ worth. Prices on some of the unrationed foods, such as fresh fruits, are colossal. Grapes sell for $4 and $5 a pound. It is true they are out of season, but that price is perfectly hideous. Stuff like watercress and mustard cress you buy by the weight and not by the bunch.

My last sightseeing venture was in Cambridge. We did all we could between the moment we arrived until we had to catch the train back; saw several of the colleges of Cambridge University, did a bit of shopping, took time for lunch, etc. But the town is so crowded that it got to be tiring pushing our way around. Cambridge is a popular leave center, of course. And we went on a Saturday which was market and Easter weekend. The combination was almost too much for the town.

Before we could get lunch, we had to go to four different restaurants. Even the last one didn't want to take us and claimed to be all booked up. Only a little persuasion on Joyce's part broke him down. Lots of restaurants just closed down for the weekend to save their rations for their regular weekday customers—that being more business than most of them can handle.

The colleges were lovely. A little clergyman showed us around. He conducts a tour once a week for the English-Speaking Union as part of his war effort. But again, Easter interfered. It was a holiday, so many of the buildings were closed. We ambled through St. John's, Trinity College, King's College and its chapel. There the war influenced our tour—all of the windows had been removed for safety and replaced with ordinary glass.

The daffodils and narcissus were all in bloom along the banks of the river in the gardens at the back. They look more like a large public park back home. It happened to be a warm, sunny day—the first we have had in some weeks, and boys and girls were drifting up and down the quiet, little river in row boats and punts. On this river they have "bumping" races. The river is too narrow for two boats to race abreast. So they race tandem fashion—a prescribed distance apart at the start. If and when the second boat bumps the first, it means he has won the race.

I'm afraid Cambridge isn't a sensible place to do much souvenir shopping. There are so many sight-seers and shop-pers there isn't much left. What is there is price-tagged pretty high. I did buy a set of three copper sauce pans in graduated sizes, which aren't particularly valuable and aren't antique, but they do make good flower holders because they are tall and narrow. We'd be smart to go back there some less popular day and see it all more properly. A little vignette for the New Yorker (Joyce), was the University Press building—a tall, spired structure commonly mistaken for a church. And on the step, tucked in the corner of the doorway (a deep, Gothic arch), completely dwarfed by its surroundings, was a modest pint of milk.

I've finally moved into another room at the hotel. It's a large room overlooking the garden and tennis courts and so much

more pleasant than the funny little square box I had before. In addition to the regular bedroom furniture, I have a desk, two upholstered chairs, a settee, and a couple of small tables. And there is still enough room to hold a dance, so you can imagine how spacious it is. I'm sitting there now, with my feet in front of the little gasfire and listening to the RAF fly overhead. This is the coldest room in the house by reputation, but Spring and warm weather are finally catching up with this neighborhood, so the question of heat won't be a problem.

The yellow gorse is in bloom in the hedges along the road. Vera and I biked out to Brandon Woods late this afternoon and picked handfuls of yellow primroses. The willow trees are all feathery with their pale chartreuse leaves, and the fields are a fresh, tender green with the early Spring crops. All four of us have bicycles now. We make quite a group when we all go out together, all wobbling from side to side. The season is quite a bit later here than in other parts of England. Even in London the trees are more advanced than they are here. I'm so glad the real cold weather is behind us. Actually, it wasn't cold weather such as we know in Chicago, but something about it makes you shivery and miserable.

It is now 11:00. If I'm to rest my tired, rubbery bicycle legs, I must get to bed. But first let me tell you about the Brooklyn boy who has been trying to get a date with Joyce. She has put him off from time to time. At last he got a little impatient and said, "Gee whiz—why do you keep me on bended needles?"

April 22, 1944

Dearest Family:

Just this minute had a telegram from headquarters requesting me to report Monday morning for a four-day assignment.

Four days is such a peculiar length of time. I'm a little bit on the edge of the chair wondering what it is. This happens to be my day off, so I must spend it shampooing my hair, shining boots, washing clothes, and getting things in shape so I can take off. But since I didn't have anything special planned for "my day," I won't be caught short on time.

We had two other days off this week when the dynamo in our donut machine started smoking and burning, during which time we caught up on sightseeing and resting. The innards of those machines get so grease-soaked with the hot fat splashing around and seeping down into the works, that there comes a time when they can't take one drop more.

The repair men had a reconditioned dynamo to put in to replace ours (one that was supposed to have been tested and approved). But after they got ours out and the new one in all of which was something of a job—they discovered the new one wouldn't work. In fact, it was in worse shape than the other. So they cleaned up the old one and put it back in. Now we are working on borrowed time more or less, expecting to collapse again any day now. New parts are so difficult to get. There are certain little screws with a special thread that they can't seem to get. Lots of the spare parts are sent from America where they have taken old machines to pieces and sent the usable parts over to us.

Vera and I spent one of those two days on our bicycles. We made arrangements to have lunch in a little town six miles away ... which doesn't sound too far. But we took another road to avoid a long, steep hill we would have had to walk up. We did avoid the big hill, but instead we had a gradual slope all the way, and added two miles to the distance to boot. We were bushed when we got there. Even got a little sunburn though it is only April.

After lunch and a long rest with our elbows on the table

and our heads supported on our hands, we walked around the town a bit and called on a man who makes hand-woven tweeds. Weaving used to be the principal industry in this little town—think I wrote you about it once before. This one man is now the only one trace left of the weavers in the village. He was weaving a green and gray herring-bone on his old-fashioned loom. We stood there watching the bobbins fly back and forth—smooth and lustrous as satin with years of shuttling.

He's now allowed to sell his tweeds to the local purchaser; however, because of coupons and government regulations, makes it all for export. Didn't see any that I wanted to buy anyway. His patterns were rather dull and uninteresting. But should we ever find that he weakens on this buying and selling proposition, I'll get him to make something to order. It would be fun to have a tweed suit that you had watched grow from skeins of yarn.

Wednesday we took another trip (by bus this time) to the town where St. Edmunds was buried. There's an old abbey and church there dating from terribly early times. It was a very wealthy abbey at one time. It owned hundreds of acres of land and exacted a toll in herrings from the people, which at that time was one of the mediums of exchange. Dunwich alone, for instance, paid these monks 60,000 herrings a year. A stinky income, if I may say so.

Again we arrived on market day. All the farmers for miles around were there and making their bargains at the corn exchange. Every market town has a corn exchange and farmers can buy and sell anything there connected with farming—implements, livestock, produce, etc. Now prices are so controlled, these market days lack some of their former spirit. But they still conduct their business this way. It isn't operated on the principle of an auction. Each man stands in one pre-

scribed place all day while the customers mill round from one to another until they have made the best deal.

This town could hardly accommodate the traffic that was there Wednesday. The streets were very narrow and crowded, and the sidewalks not wide enough for the pedestrians, so that they too oozed out into the street in order to pass a baby carriage. Between the farmers, Army lorries and the bicycles, you felt very fortunate if you managed to cross the street. Didn't buy anything. The shops there didn't look as good as in our own little town.

May 5, 1944

Dearest Family:

Think I left you up in the air with the last letter announcing a call to London for a special assignment. It turned out to be teaching donut making to a batch of new arrivals. There were eight of us called in to teach—three or four girls assigned to each of us. We looked like a little trailer camp with little wisps of smoke coming out of our eight chimneys. All the trucks were parked in a row, the backs opened up, dirty laundry hanging on the steps, girls rushing up and down, in and out, with pails of water, people shouting to their next door neighbors and everybody sampling her first donut. It was fun.

Headquarters was through with me on Thursday, so another girl and I cheated by declaring Friday a holiday, and went up to visit Stratford-on-Avon—the Shakespeare country. About all Shakespeare did for Stratford was to be born and die there. Most of the rest of his life he spent in London. Which wasn't very bright of him, because Stratford is a perfectly delightful place. The Avon is a most peaceful, friendly little river with weeping willows, flower gardens and parks lining the banks.

There are boats of all descriptions to hire—shells, row boats, punts, canoes, even motor launches.

Two evenings we went to the Memorial theater where they have a season lasting about six months of Shakespeare plays. The theater is fairly new, the old one having been destroyed by fire some few years ago. The theater is quite modern in design and doesn't exactly fit in with the landscape, to my way of thinking. Most of the people up there have recovered from the shock, and are now happy that they built something in keeping with the [present] times and didn't copy the old forms of architecture. I didn't like it too much, but did enjoy the two plays we saw … "As You Like It" and "The Taming of the Shrew."

We walked Stratford over from beginning to end. One afternoon we took a bus to see Warwick Castle, which is nearby. The Castle is closed to snoopers, having been taken over by the government, but the gardens are open. Snooty peacocks strut all around it. We couldn't stay too long because we were late in arriving and the gardens are supposed to close at 4:30. But as long as we couldn't get in the Castle anyway, it didn't make much difference.

Another day we spent in Welford–on-Avon, about 5 miles from Stratford. They have a Maypole in Welford and every Spring they have a festival and dance around the Maypole. The festival we didn't see, but we certainly enjoyed the little village. There are no shops at all except for a miniature cafe and a pub.

The people who live there are mostly employed in business in Birmingham. Welford is said to be one of the most photographed villages in England. You never saw such sweet, quaint cottages—all of them extremely old, I'm sure, but so neat and tidy and well-kept, with the lawns carefully mowed and the gardens wild with color. Even here where they seem

to have plenty of space to spread out, they build their houses very close together in friendly clusters. Pale yellow plaster between the old timber and gray-gold thatch on top. Some of them appear no larger than one room, though that can't be quite true. The roofs slant steeply and under the eaves are small leaded windows about 18 inches square. Some of the streets are merely footpaths. Gardens and houses are small, all in scale, and completely dainty. Picture-book houses, every one of them.

Home we came again on Sunday, feeling as if we had had a whole week's leave, which it was, more or less, because the teaching certainly wasn't work, and practically every evening I was in London I went to the theater or a movie.

Now I am faced with another assignment. Got orders last Wednesday to report to headquarters tomorrow morning. I stayed home today to pack and run around the village paying bills in order to leave a clean slate behind me. Now there is time to write you.

Am being assigned to one of these new trucks that I learned to drive a few weeks ago. But I don't know where or to what branch of the Army. So again I leave you up in the air like a Saturday afternoon serial movie. If you're up in the air, so am I … a new base, a new crew, new Army, new Clubmobile, new billets, and knowing nothing about any of them. Will be sorry to leave Vera. Knowing her has helped me to know England and English people a great deal better than I would have done. But she is not interested in this kind of an assignment, and besides that, the English girls are not eligible for these new trucks that will eventually follow the Army. She's expecting her husband home from 2½ years in Nigeria in October or thereabouts, and can think of little else. Sunday he is broadcasting a message to her by transcription.

CHAPTER V

Life in the Army

*A*s the Allied forces prepared for D-Day, so did the American National Red Cross. U.S. Army General and Allied Commander Dwight D. Eisenhower set up headquarters in England in March of 1944 to begin final preparations for an invasion of Europe through France. By early June 1944, three million Allied troops were assembled in southern Great Britain, ready for the attack. In the early morning hours of June 6, 1944, 175,000 Allied troops invaded the beaches of Normandy, France. By the end of June, 1 million Allied troops were in position on the European continent. Not far behind them were the Red Cross Clubmobiles. In fact, according to *The History of the American Red Cross (Vol. 13)*, the Clubmobiles' directive was "to follow as close in the wake of the armed forces as military authorities would permit."

The first Clubmobile to reach France, the "Daniel Boone," was only five days behind invading troops. In its first week of service, the Daniel Boone served 75,000 donuts. Within six weeks after the invasion, 30,000 tons of supplies were flowing daily into France. By July, the American Red Cross had opened

its headquarters in France. By August of 1944, just 2 months after the great invasion, 80 Clubmobiles, Angela Petesch among them, were operating on the European continent.

~ *Letters* ~

May 16, 1944

Dearest Family:

Today I am celebrating a year in the ETO and the rounding out of another year of life. Jeez, I'm getting old.

The big news of the week is that I am now attached to the Second Armored Division of the U.S. Army. The Clubmobile unit here consists of 13 girls, one supervisor, and four crews of three girls to operate the GMC Clubmobiles, the kind we drive ourselves. We were all called into London a week ago last Thursday to get our assignments and on Sunday we drove down here to the garrison in a convoy of 17 vehicles, including utility trucks and supply trucks.

We cleaned them all up, put the Clubmobiles in working order, and shined up for inspection. On Monday we were formally introduced to the Division at a ceremony held on the parade ground, with us and the dignitaries sitting on a small platform, surrounded by the military band and flanked on both sides by rows and rows of regimental flags.

There were speeches, short and snappy by our Commanding General, General Brookes, Commissioner Harvy Gibson of the American Red Cross, and the Top Sergeant, who made the acceptance speech for the enlisted men in a faltering, nervous voice. Rows and rows of soldiers packed the bleachers.

The finale was the serving of donuts and coffee to the assembled mob as a demonstration of Clubmobile service.

These boys were pretty busy in the African and Sicilian campaigns and didn't meet up with the Red Cross in any big way, so they were floored by the display of beautiful equipment. We had a perfectly beautiful, warm, sunny day for the event, and have been so completely taken into the family there is nothing that isn't done for our benefit. Late that afternoon, the General entertained us at a cocktail and supper party, where we met so much brass we were dazzled. Lots of good liquor, a wonderful buffet with such delectables as chicken salad and ripe olives ... a regimental band out in the garden playing (all) the while.

This is an old English garrison that the American Army has leased, and must have been quite gay in peacetime. Permanent buildings for the men instead of tents and Nissen huts they've been used to, lots of playgrounds, gyms and stuff, and even a golf course belonging to the past. Had a date to play golf last Sunday, which would have been the first in well over a year, but the Lieutenant who had played in several National Amateur Tournaments at home was so hung over from Saturday night preceding, he couldn't get out of bed. So the thrill of hitting, or the humiliation of missing, that first golf ball is still to be experienced.

All 13 of us live right on the Post, in one sparsely furnished house. We sleep on Army cots and GI straw mattresses. As much as I hate to admit it, I'm sleeping hard and sound. Hate to admit it because these mattresses are hard and lumpy as a potato patch. I'm just afraid when I do sink into a Beauty Rest, I won't be able to sleep a wink. Besides being lumpy, the darn straw shifts around and by the end of the week it all creeps down to the foot or over to one side. Then you have to take it out into the yard and punch it back into shape. But since I'm sleeping, I guess I haven't any gripe.

Everybody gets his own breakfast and washes his own dishes, then a housekeeper comes in to dust us off and get supper so we can eat as we straggle in. So far these rooms of ours have no shelves or drawers or closets, so clothes hang from the molding all around four sides of the room, and underwear drips from every chair and suitcase. It is positively school dormitory life all over again, [and you] practically have to make an appointment to take a bath.

I have a new crew on this assignment. Left the other kids behind at the Gainsborough House. I didn't mind moving too much, but was sad to leave Vera, the English girl. We lived together for nine months or more and had become quite attached. The new girls are Doreen Young from Massachusetts and Midela Shaw from Connecticut. Like them fine, though Doreen is a vague sort of individual whose complete complacency gets under my skin when I am running around in circles.

Had a ride in a tank the other day. We drove the Clubmobile out on the range to serve the boys while they were on a problem. It was a hair-raising ride with the dust so thick I looked like a cement mixer. We flew over humps and bumps, over ditches and gullies, up hills and across valleys. I stayed in the tank while they fired the guns as they practiced shooting at a moving target being pulled slowly across the distant hill by a fellow tanker. He was a brave fellow, that man, but he lived through the ordeal. Thought my ears would split at the noise of that gun. There was a whole row of tanks sitting in a row on the side of the hill, all hammering away at the same time.

Whether in a tank or any other vehicle, however, this is the original dust bowl. England has been short of rain this year anyway, but now this area, churned up as it has been by heavy equipment belting up and down the countryside, leaves you coated with a thick crust. One's hair takes the worst beating

because it just can't be shampooed every other night.

I've been two days writing this. Too many interruptions in this big family of ours. Will continue soon.

Love,
A

May 25, 1944

ENGLAND

Dearest Family:

Played golf for the first time in a couple of years. It was a crazy game, as you might expect, but lots of fun. In the first place, you play with as antique a set of sticks from the Club as could be found … all shapes and sizes, with the bindings and tapes slapping you in the face every time you swing. One of the boys said Pershing played with them in the last war. One bag had a No.17 iron in it, whatever that is. Most of the time you spend looking for the ball. We had only one apiece, so if you lose it, you're through. If we thought we would be here long enough, I would ask you to send me some. Bet you could sell an old practice ball for one pound each. The course is really quite interesting and I would like to play it properly, instead of just batting from hole to hole.

There's a nice bunch of boys here. Have met several from Chicago and a couple from Oak Park. One used to live near Austin and 12th Street. Another says he remembers Father's corner. A young officer named David Hawe from Winnetka knows John Adair, so I'm feeling quite at home.

The Army continues to be so good to us. Now our regiment has assigned one of the soldiers to our Clubmobile to do KP for us. We can really use him too. Operating these smaller

Clubmobiles is quite a lot more work than the larger ones where you had a man on the crew to do the driving and all the heavy work. We always managed to get help when there was any lifting to be done, but you had to look around for a likely prospect and then ask him as a favor to do a job for you. Now, our boy can tote 100 pounds of flour, wash the clumsy coffee urns, scrub the floor, etc.

Heaven knows there's enough else for us to do. We all work like beavers. One girl from each Clubmobile goes to work at 7:00 in the morning. It only takes one to start the day because for the first few hours it is only the donut machine that needs operating. Between 9:00 and 10:00 the rest of us show up and keep going steadily until about 6:00. Don't know what makes us so tired. Partly it is having to be so darn social all day long. If you were alone you could do the work easily and quickly, but there are always so many crowded into the little space.

The Red Cross seems to attract all the goons. It's a natural haven for them … So they come and stay and stay and we can't chase them away.

June 9, 1944

ENGLAND

My dear family:

You haven't had a letter for weeks and are probably worried to death with imagining me over the Channel. Not yet awhile. Though the recent invasion news has influenced my writing. We've been so busy and excited, and depressed, and gay and sleepless, that letter writing just couldn't fit into the picture. For about four days we have been working day and night with a few hours of cat-napping tucked in here and there in order to send our boys off with donuts. Information would

pop suddenly, and off we would go with grinding gears. Since most movements of this nature (like babies) come at night, it meant long hours.

It was a bit heartbreaking watching them mount their vehicles and rumble off into the otherwise quiet night. But the boys were certainly [light-hearted] enough; if they were feeling any fears, they didn't show it. They've known for months, as has everybody else, that this big show was coming and D-Day is the kind of thing you want to get behind you. We've all made some friends among the boys. I think the one thing they hated to leave was their Clubmobiles. We miss them too, and living in this empty camp was like living in a cemetery—just a few clean-up squads armed with brooms and shovels were left to tidy up the place and cart away the trash.

One day, following their departure, we took off to sleep and catch up. The next day at noon came a message to be ready with luggage and vehicles, to push off at 5:00 the next morning. The trucks had to be cleaned and gassed and oiled after the strain of four days of relentless use. We had to pack up everything and leave the house tidy too, and with 13 of us doing it, there was some mess. But we managed and arrived on schedule. The schedule was to bring all the trucks to London for a complete check. There we left them while we came on down to another operation, a very big and exciting one and probably as near as anyone will ever get to the War, while still in England. Here we feed the foot soldiers just before they leave, and the wounded when they come back.

Our crew lives about four miles out of town in a tent village. It's a walled tent with four folding cots in it, a rough handmade table, and a rack for clothes. No light except a kerosene lamp. But it does have a cement block floor and there are good fat mattresses on the beds with plenty of blankets.

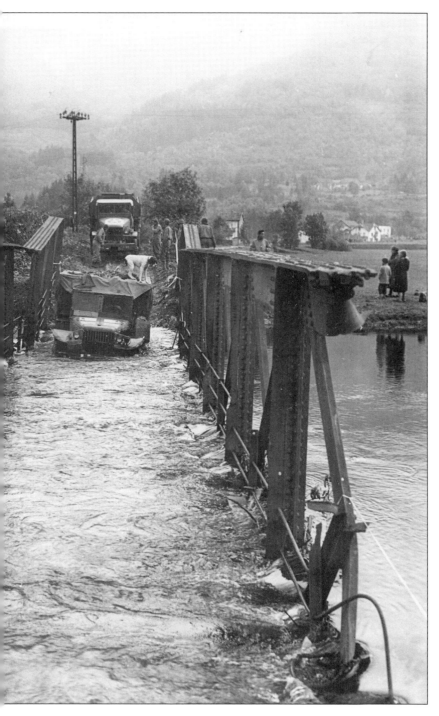

[1] NOT ONLY DID THE AMERICAN NATIONAL RED CROSS WORKER SUFFER
THE HAZARDS OF A COMBAT ZONE, THEY OFTEN HAD TO SURVIVE
THE ARDUOUS JOURNEY OF REACHING THE BATTLEFIELD TROOPS.

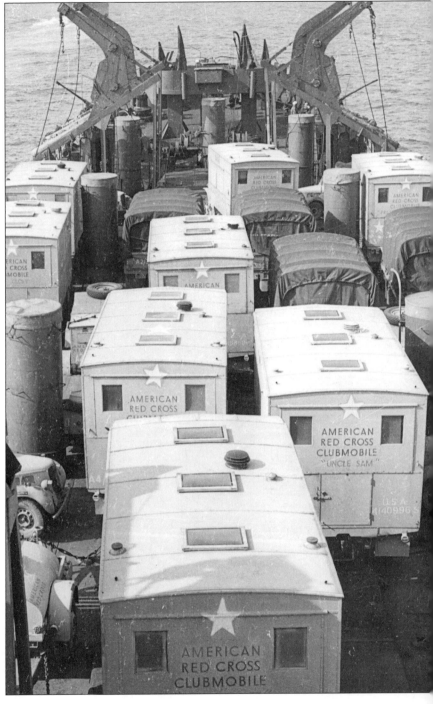

[2] FOLLOWING COMBAT SUPPLY LINES, A GROUP OF CLUBMOBILES ANTICIPATE OFFLOADING ONTO THE BEACHES OF NORMANDY, FRANCE, SOON AFTER D-DAY INVASION

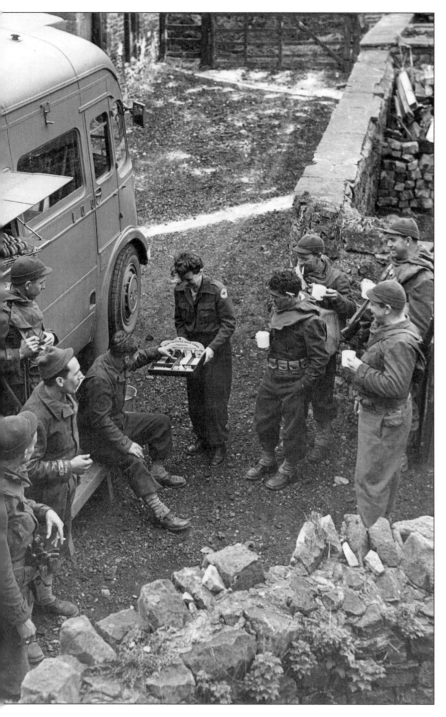

[3] AMERICAN NATIONAL RED CROSS DONUTS, COFFEE, AND GOOD CHEER, OFFER RESPITE TO COMBAT TROOPS IN EUROPE.

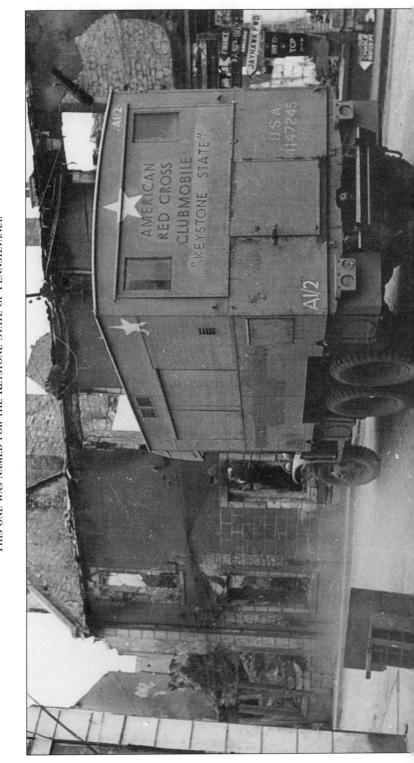

[4] CLUBMOBILES, WHEN ESTABLISHED, WERE NAMED LIKE A WAR SHIPS, MANY AFTER STATES—
THIS ONE WAS NAMED FOR THE KEYSTONE STATE OF PENNSYLVANIA.

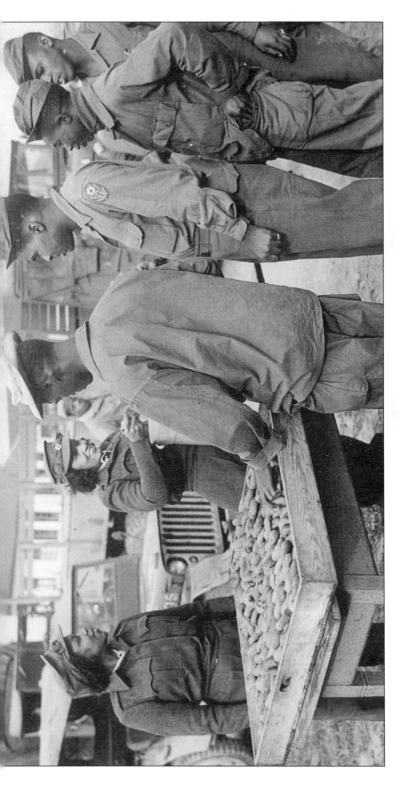

[5] Black soldiers were served by their own Clubmobile groups in World War II.

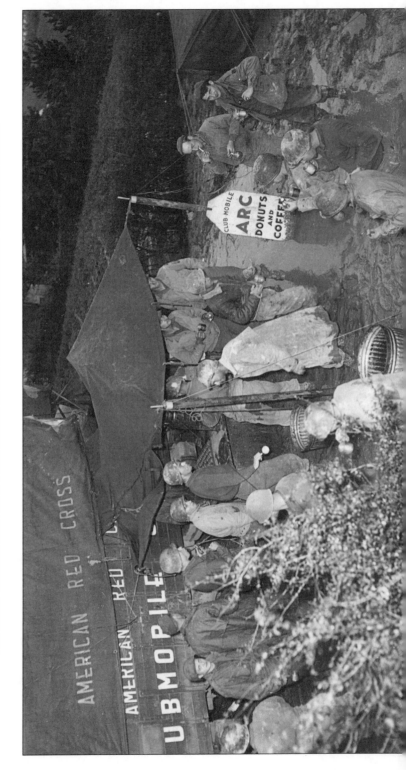

[6] Neither rain or sleet nor snow—nor air sirens—would keep the Red Cross workers long from their mission to serve American servicemen "donuts and coffee."

[7] EVEN THE JACK RUSSELL HAD TO COMPETE WITH HUNGRY SOLDIERS FOR RED CROSS GOODIES.

American Red Cross

Red Cross Donuts

1 ½ cups sifted flour
¼ tsp. baking soda
¼ tsp. salt
¼ tsp. butter or substitute, melted
¼ tsp. ginger
¼ cup molasses
¼ cup sour milk
1 egg, well beaten

Combine half of the flour with the soda, salt, and ginger. Combine egg, molasses, sour milk, and melted butter or substitute. Blend with flour mixture and stir until thoroughly mixed and smooth. Add remaining flour to make dough of sufficient body to be rolled. Roll, on floured board, to thickness of ¼ inch. Cut with donut cutter. Fry in deep hot fat (360 degrees) until lightly browned, about 2 to 3 minutes. Drain on brown paper.

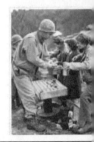

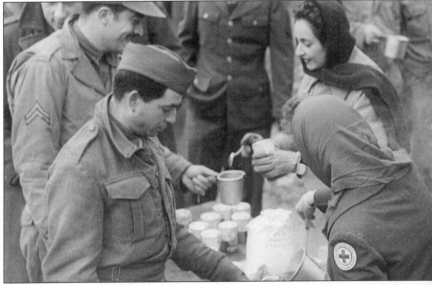

THE AMERICAN NATIONAL RED CROSS DONUT BECAME A WORLD FAMOUS TASTE TREAT THAT TRAVELED THE LIPS OF MILLIONS OF AMERICAN SERVICE PERSONEL. THE RED CROS RECIPE, AVAILABLE AT WWW.REDCROSS.ORG/MUSEUM, OFFERS EVERYONE THE CHANCE TO RECREATE THE TASTE LOVED AROUND THE WORLD.

Even then, we dress up as much to go to bed as we do to go to work, in order to keep warm. From this experience I don't know how soldiers keep warm with only two blankets to put over them and under them as well. Everything is under canvas here—the mess hall, kitchen, surgery, wards, motor-pool, everything. All very neat and tidy and compact with no frills.

Picked up a few new bits of slang in this camp. When you want something or are unhappy, you are "hurtin'." And when one of the boys gives you a line, you're being "snowed."

We are still living in the same house, all 13 of us, and getting along remarkably well. No hair pullings, not even any arguments. Ain't it amazin'? Though we did decide the other evening, we won't be happy when we get home unless we live in a tenement with the whole family eating and sleeping in one room, with rough board shelves, tin plates and cups, laundry always on the line just outside the windows, and clothes dripping from every available hook. Our next move will have even less in the way of civilian comforts. Just dig me a foxhole in the backyard when I come home.

My old crew has been pretty badly split up since I left them. Joyce has been sent on a special assignment known to our profession as a "Ranger." What it means is, a few weeks only on one special operation. Lucille, the new girl, was called to London and will probably be transferred to hospital work. She came over with that in mind and was just loaned to the Clubmobile department that, at the time, needed girls worse. Now she loves Clubmobile and doesn't want to change. And Vera thinks she might be moved too, and would rather welcome it because since I've left, she doesn't care whether she stays there or not. Such splits happen eventually. We were just lucky to have been left unmolested for as long as we were.

I've been to a couple of dances since I arrived at the Garrison, but that has been about the limit of my social life.

We're too weary to be much interested in invitations, though there are about 10 dances a week we could go to if we wanted to. The two I speak of were rather dull and not worth writing home about, though that is partly my fault since I never was much of a party girl, and am even less so now. They have darn good dance bands, though. Most of the boys were professional musicians with big name bands at home. They have been playing engagements five or six nights a week, in addition to their regular training program.

This is a stupid sounding letter, nothing interesting, nothing newsy. But a letter was overdue and I thought I'd better get something said.

Love,
Angie

undated

England

Nurses in field hospitals wear regular GI fatigue uniforms all the time and tin hats most of the time. You can't tell them from the soldiers. The first day I arrived I had my skirt on instead of the usual battle dress and was something of a curiosity. Even the nurses asked who I was and said they've been in fatigues so long they've gotten to the stage where they whistle at a skirt.

There's a little Chick Sale three-holer out across the meadow and a wash room and shower room with sometimes hot and always cold water, so we do have some conveniences. For the most part it is an attractive spot and we are enjoying it. There are volleyball courts and a softball diamond out in the field adjoining.

Our teamwork consists of serving the hospital ships by

going aboard with coffee and donuts and keeping the boys, who have to wait around to be unloaded, happy until it is time for them to be taken off. We serve them again at the hospitals while they are waiting for their examinations and wound dressings. We help the nurses in the wards when we can, by feeding the bed patients, writing letters, giving them cigarettes. We serve hospital trains that evacuate the patients to larger hospitals further in.

The boys leave England gay and noisy and cocky. But they come back quiet and subdued and a little stunned. They are grimy and bearded, their clothes torn and ragged, bandages gory, the blood still caked on their skin in many cases. But they are not bitter and I have not heard one complaint. Neither are they afraid. Only uncomfortable and tired, and ready to rejoin their pals the first chance they are given. They are wonderful kids. Every time I see a convoy going by, I get a queer, empty feeling. The ones who come back tell perfectly fantastic stories.

I admire these hospital people very much. Their work is unending. Even the ward boys and litter bearers are as kind and gentle and thoughtful as they can be, though they may be called upon to work for 24 hours at a stretch, and more too.

We don't have to do any of the donut-making here. The Army had a kitchen all set up and operating before we arrived. The GIs make them, two 12-hour shifts, with six boys on a shift. And are they browned off. Here they come to fight a War and are doing nothing but make donuts to send everybody else off. Speaking of donuts, there's the story of the colored boy who was seen to come up to the Clubmobile three times to be served. Finally, one of the girls stopped him and asked if he were trying to feed his whole family. "No, ma'am," he said. "But the other ones had holes in 'em."

This is a very stylish town. They have women street sweepers. One of them wears a little black straw hat, a blue and white print dress with artificial flowers pinned at her throat, a string of beads around her neck. Thus she pushes her broom up and down the gutter until she has a neat little stack of dust piled up and down the street, which she transfers to her little push cart.

Before I forget it, I want to tell Ede that I have received the little parcels she dispatched to me. Also got a little note from I. Miller that requires a letter from me requesting the shoes, which I will send off today.

Sorry to have been so uncommunicative lately. Sent a cable to Ede to tell the family not to worry because of no mail. We have been terribly busy and roughing it as we do here doesn't put me in the spirit of letter writing. Besides that, there has been so much we couldn't say. Some nights I work, once in a while I go to the movies in the evening, and now and then I peel spuds with the KPs. And so the weeks fly by so fast I can't keep up with it.

Eve Christensen, our Supervisor, returned today from an absence of a week or more, during which time she left me in charge. So today I have declared a day off for myself to do some of my personal chores. Several of the days she was gone she was off on a trip to one of the beachheads in France on a hospital ship where they picked up casualties to bring back to England. She loaded cigarettes, candy, donuts, gum and coffee on board the ship to feed the men on the way back. Had a nice cruise going over, but worked like a horse coming back. There is so much to do that the regular staff can't get around to. She even got off the boat in France and served the first donuts to the boys on the beach there. Exciting days.

This letter was started on the 9th. It is now the 20th. I'll get it off before another day slides by and begin again soon, I trust.

Love to you all,
Angie

June 27, 1944

Dearest Family:

Had some visitors in our tent the other day. A couple of little neighbor boys were discovered prowling through our possessions. The nurses across the way ("Fifth Avenue" our gravel path is called) saw them stealthily emerging through our "French" doorway with their blouses stuffed with loot. The girls frightened them away but they couldn't give chase because they (the girls) were in pajamas, having worked on the night shift. All the kids took were cigarettes, candy and cookies, but it made us mad nevertheless. They might have taken much more in the way of stockings, sweaters and shoes, all of which are hard to get items in the U.K. The reason they picked our tent was probably because we live at the end of the row, next to the wide open fields. It's a problem to know just what to do. We are sometimes gone all day long and there is no way of locking a tent.

I must tell you more about our washroom in this establishment ... "Nurses Ablution" is the pretty name the Army has for it. It's a little corrugated iron structure consisting of three rooms, two of which are shower stalls without doors or curtains. In these three rooms you see some wonderful sights. There might be a plump, middle-aged body singing in the shower. In the third room, the washroom, you sometimes

come upon people folded up like a newborn chicken, sitting in a footbath, trying to convince themselves they are getting a tub bath. There are others revealing their womanly curves in knitted khaki underwear, the ugliest bits of stuff ever invented by any designer. There is no wash bowl in this room, just a couple of faucets with a slatted shelf underneath and a trough in the floor to catch the waste water. When you wash your teeth you have to aim carefully to get between the slats and in the trough at the same time. For face washing, you use your tin hat. But no matter what you wash or how you go about it, you get splashed from the waist down.

Had a new experience last night of watching an operation in the surgical tent. It was much easier to watch than I had expected. It wasn't a particularly messy one, but gory enough … bothered me not at all. The only thing that made me give up was that I finally got such a snoot full of ether, I began to get a headache. The surgeon was removing a piece of shrapnel from a boy's hand. The flak had entered through the palm of his hand and lodged in the soft tissue. The doctor tried to remove it by going after it through the wound it had made [as it went] in, but he finally had to cut through the other side and take it out the back of the hand. There was another serious case where the shrapnel, a large chunk, had lodged in the man's liver. I didn't witness that one. I now feel brave enough to see a more interesting one, should there be an opportunity. I hesitated for a long time before going in for fear I might cause more trouble than the patient.

The kids next door just tried to pull our tent down on our heads. They had all four corner poles pulled out before we discovered we were sagging around the edges. Not the English boys this time, but the nurses.

They had a good movie in camp this week—Fred Astaire

in "The Sky's the Limit." You probably saw it months ago. The show is usually interrupted for an air alert or because the generator poops out right in the middle of a conversation; the sound equipment on these portable jobs isn't too good. Eventually, you get it all pieced together to make a complete picture.

Love,
Angie

<div align="right">

July 12, 1944

</div>

ENGLAND

Dearest Family:

The principal news is WORK. Never worked such long and peculiar hours in my life. The Army seems to delight in carrying out all its operations at night. So, if the Red Cross wants to be on hand, we take the swing shift too. We served two trains last night—one from 7:00 until 1:00 and the other from 4:30 until 9:00. Now we have a couple of hours before lunch with another train this afternoon, and can't decide whether we would feel better to get two hours' sleep, or better if we just stayed awake. The whole past week has been like this. We just get to bed when the telephone announces something else to be met and served.

The train last night was scheduled to be at the platform at 7:00. So the hospital started bringing down their patients at 6:00 and had them lying on their litters all over the platform in order to load in a hurry. There must have been about 150 of them waiting and that was only a portion of the full train load. But this train was late and didn't pull in until 11:30. Those poor hurting boys had to wait there about six hours. That's where we came in handy with the coffee and donuts

and the helping hand in fixing pillows and blankets, lighting cigarettes, talking, rubbing aching muscles, helping them to sit up or lie down. We really felt we had done a service for that bunch.

There weren't any nurses at the platform—just a few wardmen who had more to do than they could handle. It didn't take six hours to feed the bunch, but we stayed until they were loaded because the men seemed so grateful that we were there. These wounded are the most wonderful lot of boys I have ever seen. I want to hug them all. There just isn't enough that can be done for them. I groan when I see them lacking for anything—yet there doesn't seem to be enough of simple little items like toothbrushes for these men who have come off the battlefield, some of them without a piece of clothing to their names, and only a blanket to wrap around them.

Best story of the war so far as I am concerned is the one (a true one) about the boy in France who lost his shoes in an air attack. The next day he asked his officer's permission to go back to the supply depot and get another pair. The officer agreed, of course, and told the boy to hitch a ride in an ambulance. Because he was in an ambulance, the clearing station slapped a casualty ticket on him and the boy found himself working back through channels that he couldn't get out of. He arrived eventually here at our hospital and the doctors looked him over—then asked what was the matter. To which he replied that nothing was the matter—all he wanted was a pair of shoes. The kid had gone through clearing stations, first aid stations, evacuation hospitals, back to England on a hospital ship, and was still on his way because there was no machinery set up to turn him around and send him back. When last seen, he still had no shoes. Besides being a funny story, it is a

supreme example of the Army "going through channels."

There has been a slight pause in this letter when three ships came in all at the same time, requiring our attention, after which Sally and I collapsed and buried our ostrich heads under our GI blankets. Sally is a new arrival from the States who was sent down here from London to help out on this job. She and I hold down the hospital work. We live about five miles out of town as I have previously explained, I believe. And we have a little English Hillman utility truck (wee lorry, a Scotsman called it one day) to transport ourselves and our donuts, here, there, and around. The car is only for business purposes, you understand, but it is quite easy to find justification for a little personal jaunt now and then. Mostly we don't have the time or the energy for anything so frivolous.

Went to a party last night with a Major from our camp. It was a birthday party in an English home at which all the other men were Naval officers and all the women were nurses or civilians. I didn't know a soul and didn't have too good a time, which is what I expected under the circumstances. I'm absolutely no good in a room full of strangers. Liquor seemed to be very plentiful and I had the first drink of bourbon I've had since I landed 14 months ago. And the supper looked pre-war though it was very cleverly concocted out of the usual fish pasties and extended with spaghettis and mousses … gelatin mixtures which I abhor. The Major got tight. Our taxi got two flat tires so that we were all hours getting home. Nobody's fault, but an unfortunate evening.

News seems to be scarce. News from the front also scarce with the front moving ahead very slowly. I feel you people have more and better war news than we do.

My old crew has been all split up now. Vera has been made an Acting Captain and given a territory with all kinds of snags to harry her. She should have been made a Captain a long time

ago, and will make an excellent one, but our stupid headquarters had a policy that English girls couldn't or shouldn't have the job. Now that they have had to pull so many girls out of territory to get ready to go to France, they are finding themselves shorthanded and having to call in the English girls and grateful for them.

There goes the whistle which means CHOW.

Love,
Angie

Dearest Family:

Here I sit luxuriating in a wonderful, soft bed with cool white sheets and a downy pink comforter, in a room with four walls and a ceiling, a connecting bath where there is hot water and a tub (wonderful even if it does have a five-inch water level mark to remind you not to be extravagant).

We're in London at a comfortable and accommodating hotel smack in the middle of the West End, simply lapping up the service, having breakfast in bed and drinking cocktails before every meal. All of this strikes Sally and me with such importance because we have spent so many weeks in a tent. And while we enjoyed, and at the time preferred, the rugged life, the experience has really made us appreciate the comforts offered by Mr. Fleming and his swallow-tailed staff. We thought we deserved a little splurge before starting off on something possibly a little more rugged. We threaten to remind ourselves of our newfound plushiness by taking our helmets into the bathroom to do our washing.

I was definitely reminded of our tent life on our first evening here when I put my foot in my bedroom slippers to find a big black beetle climbing over and around my toes, seeking a quick exit—a beetle that had traveled all the way up here on the train. After I pulled myself off the ceiling, I saw to it that he met a quick and complete death.

As you have gathered, Sally is with me, a fact which gives me much pleasure. Sally is quite a charac-terœthe better I know her, the more I like her. She's one of the few kindred souls I've found. She's the daughter of Philip Reed, formerly of Chicago and now of Boston, who is one of the directors of the Armour & Company and a few other big outfits. They have quantities of money—used to live on North State Street in Chicago next door to the Cardinal's mansion. But Sally is modest and unspoiled and one of the best sports in the world. She's quite young, but full of good sense in spite of being crazy as a bat.

We were out cocktailing and dining with some of her friends last night and I thought I would explode with laughter at one of the girls who is as crazy as Sally. She got up from our table in the lounge of the hotel, took our ashtray full to overflowing, walked over to another table where an English couple were sitting and also smoking, and exchanged our ashtray for their nice, clean, empty one. I would have been furious if anyone had done the same to me, but it was the funniest bit of pantomime I have ever seen. The poor English. What they have to put up with.

Today we saw a good movie—the Bing Crosby one, "Going My Way." You've probably seen it. It's a very amusing picture. But in England, you get an extra laugh. If an alert should be sounded, they flash it on the screen as the picture show is in progress, so that those who wish to leave may do

so. They notify you again when the "all clear" sounds. These little notices always manage to appear at a point in the story to make the situation funny. Today as the big, cruel business man was mounting the stairs to collect the rent from the poor girl who had no money and no job, it happened. "An alert has been sounded" flashed on the screen. And again, when the villain left—"all clear." Perfect timing.

Tomorrow we go to Headquarters to start clearing up a little business. If they decide we can have a few days leave before sending us off with our new orders, Sally and I have decided we shall stay right here in town and catch up with our theater and concerts and shopping and high living in general. It's been some time since we have so indulged.

Ede … I think I told you the packages you sent arrived, but I'm saying it again to make sure. Everything was perfect. Thank you for the birthday socks. They came at a grand time because the bugs ate holes in the ones I had with me in tenting days. The shoes, however, haven't arrived as yet. You might stop in and ask them about it.

Artie's New Yorkers have already started to arrive and I'm most glad to have them. In spite of the no ads, the flimsy paper and the microscopic type, those overseas editions are a good idea. Thank you very much, Artie. Got the little Pocket Book edition too, which I have read and left for others to enjoy in the recreation tent (laughingly called the Officers Club) at the hospital. Also, Artie, let me hereby acknowledge that you are the best letter-writer in the whole darn family. And if those Petesches expect me to keep 'em coming, they better show some pep. I need some mail.

Father's trip to Chicago by bus reminds me of a similar one I had from California, when a small boy, about five, was sent alone in the care of the bus driver and occupied the seat next to me. He slept with his head in my lap and his feet poking out

into the aisle. Had to do it that way to keep him from falling off the leather cushions onto the floor when he dozed off. It provided him with a fine berth, but I couldn't move all night. Not so tonight … I'm approaching the horizontal right now.

Love,
Angie

CHAPTER VI
Clubmobiling 'Over There'

*A*ngela Petesch arrived in France with Clubmobile Group H in early August 1944, about 10 weeks after the D-Day Invasion of Normandy France. Group H consisted of 30 women, four male soldiers, eight Clubmobiles, one Cinemobile, and four supply trucks. According to the Group H Roster in the American Red Cross archives (tallied when the Clubmobiles first reach France the following rode into war with Angela Petesch: Della Kurtz, Peggy Maslin, Betty Brittain, Micky Flynn, Flo Ney Young, Helen Zimmerman, Betty Jane Thomas, Jean Davis, Doris Stead, Pauline Doll, Jayne Stickrod, Mary Lou Pearce, Marylin Watson, Jackie Sanford, Patrick Maddox, Sally Reed, Dorothy Bargett, Mary Lou Weller, Betty Holmes, Milda Shaw, Doreen Young, Oma Ray Walker, Helga Freeman, Ruth Armstrong, Patricia Beall, Margaret Evans, Harriet Englehart, Marjorie Sanders and Betty Liechty.

Group H was soon ordered to follow General George Patton's quick-paced Third Army as it plowed its way across France toward Germany. It was three weeks before the Clubmobiles caught up to the conquering Army and could serve its first donuts to combat troops near Verdun.

Group H Clubmobiles followed the general's Third Army troops as they raced to destiny and the salvation of U.S. Army airborne, troops, and Belgium civilians surrounded and holding on to their last provisions and ammunition in Bastogne. Other Clubmobiles had been serving the troops in Bastogne just before the offensive; at least one Clubmobile narrowly escaped the area as German troops closed in.

Once a Clubmobile was up and running, its workers aimed to serve 1,000-1,500 men a day and often served more. Angela Petesch told a writer from the *Chicago Tribune* in 1944 that her Clubmobile cooked and served 2,500 donuts each day. *(See article, p. 161).* Sometimes, service came, literally, on the run. Combat-weary troops often flooded in when a Clubmobile pulled up. Donut Dollies handed out donuts to troops marching by—in many cases providing a soldier with the last taste of home he would ever have.

That taste of home was often critical to morale. Allied Commander Dwight D. Eisenhower told a joint session of Congress in 1945 that the Red Cross *"with its clubs for recreation, its coffee and donuts in the forward areas ... (with) the devotion and warmhearted sympathy of the Red Cross girl ...has often seemed to be the friendly hand of this nation, reaching across the sea to sustain its fighting men."*

~ Letters ~

August 19, 1944

FRANCE

Dearest Family:

We are now back on the right hand side of the road. With all the delays we had, I began to wonder if we would get to the far shore before the Germans gave up. We were progressing so slowly and the Army was going so fast. But before I start

the saga of the journey, let me remind you to write and where: c/o American Red Cross, Clubmobile Group H., APO 350, Postmaster, N.Y.C.

Chronologically, the story starts with London. I think that's where I left you in my last letter … luxuriating in a fluffy bed in a plushy hotel. After two days of business we had a week's leave. Two of those days I spent with Doris. And the rest in London going to theaters and eating four or five meals a day. Then on a Wednesday we got the call to be ready to roll the next day. We did roll—rolled into the marshalling area in the evening and bedded down on straw mattresses—about 30 of us in one barracks. There we sat waiting for the next call to move forward which came about 36 hours later, to be in our vehicles with the motors running at 3:00 in the morning.

In spite of our extreme eagerness to get to the battle zone as quickly as possible, those hours in the marshalling area were happily spent. There was a Camp Show outfit billeted there at the same time who put on a remarkably fine show of impromptu nature. Most of their equipment and clothes were packed, of course, but they did as well if not better, without the fluffy costumes than with them. It was pretty cute to see the girl of the dancing team wearing khaki fatigues rolled up like clamdigger slacks, wrinkled and shapeless, and with dainty silver sandals on her dancing feet. The juggler had a stunt I'd never seen before. He set up a little teepee in the center of the platform and then rolled his hoops in such a fashion as to make them circle the tent and wheel into the tent between the flaps. The afternoon we spent in a baseball game—a contest between H and L groups which was the most hilarious thing anybody ever witnessed, with everybody running and nobody catching anything.

We staggered out of our bunks at 2:00, dressed and

packed, had a cup of coffee with bread and jam at the kitchen, and groped our way up to the parking area through the black night, laden with gas masks, tin hats, pistol belts with canteens, musette bags, and some with blankets, too. We were ready at the appointed hour, formed our convoy along the Camp road and there we waited for one long, cold, damp, boring hour because the MPs who had been sent to escort us got lost in a slight fog that was hanging over the country.

That night we cussed the MPs plenty, though normally we think they are pretty wonderful. Generally, they are big, rough-looking characters that look like bouncers or football players, but with hearts of gold as far as the Red Cross is concerned. They have done us so many favors and perform them in such a way that they make you think you have done them the good turn by asking their aid. Four or five of them guided us out of London. They stand at the crossroads and complicated intersections to direct the way and stop the traffic. Then when the end of the column goes by they hop on their motorcycles and go zooming up front again to take their turn at the next corner. And so, like sheep dogs, they herd their charges along, barking at your heels if you don't keep up or smiling and brotherly when everything is in order.

We made it to the docks and then spent the day, the whole day, sitting around the dirty sheds while the boat was being loaded. Watching our beloved Clubmobiles, loaded to the ceiling with stores, go over the side of the boat and down into the hold, was shattering to the nerves. The men drive the vehicles onto this hammock of steel cable mesh which is fastened by a pulley arrangement to the boom, and then up she goes, twisting and tilting in a most hazardous fashion, missing the obstacles such as the rail or the opening to the hold, by inches. And sometimes not missing, causing corners to be knocked off here and there, and taillights to be snapped off.

The crossing was like a Mediterranean cruise, calm and peaceful and smooth; except for the khaki uniforms surrounding us, the most unwarlike atmosphere possible. Which attitude was partly due to the presence of so many women. We all just had a very good time and the Red Cross practically took over the ship. The girls were loaded into one of the forward holds, but the ship wasn't too crowded with personnel, so permission was granted for us to bring our sleeping bags up on deck and bed down under the stars. If you can picture such a thing in war time—the hatches and the deck, even some of the gun stations, with sleeping beauties sprawled all over the place and an armed guard standing watch.

During the day we frolicked all over the boat—on the gun turrets, on the bridge, in the galley washing pots and pans and peeling potatoes, in the Captain's cabin drinking his brandy. The Army that traveled with us had their kitchen truck put right on the deck so they could prepare hot meals for their men, and they invited us to eat with them. That little act of generosity saved us from having to eat those old K-rations with which we came aboard. The merchant marine were good to us too, so between them we ate very well, with flapjacks for breakfast, good coffee, cinnamon rolls, spaghetti, white bread and butter, and stuff like that there.

These boxed rations are edible and full of vitamins, but they are cold and boring because it's always the same thing. The K-rations come in three boxes—breakfast, supper and dinner. They contain a small can of meat or egg mixture, a portion of soluble coffee or lemonade, dog biscuits, four cigarettes, cubes of sugar, a fruit bar or chunk of concentrated chocolate ... and toilet paper. From now on it appears that that will be one of the essentials. Paper of any variety is terribly scarce, and I think I will now put in a request to have

one of you send me some toilet paper, some writing paper (air mail), and some Nescafe or G. Washington coffee, plus any other little delectables that will tuck in the corners.

Having a boat with a bunch of American girls aboard anchored in the Normandy harbor seems to have caused quite a hubbub among the Army and Navy stationed there. Signals flew across from ship to ship by blinker as well as semaphore. The Port Director invited us all over to his ship for supper and a movie; craft of all descriptions circled round and round us like bees after honey. Ducks, barges, tugs, the Coast Guard, and even rowboats tied up along side. The Army being a little more essential to the war effort than we were, discharged first, which left us a lot of time to go cruising around the harbor on this small craft with the boys, who were so starved for the sight of an American girl and a voice they could understand. On the Coast Guard cutter we had fried chicken to eat as we skimmed along.

There was a church service on board, conducted by the Chaplain, of course. It struck me as being a rather pathetic sight to see the Padre all dressed up in his brocaded and embroidered robes, using the hatch as his altar, with a few ardent followers kneeling in a semi-circle around him saying their prayers and their "amens." I could only groan for their poor knees pressed into a waffle design on the metal flooring of that deck.

Movies we had too. The Cinemobile girls went down in the low hold and dragged up their projector and generator and put up the screen in what was originally intended as our sleeping quarters. The movies were terrible, but provided something to do for an hour or two.

This will have to be continued later. I am writing by flashlight now, and it isn't too satisfactory. Tomorrow we start moving again to catch up with the 20th Corps. That appears to be

our newest assignment. I thought we were going to be 2nd Armored but there has been another shuffle. The assignment is a good one, however, so we are not upset, though happy we would be to rejoin the 2nd.

Love,
Angie

August 24, 1944

Dearest Family:

To continooo *(sic)*—I'll start where I left off with the unloading. As I said before, they took the Army off first, and that makes sense. But when it came our turn, they certainly took their time. We were never quite sure whether it was intentional or whether it really was the choppy seas that delayed our progress.

The merchant marine does the unloading and if they are all like the men on our boat, I have my own private opinion of them. They are unionized, of course, and get a salary of $3.00 an hour, and by golly, they don't move until they get darn good and ready. They stop for coffee in the middle of the morning and the afternoon and the war effort doesn't seem to include them. They spent the whole day and until nine in the evening putting our vehicles on a big flat barge they call a "rhino." I'll admit they had some trouble for which they weren't to blame, when the cables broke a couple of times and took a half hour to repair; but there was really no need for all the time it took them to put us over the side. Fortunately, no damage was done to us when the cables broke because there was no load on the hammock. I shudder to think of what might have happened if one of those heavy Clubmobiles were dropped from

a height of 20 feet.

At 9:00 we pulled away from the ship with the skipper of the barge mumbling in his beard, "I'd rather have a load of dynamite." But we weren't through with the sea yet. The tide was wrong for beaching the barge, so we had to stay tied up to the breakwater all night and wait until 8 or 9 in the morning. So it was open house again with everybody in the harbor swarming over our craft looking for somebody from Brooklyn or California or Wisconsin, or just America. We slept (if you can call it that) in the cab of the trucks or curled up in the back on packing cases and flour barrels. That was the beginning of our rugged life and I'm afraid there's going to be lots more like it.

Eventually we set our wheels on dry land—French land— on one of the same beaches that the invasion troops used weeks before.

From then on, we have been steadily on the move from one camp to another, gradually creeping up to the 20th Corps. We pitch our little pup tents at night, cook a supper or eat field rations, take a bath in the helmet, and crawl into bed so tired we can't even feel the lumps under us.

Our travels have taken us through many of the towns that have been mentioned in the newspapers as German strongholds over which there was heavy artillery fire and house-to-house fighting. In some cases it hasn't been too many days since the Germans were chased out; the armies have been moving so fast only the streets have been cleared of the rubble so that traffic and supplies can move up to the front.

You who have seen the havoc wrought by an earthquake will know how these villages look and what the desolation is. A few brick walls standing upright, the rest chewed to bits and flung to the ground. But the people who are still here are wonderful and have given the Americans a tremendous welcome.

They take their places along the roadside early in the morning and apparently stay there all day just to wave at the parade as it goes by. Should the convoy stop for a moment, they come rushing out to shake your hand, give you flowers, fruit and eggs. Our convoy is not the first Americans they have seen, but the first American women. And when they see women, then starts the "Ooooo-la-las." We smile and wave and shout in return and give them our best high school French.

One town in particular we noticed was gayer than the rest, with flags and bunting; all the people [were] assembled in the square or lining the curbs. There was an uproar as our 16 trucks pulled slowly around the square. We were made to feel like we personally were the conquering heroes; we were a little embarrassed as we sat there nodding and waving first to one side and then the other, like the Pope bestowing his blessing on his children.

All of this wasn't planned for us, however. The people were dressed up to greet DeGaulle as well as the French army which was moving along the same highway we were on. In fact, we were right in the middle of the French army most of the day. We still don't know whether the General had already been there or was expected, but the populace was in a party mood and the Croix Rouge was as good a reason to jump up and down as any. So they jumped and DeGaulle couldn't have done much better.

We have at last caught up with the tail end of our private Army, but have to move again tomorrow. I don't know how we're ever going to get any donuts made. This Army is moving so fast it seems to me we will be on the road most of the time. For this day and a half, our home is a clump of bushes. The trucks are pulled in close to the brush to get the most benefit of the natural camouflage. In between the trucks are

the pup tents. It is all a happy little family in spite of the rain that has been falling for the past 12 hours. The tents keep us quite dry except for what trickles in under the canvas—it's quite possible to wake up and find a puddle of water around your neck.

This field in which we're parked is not a soft, grassy pasture, but one where a crop of beans or peas had been harvested. So it is soft and makes a beautiful, thick mud with this rain. The way we are slogging around in the mud today reminds me of the movies of war stories. It isn't a good story unless the Army is up to its knees in mud. I'm afraid much of it is true, but the worse the conditions the better the tale.

Last night we parked in the forest belonging to Count Somebody. It was nice and warm and starlit when we went to bed so we didn't bother with tents—just put our sleeping bags down on a bed of ferns with a canopy of leafy branches over us. It didn't last. The storm came a couple of hours later and all except the very rugged scrambled for a shelter of some kind. My choice was under the trailer. It was a hard road bed and not a ferny mattress. But it was dry except for occasional drops of rain water mixed with axle grease that found their way along the steel beams under the trailer and plopped down on me. That road bed was as hard as concrete with the added problem of ruts in which I had to fit my frame. It was a bad night and my philosophy for the day is—"You never know the road you're on until you've slept on it."

The mess detail is now preparing dinner, but in spite of the simplicity of dehydrated foods, I fear for the success of the meal. A couple of slaphappy girls are in charge of the proceedings. The menu is corned beef hash which comes in a can to which you add an equal amount of hot water. I doubt whether these two can do that much. We had the strangest breakfast this morning, also dehydrated. To the wood shavings you add a

dipper of water. Presto! The water dissolves the powdered milk and the sugar and softens the cereal; in one minute you have cornflakes and grape nuts with milk and sugar, ready to eat.

That brings me up to date on my tour through France. So far it's been wonderful and not all rain, though I seem to have concentrated on that.

Love,
Angie

September 8, 1944

Dearest Family:

One of my hardest jobs these days is to find the time and the inclination to write letters. Sitting up in a pup tent doesn't make it easy. And scratching my bites which cover my toughened body keeps me from concentrating on anything else. Don't know what the bites are. Am afraid to ask. But from now on I'm assiduously applying powder "for body crawling insects" which the Army supplies from time to time without being asked.

Until the last few days we have been on the road, bivouacking each night in pastures or forests with the Clubmobiles hugging the bushes and trees for camouflage. It has rained at least half of the time, as it always does in the movies, so we continue to paddle around with thick clay hanging to our boots, so heavy it gets to be a problem to lift one foot in front of the other.

Every day we see more of the "glamour" of Clubmobiling which Washington headquarters made such a point of in their sales talk and continue to do in their publicity. It has been a motor tour of France so far, at the expense of the Red Cross,

with a tremendous welcome in every town we go through. In most cases we have been the first American women the natives have seen. All along the way we have arrived within three or four days of their liberation, so that the constant convoy of Army vehicles has been like one big victory parade, and in every village, town and city, another celebration. They wave with both arms, jump up and down, shake our hands until we are limp, kiss us on both cheeks, and then ask for "cigarettes pour papa." They are terrific scroungers, but perhaps they have a right to be, since they have gone without so much for so long.

I like France ... like it better than I did England, I think, in spite of the rugged way we have to live. The countryside is lovely, extremely rural, and the country people are real peasants. I had thought that the peasant class was an old-fashioned, medieval group, but that is not so ... unless the war has reduced them to that level again. That is not true, I think, though the war has certainly retarded any progress they might have made. However, if one's country is a battleground every 25 years, how can a people be expected to recover and keep up with the rest of the world?

They are way behind the times—the women still wash clothes in the little streams and pound the garments with stones; the cows and pigs and chickens still live in the same building with the family. Quantities of the people still wear wooden shoes, and in general they have a very simple way of life. One thing in France I have rediscovered that in England I hadn't realized I missed. That is the pleasure it is to rest the eyes on a long, uninterrupted view of the world. England is so small and the roads so narrow and obscure, you never seem to get a look-see at anything.

For a week or so, we camped out in any little field we could find at the end of the day. There was never time for us to look

around to find a building to house us, though we dreamed of having a chateau put at our disposal. We would pitch our little tents and unroll our sleeping bags. One detail would get supper, another would dig the latrine (our experience with that would be a book in itself.) Somebody else would do KP. Then on our way again the next morning like a bunch of gypsies. At each stopover the natives come for miles to stare at us like we were animals in a zoo. Now and then we strike a deal for eggs by bartering with cigarettes or a bar of chocolate or soap. Our outfit is just too fantastic for them to believe. The water trailer, the cooking equipment, the trucks and the donut machines, most of all. Donuts they have never seen or heard about before.

Then one night we struck a good-sized town and stayed in a hotel for two nights. That gave us a chance to wash up and get the kinks out of our backs. What's more, it was right in the middle of the champagne country, so we drank till we were starry-eyed … and came off with several bottles each, in tow. At this point we were fairly close to our men. So one of the days there we spent making donuts like crazy; four Clubmobiles were sent forward the next morning to catch up and start the business of serving the fighting men … which we came so many miles to do over a year ago. Our crew was lucky enough to be among the four. Two were assigned to one division and two to another.

Our group of two (six girls) camped with the Army on one of the famous battlegrounds of the last War. The trenches of 25 years ago are still there, though they are now overgrown with weeds and brush. It wasn't a No-Man's-Land in this was, however, but strictly American. The Jerries did come over one night, however, and we spent a half hour in a foxhole. Here the Army put up one large tent for all of us to sleep in and the

GIs who were with us slept on the floor of the Clubmobile.

While this isn't exactly dinner table conversation, the latrine in this case was something worth writing about. The procedure is to dig a ditch like a foxhole. Then, day by day, the thing gets leveled off again with each successive little shovelful of dirt as it is replaced after each visit. In this instance the protective covering for the occupant was two pup tents buttoned end to end so that it was completely walled in. But a pup tent is only three feet high at the peak. And until you have tried to conduct yourself gracefully on such an errand, under a pup tent, you don't know how gruesome it can be. In order to get under the tent you are bent double and from then on it is a tussle. You think you are concealed, but that is ostrich philosophy as you hear your pals giggling outside at the contortions they know you are going through, as the canvas bulges here and there while you make your way along the length of the tent.

We worked for two days with the men here and they were dumbfounded to see us, but delighted that we were there. Donuts, however, are not nearly as important as coffee. Food for the men at the front consists of K- and C-rations, little boxes of tightly packed, highly concentrated stuff. All well thought out and a perfectly adequate diet nutritionally, but boring and monotonous as hell. The beverage is Nescafe or lemonade. When the Clubmobile appears with a cup of real coffee, it is out of this world. We also carry soup and tooth powder, books and cigarettes and life savers. In fact, we carry so much truck we fall over each other trying to get around.

Now we are living in a seminary. It used to be a school for little boys. Nuns and monks are seen hovering about now and then, in their quiet fashion, but for the most part they remain very secluded. We have our sleeping bags unrolled on metal cots in a great, large room, formerly a classroom and now a

dormitory ... on the same cots that German soldiers used not too long ago. The APO boys live down below. Out in back is a lovely big square courtyard where we park our trucks under the trees and work.

Today we are enjoying some of the spoils of war. Practically every one of us has a great white coat, fleece-lined, (Russian ski troop coats) captured by the Germans and recaptured by the Americans. They are beautiful to behold, though they are such big things I don't know how we will be able to lug them with us. We have also had some German rations such as mackerel packed in wine, and a good cheese that comes in a metal tube like shaving cream. Wine and cognac flows in abundance. The wine I love and some of it is exceptionally good. But most of the cognac is so rough it makes you shudder down to the soles of your feet.

Two of our girls "captured" four German prisoners the other day. The girls were riding along in an Army truck returning from a serving job. A soldier was driving. They were flagged by four men standing along the roadside, who turned out to be four Jugoslavs who had been forced to wear the German uniform, and who now, lost from their retreating Army, were gleeful to give themselves up to the Americans. So they piled the four in the truck and delivered them to the Prisoner of War Camp just outside the city.

One experience in this Army I don't want to forget was the shower under which we squealed with joy the other evening ... the first and only shower we've had since we hit France. It is really quite a phenomenal bit of equipment. I suppose there isn't another army in the world that tries to provide hot showers for its men. It is for the men, of course. But being stationed in the neighborhood, we made an appointment with them to reserve it for the women one evening.

About 15 of us went over in our little trucks with toilet bags hanging from our wrists and bath towels draped round our necks. When the men who were already in, had completed their ablutions, we were herded in in a body. The men who had arrived after us had to stand outside and wait, which they did with amused patience, knowing that when they saw us emerge with faces denuded of makeup and hair straight and dripping, it would be worth it.

This shower deal is always set beside a stream or river. The water is pumped out of the river, heated, and then forced through perforated pipes that run the length of the tent. The ground is covered with canvas too, with slatted platforms around the outside edge on which to stand and maintain balance. It was a picture that some artist should paint—with the 15 glistening bodies in the shadowy eight o'clock light of an un-illuminated tent, all of them shampooing their hair and scrubbing themselves down to a fine high polish.

Two days ago we got our first mail in France. We've been without any for over a month. One girl had something like 50 letters which have taken her days to read. There were at least one from each of you for me, and several from Artie, plus a collection of New Yorkers. The mail situation here is pretty terrible. Red Cross mail all goes to Paris to our headquarters there, where it is sorted out for each group. But we get delivery only once a week at best, when a supervisor brings a sack on a regular tour of the territory. Once a week is almost too much to hope for. Even at that we do better than the poor French civilians. There is virtually no system of communication available to them. There are no trains except a few that the Army operates. Even right within the city of Paris there is no civilian postal service. Messages, if any, have to be delivered in person. And telephones in the country are non-existent. They never have been numerous or satisfactory, I'm told; now you would

think they never had been at all.

Yesterday, while serving close to the front, I met a boy from Birmingham who worked for Stockham and is going back there when he gets home, which can't be too soon to suit him. I think his name was Westbrook. He says he remembers you, String, and identified you as a big, tall fellow. He is a slim, narrow-faced boy with pinkish-blond flyaway hair ... just as nice as he could be. His unit and their recent battle is something I want to tell you about when I get home. The censors won't let us talk about such things now.

Believe this catches us up for a while. Love to all. Keep on writing letters.

A.

September 23, 1944

Dearest Family:

Each time we move we manage to improve ourselves. From cabbage patch to chateau is our present record. Just moved into the chateau this afternoon ... into a room on the third floor with wide French windows overlooking the formal flower garden and fountain (not playing now), with a lagoon and natural wooded acreage beyond that. Two of our GIs are out in a flat-bottomed row boat right now, pushing it back and forth across the pond, green with seaweed, by means of a long pole. The grounds are quite wonderful to look out upon after our graveled cloister that has been headquarters for the past three weeks.

Another of our present blessings is just three or four girls in a room instead of 20. And since we are living with some of the tank-busters, we eat at their mess, relieving us of a great responsibility. We just don't have the personnel, the equipment,

the talent or the inclination to prepare our own meals three times a day, day after day. They have sometimes been pretty sketchy.

The building itself is not so elegant as the word "chateau" might imply. The floors and woodwork are terrible and it is not the ravages of war and enemy Germans. No plumbing [either]. But the outfit is a wealthy establishment in comparison to the surrounding country which seems to me to be quite poor.

The villages roundabout are ugly, drab and dilapidated— just a series of barnyards. Most of the shops are closed for lack of merchandise to sell and lack of money to buy. I don't know what keeps some of these people alive. Except for the farmers who tend their own crops and feed their animals, the civilians don't appear to do anything but sit on their shapes and wave at the passing Army, including us. They are a pathetic looking group for the most part—more so around this part of France than in the other sections we have seen. The old people look so much older than they really are. And the peasants work so hard with their old-fashioned methods.

Our day off last week was spent in Rheims. At least half or more of the shops were open there, so we shopped up one street and down the other. The merchandise is terribly cheap and shoddy in quality, and in only one did I see anything I was interested in buying. There, however, I spent everything I had with me. We found a very good lunch (with champagne, of course) and late in the afternoon we visited the Cathedral. The front of it is sand-bagged for about 50 feet up, which hides much of the lovely stone sculpture. Craftsmen and workmen are still repairing damage done during the last War. Fortunately, it was unharmed this time.

Part of our tour of the Cathedral was up the winding stone stairway to the top of the tower—an unending, swirling, dizzy stairway, lighted only by a chink in the thick stone wall once in

a while. Up at the top you get a splendid view of the country and a close-up of the beautiful buttresses and the leering gargoyles. The workmanship is phenomenal. Before going back to our seminary we had another glass of champagne at one of the sidewalk cafes. How I wish I knew a little something about speaking French. The girls who do, as limited as their French is, get so much more out of being here and learn so much more about the people and the conditions.

Don't think I told you that while we were on the way here, and stopped for a few days for supplies, a few of us drove into Paris. We had only the afternoon and had to drive two hours to get there, which left only about two hours in the city. It was early in the liberation of Paris. The people still seemed unsure and afraid—as if they didn't quite know who their friends were. As a matter of fact, there were still a lot of the enemy and the collaborationists to be routed out. Americans at that time were few in the city, so we had a big welcome. So much so that we didn't get to see much of the place. We made the mistake of stopping the car at Notre Dame [Cathedral], at which point we were completely surrounded by jabbering, staring Parisians who wouldn't let us get away. Even the policeman at the corner insisted on buying us a glass of wine. Our two hours were gone in no time at all, and we had to leave the most beautiful city in the world without having seen even the high spots. Now we are too far away to make a trip there practical and can only hope there will be an opportunity to see it properly, perhaps on the way home.

Another little sightseeing trip of a slightly morbid nature was to view the great French military cemetery and monument at (omitted as censorable). The monument is impressive enough, though not beautiful. However, the site it holds on top of a high hill, miles from the town in a kind of wild part

of the country, with the rows of stone crosses and the gardens stretching down the front slope of the hill, is spectacular. Adjoining is another and completely morbid sight—the trench of bayonets. Here in a trench dozens of Frenchmen were supposed to have been buried alive by some kind of blast. All that remains to be seen in a jagged row of bayonets sticking up out of the ground, which have since been hung with rosaries and artificial flowers by the religious French.

Over the trench has been erected a perfectly hideous concrete structure to form a roof about six feet thick, leaving the sides free and open except for the pillars which hold the whole thing up. Chicken wire is stretched from pillar to pillar to prevent the poor dead heroes from having their bones robbed from their natural grave. In my opinion, it is the architect of this business who should be buried alive—for his grossness and bad taste. The whole idea is hideous, of course, but the French seem to enjoy that sort of thing even more than the vulgar Americans. However, the guy that designed it needn't have contributed to the ugliness.

That, I think, takes care of the extra-curricular activities. Otherwise, it is donut-making for 10 hours one day and making coffee, serving donuts and back chat for 10 the next. There was one particularly bright spot on our schedule last week when we were serving a company of engineers. They were bivouacked in an apple orchard. And after we had spent the afternoon with the men, the officers invited us to have dinner with them. Under the trees their table (planks set on saw horses) was set with enamel plates instead of our usual tin mess gear, with paper napkins for all. On a little square table at one side was their bar with four little bottles of champagne and cognac lined up beside the glasses for eight. Behind the table, Jacob proudly stood waiting to take our orders for the before-dinner drinks. … He was a private in the Army and at present was

the cook, mess sergeant, waiter, bartender and KP for his few officers. His name has been changed to Jacques to suit the surroundings. To serve with the drinks he had little crackers with German cheese as appetizers.

For the first course of the dinner we had sardines with slices of fresh onions. Then a meat stew with mashed potatoes and two other vegetables. Sliced cucumbers for the salad. Apples rubbed to a high polish for dessert. Coffee. And champagne throughout it all. It may not sound too wonderful to you—just an ordinary picnic menu. But for an Army mess, the food he prepared, the way he served it, and the degree of elegance he achieved (relatively speaking) with the simple little things was something we seldom see. That little group of men in the orchard haven't completely lost track of the niceties they knew at home (as most of the Army has) and it was a real treat to "dine" with them.

There has been a slight pause in this letter. It is now six days later. And in that time I have been to Paris again. We had accumulated a few days leave to make the trip possible. The recovery they have made in the weeks since our first visit is remarkable. They act like a different people. The streets are crowded. The shops are busy. And there are quantities of stuff to buy. All except food. The lack of transportation still has the country tied up, as you can imagine. Paris, of course, depends upon the country for its food. They have everything else, but not that. The country villages have the food. But they have no other kind of merchandise, and all their little shops are closed and boarded up.

The Red Cross in Paris has taken over the Hotel de Paris. It is really the enlisted men's club, but visiting Red Cross stay here too. You're a fool if you don't. It's a comfortable hotel. Unlike the housing places they provided in London, here they

have private or double rooms. It is also the only sensible place to eat. They have a dining room just for Red Cross personnel. If you are lucky enough to find a restaurant open, it requires coupons to order a meal. Prices are out of this world. One man reported taking three guests out to dinner and the price of an omelet for four was $40.

Electricity is another minus quantity in the city and perhaps all over the country. But except at the Red Cross Club, where they have wangled some sort of priority or else have their own generator, the juice is turned on in the morning from 6:15 to 7:00, and again at night from 10 to 11:30. The rest of the time you use candles or lamplight, or else go to bed. It all goes back to transportation. They haven't the transportation to get the fuel to get the transportation, etc. But as I have said, the French have made a tremendous recovery in just the few weeks we have been here to watch them; with the help of the Army it won't be long before these problems are ironed out— one by one. It makes you wonder about the other European countries. France is probably better off than most of the rest. What must it be in Poland or Greece or some of the others?

We arrived in Paris about 3:00 in the afternoon. We first got our rooms and unloaded our luggage—just a musette bag slung over the shoulder. The other two crew members know Paris well; in fact, one of them lived in France for about 10 years. I depend on them for my French. So they gave me a conducted tour of the high spots of the city—just riding around—up one famous boulevard and down another. The Arc de Triomphe. Place de la Concorde. Champs Élysées. Rue de la Paix. Napoleon's Tomb.

The next day we shopped. At first we just walked and walked and walked—to get our bearings and to see what they had to offer. Then we went back over most of the ground and bought some of the things we had admired the first time. The

next morning we shopped and walked some more; and at noon had to leave to drive the 200 miles back to our chateau. I didn't do nearly enough shopping and now I am furious with myself because it will be a long time before we get back there. Except for the perfume, the prices are prohibitive. Yet perfume is what I bought the least of.

Paris is a perfectly beautiful city as you have heard tell—but far more lovely than I had expected. And the shops! Oooo-la-la! What these French can do with a chunk of material and a piece of ribbon. Their window displays are fabulous. Right now, of course, they are all decorated in red, white and blue patriotic scheme which is a little tiresome after you have walked a few miles of it. Jewelry and trinkets flood the town. Clever, whimsical, fantastic, amusing, rich-looking stuff. And the hats. Take the hats away from a Parisian and she would be the most unhappy person in the world. Most of them are great, tall creations with wide velvet or taffeta bows and ribbons draped around them. Beautiful turbans, too. Lots of women wrap handsome scarves around their pompadours in turban fashion. We would look dowdy if we tried it. But they look smart as the devil and I wish I knew how they achieved it. Yet in spite of the artistic nature of the French, they also put out some of the grossest stuff I have ever seen. They are the second- or third-raters, of course. Either they are awfully good or they are awfully bad.

We had the thrill of seeing a dive-bombing the other day. The Clubmobile was out of service when sud-denly our attention was attracted by the sound of a heavy explosion. Donut-eating stopped as everybody rushed for a more advantageous view. There in the distance in a little valley framed on either side by steep, rising hills, was a tower of gray-black smoke. As our eyes traveled upward, we saw the planes, swift little fighter

bombers sporting around in the blue sky over the target. Then they came again. They made the attack in pairs, one behind the other, tearing down in a steep dive, releasing a bomb and pulling up again in a beautiful sweep. We were close enough to be able to see the bombs released and watch them fall to the target, though the men said it must have been several miles away. They attacked again … and still more planes came from over the hill, some of them bombing, some of them strafing. You can tell by the angle of the dive, in addition to seeing the bomb fall or the tracers from their machine guns. When bombing, the planes make a steep, almost perpendicular dive. But when strafing, they come in at much less of an angle. Let me allay your fears by adding that the planes were American and the target an enemy strongpoint of some kind.

Love,
A.

October 10, 1944

Dearest Family:

The mail must be coming in terribly slowly, or not at all. According to Artie, you still haven't received any real letters from me from France. While I haven't written as often as I should, perhaps, the letters I have sent have been big, fat ones, which should have kept you busy for some time.

Have I told you, we now have steam heat in our chateau, in addition to the fireplace. It begins to look like we might be here for some time, so day-by-day we dig ourselves in a little deeper by unpacking more and more stuff to make living more comfortable. The woolen winter stuff is coming out, piece by piece. When we do finally move again, packing and getting everything

together again in a compact form is going to be a job.

I'm sitting beside the radiator now trying to pick out bits of news that might be interesting to you from a week of work that has been full, but quite uneventful. Our work days are better organized now, giving each of us a little more time to do personal chores. Those are the cooking days. We work ** in shifts. One girl gets up early in the morning. The second one comes on at 8:30 with breakfast for the first. The third one reports at 11:00 when number one goes off for four hours, and so on. It makes about a six-hour day for each of us, which reduces the boredom of donut-making somewhat.

Artie asked me not so long ago whether I needed cigarettes or books. The answer to the cigarettes is "no." Our regular [supplies] don't always come through regularly, but I have quite a backlog to hold me over such emergencies, and there are always some on the bus. It would probably be a good thing if I didn't have so many. I'm smoking far too much. Thank you, Artie, just the same. It is the poor men I feel sorry for when cigarette rations run out. Yesterday we served a large group that hadn't had any for a week or more, and I thought the bus would be pushed off the wheels in their eagerness to get at our cigarette tray. We don't have enough to give out a pack to each man—they're supposed to take one or two to have with their cup of coffee. This time we couldn't unwrap the packages fast enough, and most of them didn't care whether they got a cup of coffee or not, as long as they got a smoke.

If there are any really special books available, I would like to have them. But we are not without reading material. We carry a lot of pocket-book editions furnished by the Special Services of the Army, so between those and trading off books and magazines among ourselves, we have as much to read as our free time allows.

We have visited some of the gun crews of the field artillery lately. We are getting quite hardened to the terrific noise and the concussion now, and some of the girls have even fired them, which of course necessitates standing right next to the big babies. Though at first I must admit that the sharp report startled us so we nearly threw the coffee in our faces.

There is something quite wonderful about the teamwork of a gun crew. It's like any other team that's any good, of course. When they have a mission to fire, they permit nothing to interfere with their concentration on their job … donuts, coffee OR girls. One boy sits with a telephone at his ear all day long. Another one adjusts the range. One cleans the gun, one puts in the shell, and another one stuffs in the charge. Then they wait for the order to fire. Off she goes on some deadly errand at split-second timing. When they are working fast, everyone appears to be running around in circles, but each one knows what he has to do and is right there with the goods; the boy at the telephone shouting the orders—first a set of numbers indicating computations given by the observation post, then "Super Charge" and finally "Fire." Wonderful and awful to watch. In between rounds they take another swallow of coffee and another bite of donut as calmly as if they were shooting off a firecracker.

We too take it all too calmly, I'm afraid. We've talked about it a lot; are amazed that we don't feel some reaction to the whole business. I don't expect us or the men to feel much compassion for the poor devils on the receiving end, but I should think we would be struck with the horror of it all. Perhaps it is because we personally haven't been on the receiving end and do not fully realize what it means. It certainly is a good thing, though, that the men remain as untouched as the majority of them are, else they couldn't stand the job for long.

Met a boy from the *Chicago Tribune* this week. He is a correspondent for our Third Army. He discovered the Red Cross

in his neighborhood, so came in to do a newspaper story on them. When he asked for girls from Chicago, they sent him over to talk to me … and there was Bob Cromie, whom I had known as a reporter on the *Tribune*. In all these 18 months, he is the first person I have met over here that I knew before I came. He has been practically all over the world for the *Tribune*, his first assignment being in the South Pacific. He did a particularly good job at Guadalcanal. That was even before I came overseas.

You should see the elaborate foxholes and huts that these boys of ours build for themselves. When they get the feeling that they might be staying in one spot for a little while, they immediately start making themselves a little home. A mess sergeant had constructed a hut of straw for himself. It was a tent-shaped creation, larger than a pup tent, all of thatched straw. He himself doesn't smoke, but he was afraid some of his callers might be careless with their cigarettes, so he had a fire extinguisher hung outside the door, together with a tin can dangling from a wire for cigarette butts. Inside he has constructed a little stove of an old 50-pound fat can with a little chimney. The whole thing is as warm and cozy as you could want it.

In another camp, the boys were digging a trench to accommodate two. It was about 6 x 6 x 2 feet deep. Then there was a foundation built above ground

Girls Serving Doughnuts Delight G. I.s

BY ROBERT CROMIE.
[Chicago Tribune Press Service.]

WITH THE AMERICAN 3RD ARMY, on the Moselle River, Oct 13.—The most popular vehicles in this area are "manned" by real live American girls who bring doughnuts.

They are Red Cross clubmobiles. The group is directed by Eva Christensen of Brush, Colo., and comprises 30 girls and four G. I.s who repair tires, haul water, and perform other manual tasks. There are eight clubmobiles, one cinemobile and four supply trucks.

At headquarters, which we visited, some one said an Illinois girl was cooking doughnuts in her clubmobile in preparation for the next day. We peered inside and said, rather rudely: "Hey, you from Illinois?" A beslacked young lady turned and said: "Yes. Why?" We said, "Chicago Tribune," and she said, "Cromie."

She's Former Tribunite.

She was Angela Petesch, a member of THE CHICAGO TRIBUNE Sunday editor's staff on leave.

This group had been making doughnuts about five weeks when we saw them. They had been in France since Aug. 8. They spent the first three weeks trying to catch up with Gen. Patton's forces.

Four clubmobiles of this group are on the road daily with the other four crews cooking doughnuts in camp for their tour the next day. Each team serves about 2,500 doughnuts a day, plus coffee, cigarets, candy, books, and playing cards, all dispensed with cheery smiles to tunes from a phonograph with a loud speaker attachment.

The girls work about 10 hours a day when they are on the road. They leave about 8:30 a. m. and return about 6:30 p. m. There are 10 of these clubmobile groups in France and Belgium, according to Miss Christensen, including one that travels in and out of Germany under guard.

They Take Prisoners, Too.

Each clubmobile tries to serve between 1,000 and 1,500 men a day, sometimes making several trips if visiting small camps. Once since their arrival in France four German prisoners gave up to a clubmobile carrying two girls, Dorothea Bar

with sand bags. The roof was to be old railroad ties they had scrounged from somewhere. Tar paper on top of that was to make it waterproof. Straw and blankets were to be laid down at each side of the entrance for the beds, with an aisle down the center dug deeper than the rest to permit sitting in a comfortable position and standing upright. It was all carefully thought out with the site on a gently sloping hill to provide the proper drainage in case of heavy rains. The kids know they'll probably have to move on a couple of days after it is constructed, but that doesn't stop them from building a little nest for themselves.

Tomorrow we have a day off again and have a little trip planned to visit a small city about 50 miles from here. We had hoped we would be through with our work today so that we could leave this evening, spend the night there and have a full day to do our browsing. But that was wishful thinking. I know it is mean, but I can't tell you where we are going. Blame that on the boys who think up all these security regulations. I do feel sorry for these fellows who have the job of censoring the mails. We know one officer who had to censor the mail of the men in his company, and the poor devil got so tired of reading letters, he didn't enjoy getting mail himself. It was just another letter to read and something of a bore. Not so with us. We keep sweating out the mail, but it never seems to come. We have still another address now, which is c/o American Red Cross, Continental Headquarters, Clubmobile Group H, APO 887, Postmaster, NYC.

Love, Angie

October 16, 1944

Dear Verona:

Soap is even scarcer in France that it was in England. And because of the rugged life we lead, the soap becomes increasingly necessary. The Army takes care of our personal soap needs in an adequate manner. But your little leaves will be an advantage when we are on leave and try to wash up in some public washroom.

While we are on the subject of cleanliness—I might say we have to drive about 10 miles to get a shower or a bath. A trip over there is arranged every few days and if we can get away from the daily chores, a whole truck-load of donut-smelling females goes over. A bath once a week is a luxury. In between times we take "spit" baths out of our helmets.

Right now we are living in a chateau, but that sounds more elegant than it is. The entire plumbing in our section of the house consists of a shallow wash basin. Even that gives limited service—cold water, and no water at all after 8:00 in the evening. But we do have electric light, fireplaces and steam heat. It is a distinct comfort too, to have a roof over our heads and not be living in a pup tent in a muddy pasture, as we did for three weeks—a different pasture every night.

Have been to Paris for two days. It was wonderful, though you do have to be extremely wealthy if you want to do any shopping. Except for perfume, prices are out of this world.

Merry Christmas to you and your family from France.

Sincerely,
Angela

November 1, 1944

Dearest Family:

This is being written by firelight. The electricity just went off as it does every evening. But with the flicker from the hearth and the remnants of the touch system, I think I'll get along.

Have been on another two-day leave. We went in the opposite direction from the last time we had leave. Started about 4:00 in the afternoon—four of us in an open jeep. It was so cold we had on all the clothes, boots and overshoes we could find. Scarves tied on over our hats, with the hoods from our raincoats pulled over that. Blankets, too. Still we froze.

The first night we drove about 100 miles. The Civil Affairs office in the town found us rooms with a wonderful family. They were crowded with other guests, too, but they made room by throwing the family out of their own beds. It was a very large house right on the village square. They were a well-off family and probably still are, though nowadays money doesn't mean too much.

We drove our little Jeep 'round back and parked it in their garage. Brought our rations in the house and cooked our supper in their kitchen with the mother helping and the rest of the family looking on, thunderstruck. It was fun to rattle around again in a civilian kitchen. A mixture of French and English provided the entertainment. We sat at a real dining room table with china plates and decent silverware, with tablecloth and napkins, for a change.

Across the courtyard in back of the house, they had a great, large stable with nine fancy horses—the biggest, broadest, solidest beasts I have ever seen, with their poor tails chopped off to a tiny little brush. They are breeders of these big Belgian work horses that are famous all over the country and have

won many prizes at national shows. [The horses] are as gentle as they are big. The family told us a story of the Germans trying to use the horses and harnessing a pair of them. But these stud horses had never been broken to harness. So the Germans, when they discovered the team wouldn't cooperate, shot them. There were cute, woolly puppies at the stable, too—black Belgian shepherds.

After a night in a wonderful soft bed with sheets and a feather puff as thick as a mattress, we started off reasonably early in the morning for the other hundred miles. The only unfortunate thing about the whole trip was that our leave fell on Saturday and Sunday, and over here even on Saturday most of the shops and stores are closed. We did buy a little bit of lace and some gloves. Prices are exceedingly high, however—probably worse than in Paris. But we ate ice cream and bought big, fat grapes—delicacies we don't find around our neighborhood.

The trip home was another cold one. And uncomfortable. By this time we were sore all over. Jeeps are probably one of the best vehicles the Army has, but they weren't built for luxurious comfort. This particular one had no back seat, so the two who had to occupy that section had to sit on a ration bag which, after a few hours, gets to feel as hard as a cement block.

We had to stop for gas on the way home and drove into an Engineers' camp. We needed only a couple of gallons, but they filled up the tank for us in their usual generous spirit. Naturally, we gravitated toward the kitchen, where we filled our individual tanks with coffee, hot dogs, white bread and marmalade. The boys were too wonderful, hovering around us, waiting on us, "forcing" stuff to eat on us, clearing out the washroom for us. We spent about 45 minutes there before

starting out on the last lap with our stomachs full and our spirits riding with the moon that was just beginning to show itself through the trees. The drive up and back was most picturesque—the hills and valleys covered with fall colors like a paisley shawl.

Got my first Christmas package today—one from the *Tribune*. The box was rather badly damaged, so I felt I had to open it. It was a very good selection of items; from my knowledge of men at the front, they couldn't have done much better in hitting upon the things that the men need and enjoy the most. There were handkerchiefs, washcloths, writing paper, comb, utility lighter, box of hard candy, candied nuts, can of boned chicken, fruitcake, razor blades. The little comfort items are very much needed. If the men have been in any sort of combat, most of their personal effects have been lost. They come back without shaving equipment or toilet articles. And during the action, of course, they haven't had an opportunity to bathe or shave.

The American Army is a much more fastidious one than any other, perhaps. When they get pulled out of the line for a rest, the first thing they want is to get cleaned up. They also love stuff to eat. Up front the diet is composed almost exclusively of rations which are adequate and well-planned nutritionally, but dull as dishwater and terribly monotonous. Something good and sweet and rich would hit the spot with any man overseas that you would like to remember. Also, stuff for snacks. Writing paper is another scarce item. Every time we serve a rest area, we have more requests for that than any other thing, and we just can't carry enough to go around ... and playing cards.

I realize all these suggestions will arrive much too late for any Christmas boxes you may be mailing, but don't stop with the Christmas boxes. You have no idea of the importance of

mail call to these men. They are hidden off in the woods sometimes for weeks and months at a time. They see no one except their own little group. Most of the towns are off limits to them. Even if they do have an opportunity to meet French people, they are dissatisfied and frustrated because of the language difficulties. Frequently, we visit these isolated units. But we get to them only once in about two weeks.

"Ack-ack" boys, for instance, who live like hermits and are not allowed to leave their gun positions, are so far out they have to do their own cooking. They have so little contact with the world they have forgotten how to be sociable, and they are shy and uncommunicative. Now and then one of them will get the courage to speak for the group and tell us how much it means to see a girl. While they don't talk much, you know they appreciate the visit just by the way they stand around and watch every move you make. A letter or a package from home gives them the same lift. They're wonderful—these boys of ours—and they so hate what they're doing and how they are living.

We had a little party for one of our girls who has left the group to go back to England to be married. Her roommates planned it for her and did mighty well with makeshift and borrowed props. The Army assisted us too, of course, with chocolate ice cream and a perfectly beautiful two-tiered wedding cake, full of rosebuds and whirligigs of colored icing, courtesy of the mess sergeant. Each girl dove into her trunk for a little present of perfume or stockings or any other appropriate thing. A silver coffee service was scrounged from somewhere. A fringe of oiled paper with a border of little red paper hearts decorated the fireplace. It was all a very great success.

The amusing remark of the week was by one of the little GIs who lives here with us. He had been on a little trip to

drive the Colonel to another area, and while there saw a Clubmobile from another group. But he came back to say, "The donuts was soggy, the coffee wasn't no good, the girls wasn't so good-lookin' … boy, was I glad to get home."

November 12, 1944

Dearest Family:

A touch of snow gave us real proof today that winter is upon us. The natives tell us that the snow never lasts in this section. But I'm not sure that is an advantage. The slushy mud is going to be worse on us and on the Army than if the ground froze good and hard with a blanket of snow on top. Winter over here is going to make our job rather difficult. When we are cooking, we can close up the Clubmobile and get quite a bit of heat from the donut machine and the water heater, but even with that the floor stays cold and the feet turn to ice after standing around six or seven hours. And when the doors are closed tight, you soon suffocate with donut fumes. On serving days the back door has to be open as well as the serving window on the side, and then the place is like a wind tunnel.

I'm afraid it is going to be colder here than in England and that we used to think was the end of the limit. They have given us lots of warm clothes, however. The short winter days cramp us terribly, too. We are not allowed to be, nor do we want to be, out after blackout. But that means we must get back to our billets by 5:00, and the shortest day of the year is still a month or more away. So our groups we serve have to be fairly small ones, from 500 to 1,000, instead of 1,500 to 2,000, which means it takes us twice as long to get around the circuit. This Army regulation of not being out after blackout holds for our social life, too. Even if we have an escort, we're not allowed to

accept invitations unless arrangements can be made for us to spend the night. So when any of our girls is asked for a date, she says, "Can I stay all night?" which either gets a good laugh or scares the gent half to death.

We have had another little move—only a short distance and, we hope, for a short period of time. We have definitely lowered our standards this time and are billeted in an old school building with six or eight people in a room, which none of us like; terribly muddy motor pool in which to work, and again, no inside plumbing. The French sanitation problem is colossal, more so in this section than other parts of the country, though it's bad all over.

Here is a fairly modern school building with steam heat, electric light, water (not hot, however), but with these nasty outside biffies that are just telephone booths with a concrete floor that slopes toward a little round hole in the middle. Not so much as a Chick Sale plank to balance on. And with no flushing system, you can imagine the condition of them.

I really hold out little hope for these people. They are so maddeningly stupid and careless. About other things, too, besides the sanitation, modern conveniences of all kinds, and the manure pile in front of everybody's doorstep. They pay no attention to the war around them and disregard any safety precautions the Army prescribes, such as blackout. It makes me so boiling mad to get so little help from the civilian population. Instead, they jeopardize the lives of our men as well as their own, and the success of the whole effort. I'm sometimes not sure they want to be helped or that they are worth helping. This is a particularly difficult section of France, it is true. I just hope the rest of the country is not so bad. The reception they gave us as we drove through other sections on our way up here, at least showed an enthusiasm and a patriotism that

was gratifying. But in the frame of mind I find myself today, even that exhibition might be interpreted as a case of "Vive la Frenchman" rather than "Vive la France." Maybe I'm wrong; I hope I am.

Got the little box from you, Ede and Art, with the magnifying glass for reading V-mail. Thank you, much. Yesterday a package from String with essential paper products plus peanuts. All very welcome and much appreciated.

Bob Cromie [mentioned in October 10 letter] sent the story in to the *Tribune* on our Clubmobile group, and while I haven't seen it, I have heard that it appeared—heard in a most round-about way. The mother of a boy who works at the APO read it and sent it to him, thinking that perhaps he knew the girls from the Midwest who were mentioned in the article. He did, and it was us. The kids from the *Tribune* will probably send me a copy.

Love to all,
Angie

November 27, 1944

Dearest Family:

This morning all eight Clubmobiles went out at 8:30 to serve. Ordinarily four serve and four cook, but this was an urgent job, so the kids cooked until 1:00 last night to have enough ringers to sling today. So except for a couple of the girls who are home with colds, I am holding down the establishment alone, taking care of the office and keeping three small furnaces going. For the past week I have been helping with the office job, both to give me a rest from donuts, since I'm the oldest donut-maker in the group, and also to learn the

ropes of administering the group.

It's a pleasant relief and don't mind missing the daily trips as much as I thought I would. This is definitely the season of the year to have an inside job. Going out every day in the cold and the rain has its drawbacks. The reason for having me know how the office works is that there is a possibility that soon there will be a division of the group into two equal parts in order to give a wider coverage. When that takes place, I will be given the job of managing one half while Eve continues with the other half. A group that size won't be so hard to take care of. It is a sound idea, in fact, to split it up. The original grouping of 31 women is too large. It's so difficult to find quarters, for instance, of a homelike nature; whereas there are lots of houses available which could be made to accommodate half that number.

December 6, 1944

Time flies, doesn't it? I thought in this job there would be all kinds of opportunities to write letters—that I would have to scrounge for things to keep me busy. The opposite is true. There are constant interruptions. Besides signing up Clubmobiles, I have to chase the plumber, the electrician, the mail man and most of important of all, the PX officer with the liquor ration. In England we didn't get a liquor ration. Now we rate the same allowance as the officers, which is one quart of Scotch and a half a quart of gin per month. That plus the bottles of this and that our friends present to us takes care of a lot of snake bites. The local supply of spirits is not nearly so ample as it was farther back in France when the Army captured warehouse after warehouse of cognac and wine that the Germans had stacked away for personal consumptions or to send home to the Fatherland.

This month we are saving our rations in order to put on a big party. One of our girls is being married on January 18 to a Lieutenant in the Field Artillery. Planning a marriage under conditions here presents many problems. In the first place, nobody knows where the bride and groom might be at any future date or where the ceremony will be performed. The poor boy can get only a 48-hour pass at most. Then there is the transportation problem and where to spend the honeymoon. Paula has a sense of humor, fortunately, so all these complications don't bother her too much, and she is certainly taking a lot of kidding from these bright girls around here, who have one ribald solution after another.

Now we live in an old barracks that the Germans erected for themselves when they were occupying this area. But it is better than the word "barracks" would imply. Our building was undoubtedly part of the officers' quarters. There are six rooms on a floor, each one large enough to accommodate two. Each floor is designed as a separate apartment with a kitchen, a tiled floor and a little steam furnace which heats the entire apartment. We boast a bathroom and a bath tub, though the latter has no water attachments, not even cold. So we have installed a small coal stove in the corner of the room, on top of which we balance a 15-gallon kettle. When the water gets hot some hours later, we tip the water in the kettle into the tub, and there we have it.

All the girls have made themselves quite comfortable. It is amazing how quickly the place begins to look and feel like home. For the first day it is a mess and everybody's time is consumed trying to get the heating system and the electricity going. By the next morning, pictures and maps appear on the walls, roller bath towels cut in half or strips of parachute silk are tacked up at the windows for curtains, bright-colored ash trays and bowls of pine branches and red berries decorate the

room. Of course, we all find building a home for ourselves so important that every time we shop we acquire more and more furniture, chests and blankets, so moving now becomes a major operation.

I don't know who lived in this place before our immediate Army family took it over—whether it was American or Germans or some of the poor displaced Russians who were brought here in forced labor. There are lots of the latter who present quite a problem to the American Army. They are homeless, of course, and have to be fed and clothed, housed and worked if possible, until the time comes when they can be sent home. Judging from the conditions of these buildings, I am inclined to blame the filth on the Russians. The junk that they shoveled out of these buildings made a wall four feet high down the entire length of the street, all of which had to be carted away.

In their mess hall, for instance, they just sat there and peeled potatoes and onions for weeks and weeks and weeks without ever removing the garbage, so that the floor was about three feet deep in refuse. And they … wouldn't take the trouble to take themselves to the bathroom, though it was only the room next door. Plenty of cleaning and exterminating had to be done, as you can see. I don't know how some groups get away with it. When we move with our little corps, we have to police the joint like it was our home, and go back and do it over again if the inspecting officer doesn't approve. Even if the Russians were to blame, they were here under the surveillance of the American Army and it seems to me they could have been made to clean up their own mess. They had nothing else to do.

Our "fleet" of vehicles has now been increased by three. Various friends of the girls have recently donated captured

French and German cars to the group. One is a Ford V-8 and is the only one which is reliable, by the way. But we are trying to get the others fixed up and get new tires for them so that we can go tootling off on our days of leave, in sedans instead of Jeeps. It must be great fun for these soldiers who see an enemy vehicle on the street and decide they'll take that one, and thereupon drive off in it without any further negotiation. I think we're all going to be a bunch of thieves when we get home—we're all getting so light-fingered.

Three Christmas boxes have arrived from Walnut Creek. The kids all hollered at me, but I was firm in my resolve, so I opened them all up. Last year I religiously saved every one until Christmas Eve. This time I figured it would be something of a problem to pack away a lot of additional packages in case we were called upon to move. This, that I can't pack away in my stomach, will fit in other little crevices. Thanks for all the wonderful little parcels—they are all happy selections and please me immensely. And, by the way, Merry Christmas to you all.

It is going to be rather difficult to give all our men over here a proper Christmas greeting from the Clubmobile department. So far we haven't devised a plan. The problem is to reach as many men as possible during a three or four day stretch at Christmas time. We have no presents of sweaters and scarves, as we did last year. And it is a physical impossibility to make and serve enough donuts, and reach anything but a small minority. We should spread ourselves thinner than that, and yet we don't quite know how to manage it.

Took a little trip the other day with one of our boys in a supply truck to pick up some flour and fat that was waiting for us in a heavily fought-over city. The city fell some time ago, else we wouldn't have been there, of course. But it has been one of the important battles of the war, and it was interesting

to see it. The city itself, a fairly large one, is not too badly damaged, oddly enough. But there is one small village on the road approaching in which house-to-house fighting took place for some weeks. There wasn't an undamaged building in the entire village. The roads and walks were still littered with rubble.

There were even a few bodies and dead horses still lying along the roadside that had not yet been picked up. Up and down the highway were little families with pushcarts, wagons and horse-drawn carts, piled to the limit with bundles, boxes and babies, coming back to try to find their poor little blasted cottages. One horse-drawn wagon had a wheelchair tied on the back so that the occupant rode backwards. Under all the packages and blankets so that all one could see was her head, there was a thin little gray-haired woman, an invalid, going back home. In another one the grandmother was riding in the cart itself, piled up to her ears with household goods, the mother and father helping to push, and the kids, in their homely little wooden sabots, trudging wearily behind. The saddest, most heartbreaking sight you have ever seen.

This is a rather gruesome note on which to close, but at the moment I can't think of a lighter touch. My bestest love to you all.

Angie.

December 20, 1944

Dearest Family:

Between the work and the play, I can't seem to make a date with the typewriter long enough to get even the family letter written. And everybody else on my mailing list has been

horribly neglected.

Have been having a very pleasant time lately. The job as group leader, which I talked about somewhat in my last letter, came through. So my career as a donut cook seems to be over except in the case of emergencies when Eve and I sometimes fill the gaps caused by illness. It's an inside job which is all right with me during this kind of weather. In fact, I'm enjoying it. Though I'm ashamed to admit one reason why I like it better is because of being separated from 24 hours a day of living and working with the girls who were on my crew. Guess I didn't realize what an unsatisfactory combination of personalities it was, until I was removed from it.

One girl was such a dominant character and the other was such a bosom pal and sympathetic friend of hers, that I felt it was two against one the whole time. There were never any quarrels, but I was just a bit overwhelmed. Our mother shouldn't have been so quick to stop our childish squabbles. I can hear her now intervening at the first voice raised in disagreement and squelching any argument before it ever got underway. I don't know how to argue now when the need arises. But enough of that … I am out of it and relieved of it … and do nothing but sit in the "office" to receive callers and make appointments and give orders. It's like an open house all day and all evening, which is all right except you don't get time to brush your teeth in privacy. Every night is a party if you want it to be. The men here have been so nice to us. We have really found a home. They drop in frequently in a friendly, brotherly manner, bring a bottle with them, or invite us over to their sitting room, and so it goes.

Got Christmas presents from Birmingham and Aunt Angie this week. Thank you all very much. Christmas is only a few days away now and we have great plans for making 25,000 donuts a day for a period of five days and reach as many of

our troops as we possibly can. In order to do it, we have hired about eight civilian girls as cooks. On the night shift the boys in the area are volunteering to help by coming in for eight hours to stack donuts while a limited number of American girls take care of the machines and supervise the job. The Hi-de-ho that will go on with all those boys working all night will be somep'n, but it will be fun as well as work for us and will be about as much Christmas partying as we will have time for. After the splurge we will take a two-day rest before starting out again on the normal routine.

This donut business continues to amaze me. Even after all these months of it. The importance that the Army places on it is phenomenal. Full Colonels in the Army make a special trip to us to arrange for donuts for their commands. Generals argue with each other on questions of Clubmobile policy and donut distribution. The whole Army chain of command gets involved when something goes a little wrong, and investigations travel through the complete channel from General to Colonel to Captain to shavetail until they pin it on somebody … it might even be pinned on the little corporal who guides us or the cook in the kitchen who failed to have enough hot water ready. The little guys who shouldn't be expected to bear the responsibility but who can't do anything about it. Can't quite decide whether we are terribly important or just a supreme nuisance. In Army slang—"It beats the hell out of me."

The Germans are getting plenty fresh with their counter-attack, don't you think? We don't hear any more about it than you do, except for a few worrisome rumors and doubtless you get them too. We listen eagerly for the news which is broadcast over the amplifiers twice a day, but it is very sketchy news as broadcast by the BBC *(British Broadcast Company)*. The

censors won't release the complete reports for security reasons … and I can understand that. But I'm certainly on the edge of my chair wanting to know all about it.

You keep asking me about stuff to send to me. There isn't anything I really need. As I have said before, it is unwise to load up with items that I must transport from time to time. The best bet are little cans of tidbits for snack parties. With crackers to match. Little tasties like shrimp or sardines or mayonnaise or anything else that fits on a cracker and makes the next swallow of Scotch taste better, is about the only thing I can think of the Army doesn't furnish us. That is pure luxury, but a good one.

While we are on the subject of food, somebody better relieve Aunt Angie's mind about me. The little note that came with the Christmas present sounds like she thinks I'm starving. That note was written way back in the early part of October, so perhaps other mail has reached her and she has changed her mind. There was a period after we first arrived in France when we ate cold K-rations for about a week, which was a tiresome diet, but was plenty of food. And she can rest assured that the Army takes better care of us than it does of itself. I want for nothing except to see my nice family once in a while. We get a little optimistic now and then about V-Day and when things are going well, decide the end can't be too far off. Then the enemy throws our calculations to the winds by putting on a counter-attack which doesn't win the war for them, but certainly postpones the end. They can't be blamed for that, I guess. But I wish they'd get tired and give up. Silly talk, that, of course.

I got Daddy's letter about all the Petesch antecedents up in Brussels, too late. It might have been fun to find a bit of the family over here; though after all the years that have inter-vened, and a few of those years torn by the war, it would be a

small chance that they would be found.

It's bed time. And lucky I am to have found myself alone long enough to get this much down on paper.

Love to all,

Angie

Dearest Family:

Never have I been so lacking in inspiration for letter writing. That's because I have been too tired and haven't had the time. And that is because I've been having too much fun. The days are too confused and too interrupted to sit down for a long enough period to write a good one, and it does take me a long time to do it. Practically every evening some of our friends from the officers' quarters come over with something to eat or something to drink, so that every evening is a party. I can't seem to be strong-willed enough to take myself away from the group and closet myself with a typewriter. Practically every letter I write, I realize I start out with an apology which is more a waste of paper than anything else because that isn't what you want to hear about. But I must explain that I'm not ill, or suffering, or over-worked.

At present, I am in Cannes—in a pleasant single room with a private bath, but no view (the Mediterranean happens to be on the other side of the house). But the hotel is close enough to the sea for me to hear the surf swishing on the sand; that is closer than I have any right to be or ever expected to be. The weather is just starting to get warm—we do have to wear coats and there is no such thing as bathing—but it is so much warmer than what we have been living through 600

miles north of here.

That is the distance we had to drive. It took us three days to do it. It doesn't make much sense to spend six of nine days driving, but that is what we elected to do and we've not been disappointed. I know we will be nearly as tired when we get back as when we arrived. The reason for the slow going was the roads—all snow-covered except for the last 10 miles when we finally got out of the mountains. We took the mountain road from Dijon to Grenoble, Sisteron, Grasse, and then here.

It wasn't accidental that we found ourselves swinging around curves on narrow mountain roads with snow drifts to impede the way or snow plows to try to pass. It is the shortest way in actual mileage, though no shorter in time consumed, and we did want to see the French Alps. The drive was worth it, every bit of it, though when we now look back we feel like the fools who stepped in where angels fear to tread. Perhaps we were fools, but you get started on a thing like that and it is worse to stop than it is to go on.

We had blizzards and everything else on the way—a 45-mile detour because a bridge was out, which meant we had to go on secondary roads through back woods and tiny mountain settlements that had never seen an Army vehicle—another detour off to the other side because of a snow blockade. The drive was beautiful though, with bright warm sun on the clean white snow, with a cleanness and a stillness you didn't know existed. We didn't see any Army for miles and miles, and there was no artillery booming in the distance and no armory clattering along the roads—the same peaceful, undisturbed scene it has been for centuries.

One reason why we felt so safe and secure was because our own vehicles were under repair. A command car is a big, heavy thing and not very fast, but comfortable riding, with enough

power to push through anything. It's a sedan-type body for five passengers, with a canvas top, built on a ½ ton chassis. It drives like a truck and has to be double-clutched, but it wasn't too clumsy to handle and we felt very fortunate to have it. As I have said before—the Army is very good to us.

Too good. Every time I go off on these trips, I feel a little shame and remorse. The Red Cross is the most privileged group on the continent. Nobody else has leave. The Army isn't given time or a vehicle to go riding through the Alps or sit in the Riviera sun. And the natives have nothing. Because of a very active and uncontrolled black market, and because of inadequate transportation, these people down here haven't had a meat ration for three weeks. Normally, they get only half a pound a week. So they just do without—there is nothing else to take its place. Or go to the black market, which they seem almost obliged to do if they have the money, in order to exist. We are so completely away from the Army right now, we feel we are seeing a foreign country for the first time. Only then do we begin to realize what the people are putting up with. Our working days are so completely absorbed with the Army and our needs taken care of so adequately by them, we forget.

One of my first acts of civilized life on arriving here was to get a permanent and a hair cut which made me feel like a lady again. My hair had reached the spaniel stage and was completely beyond my talents for taking care of it myself. Now I feel I can last out another three months.

The Red Cross has taken over the Savoy Hotel here in Cannes—just for vacationing Red Cross girls. They mother and pamper us with breakfast in bed, prompt cleaning service, heat and hot water, polished shoes and anything else we ask that they can possibly do. Good beds and hot baths are

still our greatest luxury.

Back up north where we live with our corps, some of the officers have a bath and hot water in the house that they call home. We have cultivated them, of course, and fit ourselves into the bathing schedule on the off hours. Even then we sometimes interfere with their shaving because there are at least eight men in the house, which number would normally tax the facilities without women chiseling in. They're good eggs, though, and try not to discourage our bathing too much. We're careful not to over-do the privilege.

There is one trick to the whole procedures, though, and that is, there is no lock on the bathroom door. So you either go in pairs—one girl bathing while the other stands ready to bar the door, or you ask one of the men to stand guard outside. Failing that, you hang a little sign on the door and take your chances. The men have made a fairly permanent signboard which hangs just outside the room. It is reversible since the men find they need some protection, too. One side reads, "Red Cross bathing—knock before entering," the other side reads "Home Team bathing—enter at your own risk."

On our trip back north we're going to take the other road through Marseilles and up the Rhone Valley road to Lyons. It's longer that way but it may even be quicker. It should be easier.

The next letter will be a flashback to catch you up with what has transpired in the past five weeks, such as Christmas and New Year's and the wedding. Haven't heard whether my Christmas packages arrived there safely. Hope they did, though there was very little of value in them. I'm sure I thanked you for the boxes I got here. Though there was one from Birmingham which I haven't mentioned till now. A luscious, rich, moist fruitcake was addressed to me from B'ham but without a return address. I accused the Petesches until

a few days ago when I got a box of cookies from your friend, Mrs. Haskell. Then it occurred to me the cake might have been from someone else. If you know about it, will you please thank them for me and send me their address because I would like to write them, too.

Love,
Angie

February 4, 1945

Dearest Family:

Here's a copy of a little poem we keep hanging on our wall to keep our sense of humor up where it belongs. It may sound very amusing but it is all too true:

CHOW LINE SERENADE

I sing a song of the fellow who serves my food…
And the way he dumps cake on my pork,
Such finesse—it's a dream! What an artist supreme,
Did he learn at the Waldorf or Stork?

Not a surgeon can equal his delicate touch…
As he sprinkles baked beans on my pie.
With one swallow-like swoop my dessert's in my soup,
How unerring, how steady, his eye!

Like your salad with gravy? Or stew on your fruit?
He will fill up your tray to the brim.
So three cheers and a bow for this maestro of chow,
For they named the word "MESS" after him.

Speaking of a sense of humor, the American soldier has one the like of which is hard to beat. For instance, on one of the roads over here as you cross over the German border, is a large sign which reads, "You are now entering enemy territory by courtesy of the 00th Division." In another place our engineers have repaired a bridge that was blown out and in the manner of American advertisers, have printed in great large letters on the side girders which hold up the floor of the bridge, "Under New Management—00th Combat Engineers."

Everybody should have a chance to know the American GI. He's much different than he is at home—more carefree, more uninhibited, more natural, more resourceful, more lovable. What a character. All the men name the vehicles they drive, as you know. Usually it is named after a girl. One big black truck driver calls his 18-wheel tank retriever "Embraceable You." But the GI who named his Jeep "Butt Buster" had the right idea.

Before I forget it, I want to report two more packages from Birmingham, full of pretty smelling bottles and jars with little notes attached to each package. Also a pair of shoes arrived from Ede and she is to be complimented for finding exactly the kind of shoe I wanted and in exactly the right size. She is a mind reader. Thank you one and all. Also got a Christmas package from Sidney which pleased me very much. Will write to her soon.

I promised in my last letter to give you all a flashback to Christmas. It all seems rather far away and pointless now, but I might want it for the permanent record.

Just before the holidays we got permission from headquarters to take four of the donut machines out of the Clubmobile and set them up in a garage or building to make a static kitchen. All the Clubmobile groups had been wanting to do that ever since we got here. In England there was some point

to having them in the truck because the crews made most of their donuts right at the camp and it furnished part of the recreation because the boys loved to help or just stand around and watch. But here, because everything was moving so fast and no camp was anything but a temporary bivouac, there was no electric power—the donuts had to be made here and then carried out to the camp to be served. That meant that the Clubmobiles on which the donut machines were being used that particular day were immobilized and it required at least three machines every day to do the cooking. Naturally, it cut down the amount of work that we could do.

So beginning on the 23rd of December, we really got down to production and poured it on for Christmas. We have hired six civilian girls to do the cooking with the aid and supervision of one of our own crews. For five days we made donuts about 18 hours a day and succeeded pretty well in covering all the divisions in our area, with a Clubmobile serving for Christmas. That's all we could give them this year. There were no presents of sweaters and scarves as a special Red Cross present.

That deal of cooking 18 hours a day sounds rougher than it really was. It was all worked out in shifts and every night at least half a dozen men and officers from our own camp here volunteered to assist. They were so cute, got into such messes with the dough and looked so funny tied into our coverall aprons with tin helmets on their heads and holsters and canteens bulging grotesquely around their middles, that it was always more of a party than a job. They always came with a bottle or two of wine to fortify them—and it's a wonder that we got anything done.

One of the best episodes was when one of the men attempted to replenish the fat in the kettle. He picked up

a cup of liquid that looked like melted fat on the table, and poured it into the machine. Immediately, all hell broke loose, with everything sputtering and boiling and the sides of the machine seemed to expand and contract under the pressure. It was a cup of beer. Another time, a little scrap of soap that looked like lard went into the kettle. This time there was no sputtering, but soapsuds filled the machine like a bubble bath.

The officers had a mostly successful party on Christmas Eve which consisted mostly of drinking and lasted until 5:00. The punch was spiked with medicinal alcohol so the effects were immediate and forceful. Consequently, the party was completely underway within five minutes. New Year's Eve was another party, but small and quiet and sober.

The real shindig was the wedding we've been sweating out with Paula for two months. That long ago she and Doc became engaged, so while waiting for the 60-day interval that the Army requires marrying couples to wait, plans were made. And plans were changed. The groom was moved so far away he couldn't so much as get back to visit the prospective bride, let alone take the responsibility for handling the business and taking care of the papers. Mail delivery was so erratic that the last few days Paula wasn't even sure that the groom would be here or that he even knew when he was supposed to be here.

The girls formed themselves into little committees—one for making the appetizers, one for making the drinks and tending the bar, one for getting the apartment and food stocked for honeymooners. You have to get married twice over here—one civilian ceremony by the French, and one military ceremony by the Chaplain. The first was purely a legal bit of business, requiring the signature on certain papers. The second was performed in Eve's quarters, a two-room apartment consisting

of office and bedroom-sitting room. About 12 of us witnessed the ceremony with one of our GIs standing guard outside the door so that some goon wouldn't come in asking for donuts in the middle of the "I do's."

We forgot the telephone, though. And sure enough! The Chaplain hadn't gotten a good start before it shrilled out three long rings. We tried to ignore the interruption and the Chaplain bravely carried on though the phone was right at his elbow. An officer stepped up and disconnected the thing, and everything seemed under control until the bride's attendant, who could not contain her giggle any longer, exploded noisily.

We toasted them amply with beaucoup champagne and then went over to our recreation room where we had the gayest reception and the funniest that anyone has ever experienced. Officers and men alike were invited, with a General to top the list. It couldn't happen anywhere except at a Red Cross party because no one else would have dared to mix the men with the officers socially. Privates were cutting in on the General and vice versa; and there being such a big stag line, the girls hardly took two dancing steps with a partner before the combination was broken up.

I hope by this time your minds are all at ease about me. Can't say I blame you too much for being concerned, what with the bad news in the newspapers plus the absence of any mail from me. Just always remember that the Army is taking very good care of us and will not take any long chances where our safety is concerned. Don't know where Aunt Angie is getting her information, but from some friend of a friend of a friend … she has me sitting by the side of the road all night in the Clubmobile. We did have to camp out last August as we came across France, but she better stop imagining stuff. All the Clubmobiles get back to camp every night before black-

out—the Army requires them to. Thanks, Aunt Angie…

We all got back safely from Cannes. Took the valley road back which we thought was longer. Actually, it turned out to be a few miles shorter because of the absence of curvy mountain roads. One third of the way was completely clear of snow, but the rest of the way was worse than it had been on the way down, because of heavy snowstorms during the week we were away. Lots of it hadn't been plowed, so for 50 miles or more we crawled through the single track of bumpy, rutted snow and stuck our noses into a snowbank whenever we had to pass another vehicle. We drove straight through with about four hours rest to break the trip in order to have as much time as possible in the sunny south. So we were tired when we pulled in, but had time to recover before we had to go to work. It was a nice vacation and we none of us regret it, but I'm not interested in a repeat performance.

Artie asks again about sending me a few books. I discouraged him once before because we were moving so often and it seemed like too much additional stuff to pack and move. I've kinda changed my mind now. I would love to have a couple of good ones when he has time to pack them up. And maybe Ede would make up a box of edibles such as little fishes or shrimp with crackers to put under them. Just plain soda crackers don't travel very well. If you can find Triscuits in the stores, they seem to stand the voyage very well. Either that, or pack crackers in a tin box that can't get crushed and won't get damp.

Here at camp, a Major Moore is one of our close friends. His father used to be a newspaper man in Louisiana. So he kids me day after day about the *Chicago Tribune*, Col. R.R., the Sunday supplement, etc. Every time he reads a reference to the *Tribune* in *Time* magazine (and there's at least one crack every week), I'm in for it again. So he has composed this little verse for my benefit:

Don't give my folks the information
It will cause great consternation.
They don't know I work for the Trib.
They think I'm safe in a south side crib.
Lots of mail has caught up with me lately. But don't relax.

Love,
Angie

February 24, 1945

Dearest Family:

I've suddenly gone domestic. A couple of weeks ago our group was reduced in strength by one member, which left an empty bed and half a room. So being a straw boss, I went into operation one evening and made two other people move themselves from one room to another so I could have a room of my own. Now and then I think I should be embarrassed at having such a plush set-up when the rest of the kids are crowded two and three in a room the same size. But then I talk to myself and say what's the sense of being a BTO if you don't get something out of it.

Though housekeeping is not my first love, it was kinda fun cleaning the place up and scrounging the few bits of furniture. The room is now quite pleasant with Army blankets covering the table, the cot, the trunk and the wardrobe ... a tattle-tale gray sheet cut in half for curtains, a little table lamp, a couple of plants and the most distinctive feature of all—a tremendous mirror about 4 x5' in an ornate, gold frame hanging on one wall, with a wide, double shelf under it which acts as a bar, bookcase, mantle, what-have-you. The mirror is strictly an empirical piece and completely incongruous, but

we can't think about periods when we furnish and decorate a room over here. On another wall I have all my little family snapshots pinned up with thumb tacks. Then Doreen has painted me a picture to hang up if I ever get it framed—a picture of two beautiful, spirited, cobalt blue horses that were inspired by Elizabeth Arden's Blue Grass advertisements.

To start my life in my new room, I cooked a spaghetti dinner for four. It just happened that the mess was having roast pork loin for dinner, so I put my arms around the mess officer and came home with 4 pork chops, 2 onions, 2 cans of tomatoes, spaghetti and garlic. It was some job cooking on a one-burner electric plate. First of all, I spent all afternoon making the sauce. Then it took an hour to get the water hot to cook the spaghetti. At 6:00 I took that pot of water off and boiled up a little dehydrated French onion soup. While we drank that, we put the water back on to get hot again. And while the spaghetti was cooking, we had another drink. Naturally, when the spaghetti was done, the sauce was stone cold. But in due time we ate, and ate plenty after waiting so long and smelling good smells for that length of time, the courses interspersed with Scotch to further whet our appetites. It did taste good. Like all quantity cooking, everything in the mess has such a sameness about it. To have something cooked the way you like it was a treat.

My life in the new job is getting softer and softer. We have been here so long and everything is so well organized that the job practically works itself out. So now, Eve and I, the two chairborn, have made a deal to take care of the office on alternate days. One of us is responsible for the day with the other somewhere in the vicinity so she can be found if needed. The off days are not considered leave, but there is seldom, if ever, anything that requires the second girl on duty, so she can sleep all day, do her laundry, read or write or take a walk, or even go

out and work on a Clubmobile.

Now that Spring is beginning to make itself felt in France, I will go out Clubmobiling more and more. That is the only way you can feel the spirit of this job. We get stale as anything sitting in the house day after day. Right now there seems to be nothing at all to write in a letter. When you do nothing, there is nothing to talk about.

Going to Luxembourg today with a couple of the girls who are taking a day off. When we first got within driving range of Luxembourg, I can remember how we all strained every muscle to get there. Luxembourg sounded so romantic. It is still the only decent city to visit within our radius, but even it doesn't have much to offer because of the strain of the war. Having been there a few times, it has now become old hat. I've noticed, though, that within the last month or so, that the city is coming back to life rapidly.

There is a lot of Army strolling through the streets and the Army spends its money freely. More and more shops are opening; the display windows have something else to show besides patriotically draped pictures of the Grand Duchess, which for a long spell was all you saw in the shop windows up and down the entire street.

Did you see all the pictures of the Red Cross wedding published in *LIFE* about the end of January? The Wagstaffs saw it because they sent me a copy, and deplored with me the way it was handled. Peggy is one of our girls and one of the three who were married since the first of the year. It's a damned shame the editors didn't show a little better judgment. They had everything to work with.

The photographers followed Peggy and Johnny (who used to work for the *Tribune*) around all day and had a running account of the entire proceedings. And there were many

episodes which should have been interesting to the American public—such as the Dutch civilian ceremony with the little Dutch girls dressed in native costumes, the breaking of the plate for good luck (an old national custom), the military ceremony, etc. Why they felt obliged to make it a publicity campaign for all the newspaper correspondents by showing the backs of their heads while each and every one kissed Peggy, is more than I know. There were a lot of important people present from the point of view of the press, but *LIFE* made the whole thing look like a brawl, and I think did Peggy a dirty trick.

Best of love to you all,
Angie

March 9, 1945

Dearest Family:

I've been out on another sight-seeing trip and at last there is a little something different to write about. Why don't you write to the Red Cross and tell them to send me on more and more pleasure trips so that I can keep up the morale of the Petesches?

Milda and Doreen and I packed ourselves and our luggage in a cozy, covered Jeep (most of them are open, you know) and went on a tour of some of the towns and cities north of here. We went into four different countries, besides the one in which we live, which sounds like more of a grand tour than it really was. The distances were really quite short and we were gone only a total of four days.

The first night we spent in Spa, Belgium, a watering place of some prominence in the old days. Even the ex-Kaiser used

to have a home there. The place had been recommended to us by some friends who had found it pleasant and quiet, nice weather and good food. It sounded just like the place we were looking for and we left home expecting to spend our entire leave right in that one spot, bathing in the mineral waters and gorging on the eggs and beefsteak.

But the minute we stepped in the door to arrange for rooms, we were disappointed. Instead of its being quiet, we found the small bar room and dining room on the first floor crowded with noisy American soldiers who gave a whoop when they saw us and made such a racket and offered so much loud advice, we couldn't conduct our business with the proprietor.

With our halting French and his even less adequate English (all with gestures, of course), it would have been hard enough to get the information across. The confusion of swarming GIs wanting to buy a drink for us, wanting to know where we were from, wanting donuts, wanting us to have dinner with them ... wanting everything except to let us have a moment alone with the innkeeper, made the transaction most difficult.

We did finally make arrangements to stay, but they did have other guests there too, so our accommodations were not as advertised. One room was under the low, sloping eaves of the roof—without heat and water and afforded only a place to sleep. We discovered that sleep was not easy either, with all the cognac going to the heads of the soldiers downstairs. We did have pretty good food there, such as fresh eggs, lamb chops, fresh green salads, coffee with whipped cream, wonderful soup. But we never ate a meal alone. Teetering and boring GIs were always hovering over our table and menacing us with the ever-present possibility of their glasses of wine

and beer in our laps.

The thing that really bothered us about the whole set-up, though, was the black market that it was. We should have realized that, of course, when we were told about it. But I guess we figured that if other people could enjoy the black market, we could too. It didn't work that way. Over here it doesn't take a wise man to know that there isn't food and liquor like that, in those quantities, except on the black market. We failed to realize that when we made our plans to go. But after having a couple of meals there, we couldn't ignore it any longer.

The soft, white hands of the innkeeper, his new, fashionable clothes, the well-dressed people that drove up in cars with black market gasoline, the unlimited liquor, the elegant food that ordinary civilians haven't seen for four or five years, sickened us all and we couldn't stand it any longer. And the prices. Oooo-la-la. We knew it was expensive, but 40 francs (80¢) for a demitasse also helped us to make up our minds.

So, after a day of it, we pulled out and I'm glad we did. The rest of the trip was much more enjoyable. We had to go back under the wing of the Army for our beds and meals, but as tired as we were of Army food, that was the only decent thing to do. When you see the short rations the civilians have to get along on and realize that most of the children will never recover from the malnutrition in these first few years of their lives, you are reminded all over again how lucky you are.

Money means nothing here. The rich suffer with the poor. The food just doesn't seem to exist, or if it does, it can't be transported in sufficient quantities to the congested areas. And there the black market comes in. They seem to get the food all right and the people who could, just about had to play with them in order to live. I suppose it is inaccurate to call

some of that traffic black market. The prices of only a few food items are controlled and it is only traffic in those items that can be called an actual black market. With the rest it is just a question of supply and demand. That naturally boosts the prices up, but it can't be called illegal. That is what is so maddening. The prices of everything should be controlled by rationing, and these profiteers thrown in the clink. I get so mad. But it seems to me that France [had] better get organized. England is certainly to be complimented on the way she has handled the problem.

Our next stop was Maastricht in Holland. Maastricht is the oldest city in Holland and quite a charming little city. We saw the town, met and visited with some old Red Cross friends and again slept in an attic bedroom, again cold and unattractive, but this time, an honest bed at least.

However, the bed, honorable or not, discouraged us from wanting to spend a second night in it. So from there we drove over into Aachen, Germany, and there stayed with another one of the Red Cross Clubmobile groups, like ours. We had friends there, too. They had ample and comfortable quarters, and the fact that three guests arrived unannounced didn't cause a ripple in their lives.

This is the first time I have visited another group and it was rather fun seeing the way others live and operate. But poor Aachen. It had been quite a handsome city, and an old one. We tell ourselves it is what we want to have happen to the German cities. And I do honestly think that they should be made to feel some of the same kind of suffering they have heaped on others. But when you see destruction like that and the irreparable loss of property, [you can] only try to realize the sadness of those people who are left and who have lost everything they loved, and your heart is torn to bits.

Miles and miles of just empty shells of buildings. In the middle of it [there is] one miracle left standing. That is the old, old Charlemagne Cathedral. The original part of the structure—a simple octagonal tower—resisted it all. Everything around it was shattered, even the newer church and the Gothic wings that had been built much later, were a mass of ruins. But the little tower still stands with all its wonderful gold mosaic on the walls and dome—still intact.

It was Sunday when we drove through the city, though until we went inside the cathedral and discovered a service was being held, we hadn't realized it was Sunday ... every day being like every other day to us. Along one of the eight walls of the tower was a low platform with a simple altar, with none of the statues and tapestries and candles and brocades that Catholics ordinarily bend the knee to. On the floor of the cathedral were less than a hundred old, worn, kneeling chairs. There weren't more than two dozen people there. It was the most touching, most impressive Catholic service I have ever seen. The sermon was given in German, of course. I wanted so much to be able to understand it to know what the attitude of those people was.

The trip up and back again took us through the same territory over which the Battle of the Bulge was fought. We saw many of the towns that were so prominent in the news then. They are very interesting to see in a morbid sort of way. One town in particular distressed us, because we had seen it and known it before the bombs and artillery flattened it. We had stayed there one night, in fact, during a previous leave. I'm sure I told you about the nice family who took us in and their fine horses that they proudly showed us. The shell of the house was there with great, gaping wounds in the walls, all the windows blown out with torn scraps of curtains and

draperies hanging over the window frames, the iron fence around the property a writhing mass, and a little company of black GIs living in the remains of the stables that had been perforated with bullet holes and burned by the flame-throwers.

I'm sure that the people and their stock were removed to safety. They had plenty of warning and the MPs we talked to said that the civilians had been evacuated. Of course, no one had any specific information about the family. But we do know that they had other property and were people of some wealth, so they are doubtless much better off than most of the others.

The war news is so exciting now with everything driving forward at a great rate. We now call our little office the "War Room" because we have the wall plastered with maps and one of the boys comes over every evening to bring the situations up to date, scratching in the new advances with his green crayon. "War Room" is a better name than you know for that office of ours. More arguments and discussions take place in that room as we fight the war from our blanket-covered trunks strung around the room to take the place of chairs. Here, too, we settle a few little private battles.

Saw another plane shot down the other night. An ack-ack unit is stationed close by. They haven't had much to do lately, so when we heard their guns start firing this night, we all rushed outside or turned off our lights and hung out the windows. Suddenly we saw the reflection in the sky—a direct hit. The sky was overcast that night so that we couldn't see the plane itself, but we got a broad glow of light diffused through the clouds. Eventually, the plane dropped below the clouds and we could watch it twist and spin to the ground where it exploded in another great burst of flame. Our little courtyard

was alive with people by this time, screaming and cheering our compliments to our gun crew as if it were a football game.

Happy birthday to Aunt Angie, and love from

A

March 21, 1945

Dearest Family:

I neglected to tell you one of the most important episodes of our recent trip to Holland. We considered the experience quite worth the whole journey, and something in which you would be interested in hearing about too.

Near an old Dutch city are miles and miles of limestone caves. During the occupation of a section up there by the American paratroopers, these tunnels were used as an escape and a hiding place by the Americans. But the thing that interested us was the fact that in a portion of the caves, the Dutch have hidden a great number of valuable paintings removed from metropolitan galleries to this underground vault to protect them from destruction and theft. During the German occupation, the hiding place was a secret. Now the news of where they are hidden is no longer withheld, but it still is not generally known.

Because of this we had some trouble in getting in touch with the right people and those who had authority to give us permission to pay a visit to these old Dutch masters. Doreen, as I think I have explained before, is professionally interested in art, having been on the staff of the National Gallery. It all meant more to her than anyone else and consequently, she was more than willing to take the time and trouble it required to snoop out the right people.

She spent half a day doing it, as a matter of fact, going from Civilian Affairs to the Army to the Red Cross and back again, until finally she got in touch with the gentleman in whose care the pictures had been left and who had the authority to take us on a tour. Generally, his habit is to refuse all requests. We were told that even Generals had been denied the privilege of seeing the paintings. We can now understand why. The room is so crowded that not more than three guests can be shown through at one time, and at that rate the poor man would wear himself to a nub if access to the place were made easily available. But Doreen being a girl and being Red Cross and a professional won with one hand in her pocket; not only the old gentleman, but his wife too, went out with us to show us his precious works of art. They couldn't have been more cordial or more hospitable. Doreen made an appointment with them for 10:30 the following morning.

The caves are a little bit out of the city. We all rode out there in our little Jeep. Then they led us through tall iron gates and thick steel doors into long vaulted tunnels until we came to a smaller adjoining cave that had been walled like any other room, and provided with automatic heat and humidity control in order to house the paintings under the most ideal conditions. That, I think, was another reason for his not being too agreeable to showing a lot of people through the exhibit—at least it was one of his excuses. Lots of people coming in and out of the room would have upset those ideal conditions and destroyed the perfect temperature and humidity.

In this L-shaped room about 20 feet in each direction the pictures were hung on a series of sliding wire doors—hinged doors that reminded me of a mammoth bookkeeping records system. The doors must have been about 10 feet square with every inch of them covered—some of the pictures even hung

sidewise in order to utilize the space as economically as possible. The watchman carried a large floodlight and reflector on a long extension cord to light the pictures for us to see, and so we went over them, folding back the doors one after the other, until we had viewed them all. Our host enjoyed the visit, too, because he loves his pictures, though art was not his profession; he was proud of having them in his charge and of the way they had been taken care of. He had been in the Diplomatic Corps in his younger days and he and his family had lived for years in the Dutch Indies and in Malaya.

It was not the ideal way to enjoy art; the pictures hung as they were, crowded together, insufficient lighting, and having to stand right on top of them to see them. But it was certainly a treat to see them under these conditions and we were plenty excited about the visit.

General Patton and his Third Army are really on the warpath again, and before very long we are going to have to start chasing after them. We've been left so far behind we can't reach our men any more. If things keep up, it will be another rat race like it was across France, with one night stands and never enough time to set up operations. Maybe we won't be able to make another donut ... Hallelujah!

We're all very eager to move in spite of how comfortable we have made ourselves in these rooms during the last few months. It will be good for our morale to get on the road again. But such roads! Between the shelling and the bombing they have undergone, and the normal cracking up that comes with the Spring thaw, they are in terrible condition. The girls find it terribly tiring to ride over the bumpy roads all day in those clumsy trucks. In fact, a couple of girls (not of our group) have had to be hospitalized because their insides have become all screwed up and displaced because of the terrific jolting.

The quicker the Army moves, of course, the better the con-

ditions are that they leave behind them. In these towns that have been made such strongholds and have required house-to-house fighting, there is nothing left. No water, no gas, no electricity, no houses. But in the section where the Germans have been surprised and have been cleared out quickly, there are usually good accommodations to be found because they haven't had a chance to shoot them up.

This may reach Daddy in time to wish him a happy birthday. But even if it gets there late, he'll know I remembered him. Are you 100 years old yet, Daddy?

Love to all,
Angie

March 29, 1945

Somewhere in Germany

Dearest Family:

Notice the dateline and that will give you an introduction to the subject matter of this letter. A week or so before we got orders to be ready to take off, all of our particular troops had gotten so far ahead of us there was almost nothing left for us to do. Headquarters of the rear echelon were left sitting behind for what seemed to be an interminable time. In fact, all the SOS troops and general hospitals had caught up with us, putting us in what we call Com Z, and we were getting pretty sensitive about not being front liners anymore.

Toward the end of our stay, we just stopped operations and took about three days to get packed up and dismantle the donut kitchen. It took three days, too, because having been in one spot for four months, everything, just *everything*, had been unpacked. But moving orders didn't come. So we

sat some more, lolling in the bright sun and feeling completely useless.

The time off was good for the girls, I'm sure, in spite of their restlessness. All other Clubmobile groups up and down the line had moved ahead long before we did, and it was pretty galling. We felt like we were back at the beaches. Then suddenly, a little sheet of paper was delivered to our office which said we would move in the morning in three separate sections, each section with not more than six vehicles. If a section is any larger than that, it is called a convoy and then you have to get a special permit. So we "infiltrated" into Germany.

No matter how much time you have to get ready to move, it is always a scramble at the last minute. There are so many things that can't be done until just before the take-off, such as getting our bedding rolls, cots and personal stuff on the trucks, hitching on the 12 trailers, and policing the area. But there were a couple of additional tragedies to add to the general confusion—a flat tire discovered just as one of our sections was ready to pull out the gate, and one truck the boys had forgotten to fill with gasoline. Those poor, dear boys of ours. How they worked those last few days. Our vehicles are getting in pretty bad shape anyway, from traveling on these bad roads.

The rest of headquarters moved with the help of about 80 men, two per vehicle. Our poor five GIs moved us and our 18 vehicles besides, and had to do a lot of personal stuff for us in the way of loading trunks and barracks bags that are too heavy and clumsy for us. We were so proud of them. We finally got off by switching a few trucks from one section to another so that tires could be changed, though the last two sections were delayed in starting by about half an hour. Eve led the first section, Betty Holmes the second, and I the third. Each section had two MPs riding with us as guards. And ours, the last to leave, was the first to arrive. The first one took a wrong

turning and everybody behind them (including a lot of Army vehicles) blithely followed, only to find themselves going in the wrong direction.

It was a long trip we had, but not nearly as tiring as it was reported to us. For one thing, it had rained the night before so there was none of the choking dust that is so exhausting. We all made the trip without a hitch except for one flat tire in the entire group. But it was a strange trip. The difference in the attitude of the people was so noticeable. There were no incidents, and we all realized there would be none of the jubilation and flag-waving, but experiencing it was something new. On the way we met truckload after truckload of German prisoners being transported to the rear. A few civilians stood along the road and waved to their men. But it was a weak demonstration and sad. The prisoners didn't even bother to wave back.

I don't believe the civilians here are particularly dangerous, but the Army regulations are terribly strict at all times on curfew and fraternization and going out with an armed guard. My feeling is that they are so relieved that the war is over for them, that even though they are on the short end of the stick, they are not interested in doing anything to create additional trouble. Of course, you can't tell when some fanatic might make a futile effort to do his bit and possibly some damage; the Army is right to take every precaution to avoid such.

On the first half of the trip the cities were pretty well damaged—one in particular was a mess. That was one in which they were fighting back and forth for weeks, house-to-house. The boys used to talk about that battle. There was a big brewery in the town. One day the Americans would have it, the next day the Germans. Everything else in the town was flattened to the ground, but the brewery was allowed to remain

standing. And you know why. [In] this particular section here, where the battle moved so fast and everybody was on the run, there wasn't time to blow everything to the skies with bombs, artillery, grenades, booby traps and the like.

We arrived at our destination about 6:00 and started unloading. The building reserved for us was a big old three-story affair, messy and unattractive. But all buildings of its kind look unattractive at first sight, and in the half light of evening. We were all tired and a little disappointed in the set-up, and you never heard such complaining and bitching. Women can certainly make a racket when they want to.

About all we had time to do was take our cots and bedding rolls off the trucks before dark. This we did and staked a little claim in the corner of any room we could find. There were no lights, of course, and that added to the ill-feeling. Our five boys didn't have any place to sleep. Working for us as they do, puts them in a slightly different category from the other enlisted men in the company, and they had been forgotten when the advance party figured on the quarters. So we crowded ourselves together a little more and made a room available for them. It wasn't long before they had the coffee pot out and when we finally got the dirt off our faces, things began to look a little brighter. We made ourselves realize we weren't on a luxury tour. The rooms really could have been made quite livable if we had stayed long enough to work on them, but in the morning the company commander came around to tell us he didn't approve of our billets, so we should not unpack any further, and something else would be found for us to move into in the afternoon. Eve and I went with him to look at property.

I hope I never have to do that again. There was a nice looking apartment house up the street. The plan was to inspect it and if it were found to be large enough and satisfactory

enough for our peculiar requirements, the Army would take it over and the people who lived in it would have to evacuate. I could see in their eyes they knew why we had come, and they were worried and frightened, though they graciously showed us the rooms.

No matter how much people talk about giving the same treatment back to the Germans that they have forced on others, no matter how many displaced Poles, Russians, French, Dutch or any others you see walking along the roads with no place to go, no matter how big a chump they think the Americans are for their softness and humaneness, no matter how uncomfortable my own living conditions are, I can't look at such business objectively enough to be able to go through with it. It is part of war, and there is nothing humane about war—and the argument that the Army comes first and civilians second, or that the next Army group following us will take it over if we don't, I know is true.

But if there is any evacuating to be done, they better not ask me to help do it, because I'm too chicken-hearted. I don't know when I've felt like such a worm standing over those people—old women and little children—with a big ax about to fall. The Army will have to evacuate them first and not tell me about it. Which makes me a very weak character, I guess.

Eve and I both came back to the office miserable as a pair of whipped pups. It was our decision to make and the Captain who accompanied us was just waiting for us to say the word so that he could go through the formalities of giving the people two hours to get out. If it had been for our own comfort alone, I know neither Eve nor I could have even considered putting through the order. But there were 30 dissatisfied females breathing down our necks,

all with fancy sounding arguments, though I don't know whether they could have been so strong if they had had to do the job.

Fortunately for us, before we had given the sign to the Captain, a representative from the General's office came to tell us there was a beautiful country estate waiting for us that had been requisitioned for the General himself, but which he had changed his mind about in favor of something better. These people had already been given their orders and knew they would be expected to move. Besides that, they seemed to be real Nazi material because the husband had been a big chemical manufacturer and had received commendations signed by Herr Hitler himself. So with my ostrich philosophy I didn't feel any qualms whatever about crowding their household of 30 people into the tennis house and the top of the garage so our 30 Red Crossers could enjoy the luxury of a beautiful country estate with all the trimmings. The mistress of the house conducted some kind of school for small girls. They, together with all the servants and gardeners, made up their family.

So, for the present, we are really living in the lap of luxury. The house has 20 real beds in it which is quite a house, as you can see. There are 10 poor unfortunates who still have to sleep on Army cots. There are three bathrooms. The house is beautifully equipped with a furnace and hot water and electricity (when the power is on), an electric refrigerator, washing machine, and a dumb waiter. There is only one problem and that is the kitchen. There is no gas in the village to operate the cooking stove. So the meals for our big family, enlarged by four maids, four MPs and beaucoup guests, have to be prepared on a one-burner coal stove which we have since augmented with one field range.

The maids and the MPs live in the basement rooms. Six

girls are bedded down on the first floor, the rest upstairs. But on the first floor, in addition to two large sleeping rooms, are a large sun parlor, billiard and ping-pong room, library, music room with a grand and an upright piano, tremendous dining room and butler's pantry. Also a little powder room.

The house is set on the side of a steep hill, thickly wooded and far away from everything. The trees are just now starting to bud and the flowering trees are showing little specks of color from which the blossoms will burst in a few days. Shady paths wind up and down the hill. A fine clay tennis court adjoins the house. We have set up our own mess with two of the French maids we brought with us, to do the cooking. What a difference it makes from Army rations to have them prepare a la French cuisine. Even on the one-burner these girls perform culinary miracles. Today we hired a house cleaner and a laundress. So the Krauts are doing all right by your little Nell whether they know it or like it. The General says he will find us equally good billets from now on. Of course, he can't always be held to such a promise, but you can bet that if there is a good spot in the vicinity of our next move, he will see that we get it. We invited the General to dinner last night in spite of the emotional strain that is put on the maids each afternoon, rassling with the coal stove. There's an air of suspense around the house every day while we all conjecture whether they will be able to produce a meal at all, whether the dinner gong will sound before 9:00, or whether the maids with their volatile French tempers will just quit in the middle of operations and prefer to return to their mangy little village where we found them, with a manure pile in front of every house. "Due to the tactical situation" the General couldn't accept the invitation, but he hoped there would be an opportunity later on.

This is the first time we have tried to live quite independently from the Army. Except for the first few weeks when we were traveling all day and camping at night, we have always relied on them for messing facilities. So setting up our own kitchen raises a new problem for us every day. But with each day's practice, things should begin to run a little more smoothly and eventually the tearful demonstrations Marie and Simone staged yesterday will not be provoked.

I mentioned prisoners a few pages back. Thousands of them have been taken, as you know. But some of our kids in a Clubmobile came upon an accident which happened to one truckload that ought to be put in the movies. The prisoners are packed so tight in these trucks they can hardly breathe, and those in the middle couldn't blow their noses if they wanted to. They stack 100 in an ordinary 2½ ton truck that normally carries about 25 American soldiers. When you see them coming down the road you wonder what prevents the side boards from blowing into splinters under the pressure. The sides actually bulge.

The accident I'm talking about was one of such a nature. The truck had to go around a little corner and cross a bridge. The additional weight as the truck leaned to one side making the curve did snap the side boards, so that just as the truck got on the bridge, all the Krauts fell in the river. The girls came upon the scene just as the guards were rounding them all up again, pulling them out of the drink, calling for medics for a few that were laid out cold on the river bank. There they all stood, a cluster of wet, shivering Germans, waiting under the point of a gun for the party to get reorganized so they could continue on their way.

This ought to be enough letter to hold you for a while. It's been a treat to have something new to write about.

A special message to Daddy—I got the Valentines about

the 25th of March, too late to do anything with them this year. And hoping I wouldn't be here another 11 months to see the celebration of another Valentine's Day, I gave them to a little French girl who gave me a big, toothless smile when she saw them and has had her nose plastered up against my window ever since.

Best love to all,
It can't be long now ...
Angie

CHAPTER VII

Going Home

y early 1945, Nazi Germany was crumbling against the Allied advance and Red Cross Clubmobiles were hot on their heels. Clubmobile workers saw the devastation of war first hand—in the eyes of the men they served and in the countryside they traveled. During Clubmobile Group H's trek across France and Germany, the Donut Dollies shared the joy of liberating war-ravaged towns, passed by the battering of German collaborators by townspeople, and witnessed the horrific aftermath of the Third Reich's war and holocaust machine. Angela Petesch visited a place where much of that horror began, German leader Adolph Hitler's retreat, the Eagle's Nest.

The Clubmobile journey did not end when the war did on May 8, 1945. Most Clubmobilers continued to serve up donuts and coffee to troops heading home, well into summer of 1945.

~ *Letters* ~

April 16, 1945

GERMANY

Dearest Family:

Twice more we have moved—big jumps both of them—farther into Germany. Here we expect to stay for a few days and have set up our kitchen. But already everything has moved ahead of us so far and is still moving so fast, there isn't much we can do. It is so much like the trip across France last Fall when our General Patton broke out and made history by covering 600 miles in 30 days. Now he's doing it again, and we expect to shake hands with the Russians any day now.

The war has been moving so fast it makes you wonder where the catch is, and if there isn't some surprise they're going to spring. It is true, of course, that the Germans don't want the Russians to get in if they can help it, so they have doubtless placed most of their strength on the Eastern front. And right they are. We're so darned polite to them.

For instance, the civilians are verboten to ride or walk on the streets in our bivouac area, so MPs are stationed at the corners to enforce the rule. The darned civilians read the signs and keep right on walking until the MP sees them. Then he hollers at them or swears a little in English to chase the people around the block. The Russians would probably take a shot at them and not be bothered with the hand-waving. The German civilians have no fear of us whatsoever—I wish there were some way of making them feel some of that fear. Though I admit I don't want that at the expense of making our men killers and transforming them into hard, tough characters for the rest of their lives.

It is strange to be sitting in Germany—in the middle of a

conquered country. Terribly strange. I have to keep remind-
ing myself of where I am, because except for the large cit-
ies where you really see the damage of bombs and artillery,
Germany doesn't look as conquered as France or Belgium.
The country villages are all intact, the fields are being culti-
vated in a normal sort of fashion, the countryside is beautiful,
the people are quite well-dressed and look much better fed
that those of France. Of course they occupied these other
countries for so long and robbed them of food and supplies for
their own benefit, it is natural they should look better off.

We are in a real Nazi city now and for the first time I'm
beginning to have a real feeling of hatred and antagonism for
the German people as a whole. You can feel it in the air. The
stories that have come back to us from the men who have
visited the concentration camp nearby, where so many atroci-
ties were committed, have done much to stir us up in all our
Army papers and probably yours, too.

Hundreds of bodies of slave laborers were discovered
there, the bodies of three American airmen included—some
burned, some starved, all emaciated, stacked up like cord-
wood. The German mayor or burgomeister and his wife were
taken by force out to see the place after the Americans took
over the area. They went home and hung themselves that
night—whether from shame and remorse that they belonged
to such a murderous race, or from fear that we might do the
same to them, I don't know. Thousands of American soldiers
have been taken to see it as a kind of exhibit A to help teach
them to hate and fight.

Our girls have wanted to go too—one of those morbid
things that attracts and fascinates even though it's revolting
and sickening. But our Army bosses won't let us go. The
refusal of permission made our girls awfully mad and they

couldn't see that the restriction was intended as a compliment to us as women. The Army felt, and rightly so, that it would be unbecoming for us to view a stack of starved, nude male bodies. While at first I thought I wanted to go too, now I'm glad they wouldn't let us—and pleased that our men thought that much of us. It is just little things like that that set us apart from the rest of the world and make me glad I'm an American. Maybe we aren't very good warriors, but we're certainly a better people.

We lived in our beautiful Nazi chateau (schloss it would be called here, I guess) for about two weeks and had a wonderful time resting and playing and enjoying the comforts of home. There was a lot of entertaining, with guests for dinner every night to partake of our French cuisine. It gave us an opportunity to return a lot of obligations we owed to our friends in the Army who have done and continue to do favors for us. It was a wonderful set-up, but when the orders came to move, everybody was happy and ready to hit the road again. We were more or less imprisoned there, as we will be wherever we happen to be housed in Germany.

No trips anywhere except on official business and then only with armed guards. After the freedom we had in France and England, traipsing all over the place by ourselves, it is hard to discipline ourselves to this new restraint. Being cooped up in our Schloss, even though it was a beautiful, comfortable and spacious place, finally got on everybody's nerves. We had been doing nothing long enough and the feeling of restlessness that the war gives to everybody was getting a strangle-hold on us. We heard no complaints about having to pack and move out, though we all knew we would probably never be so comfortable again.

So we got up at 5:30 one morning and took a big, long hop and found ourselves billeted in what was formerly an orphan-

age. It was comfortable, though. Small rooms rather than dormitories that the word orphanage usually connotes, lots of furniture around, beds, indoor plumbing and hot water. No electricity, however, which is the case in practically every stop in Germany, but our generator took care of that. We slept hard that night after 10 hours on the road. So hard that it took at least 15 minutes for Eve to realize the buzzing in her mind was the telephone ringing when the Company Commander called at 12:00 that night to say we were moving again the next morning at 7:00.

Up again at 5:30. But because of the long trip the day before, the Red Cross didn't have enough gas to put their whole convoy on the road. So we stole the gas from some of our vehicles to about fill the first six trucks, and Eve took off with that section on schedule. The rest of us stayed behind to wait for the gas truck, which had to go 50 miles back in the direction from which we had just come. They didn't return until 2:00 in the afternoon. In the meantime, we had to send our boys out to scrounge what they could from neighboring units, but they didn't find enough, so we had to wait it out. We left just as soon as we could get the gas poured into the 12 tanks, and covered the 70 miles in 2½ hours.

One of the supply officers was riding with me in the lead vehicle … he had stayed behind with us to act as escort. It was the first time he had witnessed a Red Cross convoy and he was SO impressed. He kept looking back and then would report to me that they were all right after me, right in line, and what killed him, he said, they were keeping that 60-yard interval. It made me very happy for him to say it was the best convoy he had ever seen, even though all of it was purely accidental—the girls not conscious of the convoy regulations, but just driving and keeping up and having a good time waving

at everybody along the road as they buzzed by. The Red Cross does a pretty good morale job just riding along the roads, you know. All the American men recognize our vehicles, of course, and when they see us coming you can see them wake up and a big smile lights their faces as they return our greeting with a big, foolish salute and a wisecrack to go with it.

Here, we are living in three separate houses, which is both good and bad. It is a treat to most of us to get away from the big family idea, with only 10 to a house. The disadvantages are getting messages relayed to everybody since there is only one telephone ... giving assignments and giving instructions. It is not so simple as running upstairs. Now we have to run from one house to another looking for people. Eve left today by plane for a week's leave in England, which means I'm left with the family.

A few hours intervened between this and the last page. In the meantime, five Clubmobiles were requested to go out on detached service for several days, and now I find myself completely alone in our house except for our boys who live in the basement. While the girls are gone, the boys are [for those days] going to occupy the second floor and sleep in real beds for a change; I will have the first floor.

I have just been up to see them getting settled. There is a nice bathroom upstairs, but no hot water. So they have rigged up two hot plates and one gasoline portable stove with a pail of water on each—there is going to be at least one good bath for them, if not more. Those boys of ours are really wonderful. They keep collecting stuff no one else can see any value to. But weeks, maybe even months later, some ingenious contraption evolves and everyone else wonders why they were so dumb and didn't think of it. Most of the devices are strictly [Rube] Goldberg, but they work in a clumsy sort of way and do the simple job expected of them, though the mechanism may

be complicated. Jack especially is wired for sound. He carries hundreds of useless-looking gadgets with him and every day more are added to the collection.

This letter has been going on for too many days now. I'll send this much off to get it in motion and carry on another day.

Love,
Angie

Dearest Family:

Every letter starts off nowadays with "moved again." This was another long hop of about 180 miles. And it is a plenty tiring day to get up at 4:30, breakfast between 5 and 5:30, complete the packing, hit the road at 7:00 and arrive at your destination about 6:00. But having arrived, your day is not through. Because then you start unpacking and shoveling out your new quarters so you can go to bed.

Our convoy this time was a terrible mess. Everybody got separated from everybody else at one time or another, because of all the traffic on the road; so with all the Army's planning to give us plenty of MPs and male escorts, there were times when one vehicle would discover itself belting down the road all alone, having lost the car in front, and outdistanced the one behind. At rest periods or stops for lunch, little groups would rejoin each other along the roadside. But then flat tires or some other minor breakdown would necessitate their falling out again. We've been doing plenty of traveling lately. Since our jump-off into Germany we have come just as many miles and in just as short a time, as the other famous Patton march across France. Still we are behind—way behind—our

fighting men, which leaves us again without much to do.

This time we are living just on the outskirts of town in a large Army garrison. The outlook is dull and stultifying, but in Germany I prefer that to living right in a city with the civilians you are not sure you can trust, who are wandering about. Cities vary in that respect, however. We have been in some where there was a definite atmosphere of unfriendliness and in some others I have not felt it at all. But I definitely feel more comfortable when we have a little area of our own such as this where no one is allowed within the gates without an examination of his papers and questioned about his business, even though it is a kind of imprisonment for us.

With each new move we find a new housing problem. Back at Thionville, we lived in a kind of barracks with barely enough room to provide sleeping rooms for our girls and no place at all for them to entertain their guests. Then we got a great big house with lovely living rooms where everybody entertained together—GIs and officers alike. Now each crew has a little apartment for themselves with kitchens where they can cook their own meals and snacks if they want to. Now each crew entertains in their own sitting room and sometimes we don't see each other for days.

Eve and I are rooming together in what is now a very attractive apartment. We have scrounged furniture out of the basements, made bedspreads and curtains out of blue and white tablecloths. We take turns in getting up in the mornings so on alternate mornings Marie, our French housekeeper, brings me breakfast in bed. It's a tough war I'm fightin' right now. Breakfast in bed, no work to speak of, and a nice Captain to entertain me in the evening.

I sat in on a Court Martial trial the other day. The case wasn't particularly interesting, though I had thought from the advance rumors that it might be, because it was a murder

case. A little colored guy from a Quartermaster outfit shot and killed another man in his company because he accused him of stealing his wallet and cheating at cards. It was a gruesome enough thing, but the guy told everybody he knew immediately after the shooting and admitted to the Court as well, that he had done the shooting, so there wasn't much of an argument. It was a riot to listen to those … witnesses, though. "There was C.P., lying in a pool of blood with a can of hamburger under his arm." I shouldn't laugh because the accused got the death penalty. … The military court is a pretty harsh proposition. It is probably as fair a trial as you'd get anywhere. But the sentences are so terrific when you consider what people get away with in a civil court. Refusal to obey an order is death. But the men argue that it is just, since refusal to obey an order may cost the lives of hundreds of men. At home if you refuse to obey, you lose your job—maybe.

We have a Lieutenant friend in an Ordinance Collecting point who has the following slogan, which I think is one of the best in the Army … "Shoot the bull, pass the buck and make nine copies of everything."

One day later.

I'm now working on a liberated German typewriter on which the "y" and "z" are interchanged on the keyboard. So if a crazy spelling or an umlaut creeps in, ignore it or spit on it, shoot it full of holes, or follow whatever impulse you have been saving for the Germans.

The Germans, by the way, suffered a heavy blow last night with the announcement of Hitler's death. Marie, the maid, came bouncing in this morning singing loudly and gleefully, "Hitler iss kaput, Hitler iss kaput." So we all joined in the chorus. So far there hasn't been any additional news as to

what happened, so we are all conjecturing as to whether it was a natural death, suicide, assassination, or whether he's been dead for months and they are just getting around to tell the Germans. Whatever the cause, it was good enough reason to celebrate mildly and get in condition for the real bender everybody has promised himself when we get the news of final victory. Hitler's death has not brought about any cessation of hostilities, but personally I'm expecting it any day. They just can't hold out much longer—there is so little for them to hold now.

Then after it is all over I'm going to see if I can come home. The Red Cross hasn't, up to now, stated any policy on their plans after the armistice for their overseas personnel. Though they did put out a feeler not so long ago and asked each of us to state our own personal preference as to whether we wanted to stay with the Army of occupation, go to the CBI (*China, Burma, India theater of Operations*) or go home on a 30-day furlough and be reassigned, or just go home.

There will be plenty of work to do here after the war is over, probably more important and more necessary work than the Red Cross is doing now, and they'll need plenty of people to do it. If they allow those who want to go home, they'll have to get plenty of replacements. But I feel that those who have been here two years and more have a pretty good chance of being considered. And that includes me. It won't be too soon, so don't start meeting the next boat. It will take them a long time to reorganize and set up their machinery.

I'm not interested in coming [home] until this little fight is over here, but after that I'll start operating on Paris headquarters. Besides wanting to come home just to come home, I feel I've outlived my usefulness over here. All the girls who have been here two years and more are pretty much fed up with the job and seem to have lost the spark. And when the girls are tired and unenthusiastic, they aren't much good as morale

boosters. I'll probably get fidgety at home after two weeks, but I'll take my chances on that.

Got a package of lovely edibles from Mrs. Adair and another from the Wagstaffs—all in the same week. So the cupboard is no longer bare. I do thank everybody very much. I have lost Mrs. Adair's address, so, String, if I address her letter to you, will you please forward it for me.

In the next few days I'll be sending a big box of stuff home that I have accumulated in the past few months and have gotten tired of lugging from place to place … just little mementos from here and there and nothing very valuable. Open it up, Ede, and if there is anything you want to use, do so.

Love to all,
A

May 16, 1945

Dearest Family:

My third ETO birthday. I'm beginning to feel like a furriner.

The war is over and Hitler is kaput. It was a strange feeling we all had on VE Day. I think it was the same generally all over the American camps. We had all promised ourselves a big celebration, but nobody worked up the necessary enthusiasm, though we all felt as if we should be jumping off the rooftops. One officer threw out three little puny streamers of confetti from his balcony window, everybody had a couple of drinks, and that was as much demonstration as I saw in our quarters. I think that the reason was that we all knew and had known for days and weeks that it couldn't be long. In fact, we did know the papers had been signed some days before it was

officially proclaimed. There was no surprise element involved and we had been toasting the occasion for some days. When it came, it was more with a sense of relief than one of great jubilation ... by the men in the Army. Besides that, they all knew the war wasn't really over and that there is another long, difficult campaign ahead for most of them.

Visited Nuremberg the other day. It is flattened except for the great Hitler stadium which received little damage. This continental tour that I'm getting is certainly giving me a warped idea of the beauties and culture of Europe. Except for the natural beauty and charm of the countryside, all we see is rubble and filth, and all we hear about are the atrocities. By the way, all the atrocity stories you are reading about in newspapers and magazines are true. And probably more horrible than any reporter is able to convey to his reading public by the use of a typewriter—all the correspondents say that. There aren't words to tell other people and make them understand. It has to be seen and smelt to get the full horror of it.

How could they have found so many sadistic people to operate these awful places? We were told a story the other day about the wife of one of these camp commanders, a sadist herself, who had her house full of lampshades made from human skin with a scalloped border of fingernails and a human bone for the standard of the lamp. She particularly liked tattooed skin, so any prisoner who happened to have his chest decorated had priority in the slaughter pens.

Earlier in the war I used to scoff at these hints of atrocities and not believe them because they sounded more like a carry-over from the last war that the little boys remembered from their fathers' telling about when they returned from France and Belgium. They were bedtime stories compared to the facts that have been revealed in this war. Now I'll believe anything. I haven't seen any of these concentration camps per-

sonally. I think that's good, because the men who have been fighting and killing for the last few years came home green and shuddering and hating.

Our Clubmobile group is rather split up right now. The eight Clubmobiles with their crews and Eve to boss the job are about 150 miles ahead of us, so that they are in closer contact with the troops. I, with our GIs and five girls, stayed behind to operate the kitchens. All we do is try to keep up production and send the supplies up forward every other day. It's a little lonesome and plenty boring, but it will be only about another week and we will all be together again.

I'm trying now to get four or five extra helpers—Germans, Poles, Russians or Czechs. Then all the girls will be sent out and the American girls won't have to be wasted on the drudgery of making the damn donuts. We have three new girls to replace several of our old members who have gone home on medical discharge. They are attractive, popular and a great addition, except that they don't like to work. Two of them are fluffy little blondes who have been taken care of all their lives by someone else, and they don't aim to have it any other way. Consequently, I think they hate being here and the messy cooking job I've had to give them.

A couple of days have gone by. I can't ever seem to get a letter done at one sitting. In that interim I have had a little side trip to Pilsen. A couple of girls from another group who were returning from leave, descended upon us looking for transportation back to their unit. And since I had been crazy to get a look-see at Czechoslovakia, I magnanimously offered to take them home. We piled the car full of people, including one GI as the armed guard, and spent the afternoon and evening riding through the country in an open command car like real tourists.

In general, it was an unspectacular trip—I was expecting much more. But in fact, we had seen much more beautiful country in parts of Germany that we had gone through. The city of Pilsen, at least what we saw of it, is drab and provincial. The Pilseners, however, were having a celebration and they were all out on the streets and along the roads welcoming a column of Czech soldiers who were coming into the city. So again we got in on the celebration and waved ourselves into a frenzy. In the town square, the Russian generals were pinning medals on soldiers of one of the American divisions. It was just like France all over again, and it certainly did feel good to have somebody glad to see you again after our month or two of non-fraternization in Germany, when we couldn't so much as smile or wave at the little German children.

So now I have added Germany, Czechsolovakia and a little corner of Austria to my Cook's tour. And I have seen the beautiful, blue Danube.

Speaking of the Danube reminds me of a near tragedy we had in our group. Three of the girls went boating on the Inn River with three officers. It is a very swift, treacherous river. When they got out, they couldn't get back and broke four oars trying to pull against the current. So they started drifting downstream, completely helpless, until they approached a pontoon bridge which they figured would stop them. They were traveling so fast, though, the impact with the bridge threw them all out of the boat. The current was so swift it dragged all six of them and the boat under the pontoons.

A couple of the kids got hung up on the cables under the bridge, but eventually all six came out on the other side. Three were able to grab onto the wreckage of the boat; they kept swirling downstream over bombed-out bridges and twisted steel girders on which they might have been impaled. Those three were finally rescued about eight miles from where the

accident happened. The other three were clinging to the cable of the bridge, being bounced up and down by the rushing water. All that happened to them was the exhaustion you would naturally expect, and a few bruises.

Best of love to you all.
Angie

June 2, 1945

Dearest Family:

The censorship regulations are, for the most part, lifted. Now it can be told. But I am so in the habit of schooling myself against saying some things at all, or saying them in some vague, round-about manner, that now when I suddenly open up and announce I am in Reid, Austria, I feel slightly guilty.

I think you know pretty well my itinerary across Germany. It was in Thionville, France, we stayed for such a long time while the battles of Metz and the Bulge were going on. Then when we started moving into Germany, the Armies didn't meet all the resistance they expected, so we moved often and great distances … first to Kircheim-Bolanden, where we lived in the big, fancy chateau belonging to the high-ranking Nazi who was a chemical manufacturer.

From there we went to Furstenhagen, a little tiny town that holds no memory at all, except that when we arrived we were told not to unpack or unload because we were moving again in the morning. Next day we jumped to Gotha. It was there I began to notice the feeling of antagonism in the air.

From Gotha we moved to Amberg into a large German garrison just outside of town. There we were housed most comfortably and happy because we had little apartments and

led more or less separated lives for a change, instead of one big family. Now we are in Reid, a place without much personality of any kind except that it is near the lake district and the Austrian Alps, with the beauties of Austria within easy range. We have one more move to make to our final occupation area, and then when I have seen that and the country around it, I'll start making plans to come home.

There is one thing I want to do before leaving for America and that is to see a little bit of Switzerland. As yet, the border isn't open, but I've been hoping that it may be before I part, so I have been saving my leave which is long past due for just such an opportunity. Four of our girls have already left for home, but they are the married ones whose husbands were going too.

The most interesting trip I've had since arriving in this neighborhood was a ride down to Berchtesgaden and Ober-Salzberg. We drove around the city of Salzberg on the way down and looked the place over. It has been damaged somewhat by bombs and artillery, though not nearly so much as other larger and more important industrial German cities. But it isn't ruined and will be cleaned up and restored before too long. It is a lovely place—a fashionable looking city with broad avenues and fine, attractive buildings, whereas most of the other cities of similar size that I have seen have been so provincial and quite lacking in any charm or beauty. Salzberg sits in a lush, green valley on a river with soft, friendly, little mountains covered with the plush of untrampled, grassy fields and pastures and small pine forests. All the hills around that part of the country are dotted with these sweet little chalets.

I like the way these Austrians live. They pick out a nice site on a mountain or near a river, build their little houses with wooden or wrought iron balconies at the upper windows, far away from the highways, without roads or visible signs of

approach. There they sit, nestled in the green and natural beauties of the country, surround them without benefit of landscaping or gardening or other "improvements." The whole country seems to be occupied on that plan, or rather lack of plan, with the little white plaster houses scattered over the landscape, shining in the sun.

At Ober-Salzberg, Hitler had built for himself quite a settlement. Besides the private homes for himself, Goering and Bormann (who was he, by the way?) ... there was a hotel, guest houses, a couple of cafes, barracks, SS headquarters, a nursery, and so on. Every building was pretty well shot up. Our bombers are really plenty good at pin-pointing their target. But there was enough of it left so that we could get a good idea of what it looked like. And what it looked like was disappointing. The buildings were all of a rectangular, barracks type, with no effort at all spent on architecture. All camouflaged, naturally, in that hideous brown and green paint. I can only hope the interiors show a little more elegance and taste.

To get there, we turned sharply off the main highway at Berchtesgaden and climbed a steep mountain road for a couple of miles. Halfway up the mountain are these remains of the home of the now defunct Hitler. We drove around the grounds for a bit, and then started up the mountain again, toward the Eagle's Nest. It is remarkable only for its location. On the very peak of the mountain is this two-story yellow brick building with a view of lakes, valleys, rivers, forests, and mountains such as you have never seen. I say it is a two-story building—that is all you can see above ground. But there are 13 stories underground which were probably sleeping quarters, hideouts, storerooms, and the like. Old man Hitler had an elevator. But when we were there, that had been sabotaged, of course, so we had to park our car and climb the mountain

for those 13 stories so we could see the buzzard's nest.

There were a couple of fancy electric kitchens, servants quarters and power plants on the first floor. Above were some small conference rooms, a banquet room, a reception room and a sun room—all wood-paneled. The banquet room was long and narrow with a great rectangular table and seating space for 30, built-in cabinets along one side—that is all. A simple room with no fixtures or furnishings to give it the slightest touch of elegance. The reception room was perfectly round, with windows on all sides except for the entrance to the room and the big fireplace. There was a low, flat, round table about 10 feet across, in the center of the room, and a string of chairs all around the edges of the room. But it looked like a hotel lobby and not a very good hotel at that. Every chair was the same style and covered in exactly the same piece of upholstery. The round table had a flannel covering over it, but under the flannel it looked like plyboard. No little tables, no lamps, no draperies, no warmth. What furniture there was, was ordinary, cheap stuff. The man's desires certainly seemed to be simple enough as far as his own personal comforts were concerned.

Another little trip I took was down to Gmunden See, but there wasn't much to see. It was a beautiful, hot, sunny day and all we did was sit on a blanket in the middle of a field of tall daisies and watch the boats on the water and admire the sheer cliffs on the opposite shore. Gmunden is a popular resort town in the section which has now been taken over by the Army and operated as a rest area for American troops. They are having a beautiful time boating and swimming and riding horseback. There are lots of rumors abroad that our next and final move will take us to the shores of one of these lakes around here. A summer vacation in the Austrian lake district sounds pretty good—no?

Doris Nelson was married on June 2 to Major Frederick

Foley of Milwaukee. I wanted very much to go to England for the wedding, but her message was so long in arriving that I didn't really have time to make the trip. Besides that, transportation is just a little difficult to arrange right now, with the Army using everything on wheels or with wings in the redeployment of troops. Perhaps I can go later when I can have a real visit without sharing her honeymoon with her. The only reason I would have for taking a leave in England now would be to visit her. The stories that have come back from there are that the English have retaken London from the Americans.

Our home here now is a large apartment on the village square—the third floor over the post office. It formerly belonged to one of the big Nazi agents of the country who is now in the klink. But his wife cooks our breakfast for us for the privilege of using her own kitchen for her own cooking. It isn't a particularly good place for us because there isn't enough room. We thought at first we wouldn't need room for more than eight people at a time, since everybody else would be out on detached service. But for some reason we got screwed up on those plans and there have been 15 and 20 at home at the same time—besides a couple of guests. We could hardly walk from one room to another without stumbling over a body. People were sleeping in the halls and in every corner of the house—some on the floor, some on cots and eight lucky ones on beds or couches. In the next couple of days we hope to get most of these extras out into the field again and unclutter this place a little.

Time to go to lunch now and I will mail this on the way. It's been sitting in the typewriter for days now.

Love,

A

June 24, 1945

Dearest Family:

If I could just transport my family over to this particular spot, everything would be perfect. We have the ideal situation—a lovely home right on the edge of a big lake (Wurm See) with all kinds of boats at our disposal, horses to ride in the near vicinity, a golf course about eight miles down the road. There are two yacht clubs in the town, one of which is now the officers' mess and the other the officers' club.

The weather is beautiful, with a hot sun during the day to burn us brown, and delightfully cool evenings to make us sleep. We girls occupy two of the nicest houses on the lake. One is a great big affair which we operate more or less like a hotel for the girls when they come in from their detached service, to enjoy their days off. It is the summer home of a countess, an English woman married to a German. In it we pack 27 girls without too much crowding.

The three of us who are the more permanent residents, that is, the managers of the office and kitchen, have a small house to ourselves. It's a little, brown-stained wood chalet with a balcony upstairs encircling the three bedrooms. There's a small room on the front of the house with windows on three sides where we have our breakfast in the morning sun. The flagstone terrace all across the front ends in a low brick wall, and from there the grassy slope drops quite suddenly to the edge of the lake. Along the terrace wall our house wears a necklace of deep red roses, and there is another rose bed halfway down the slope which from the lake makes the house look like an ample-bosomed lady wearing a corsage on her billowing chest.

I'm starting my leave tomorrow and I'm going to stay right here. You couldn't find a lovelier place if you went hunting

for it. And there are some nice little side trips. We're not too far from Garmisch, Innsbruck, and Oberammergau. Which reminds me … the Special Service Colonel from the Third Army went down to Oberammergau to see if they would put on a performance of the Passion Play for the benefit of all the Americans now occupying southern Germany. They explained they would like to do so, but at present it was impossible because Jesus Christ was in jail. He was a party member.

This Bavaria is like something out of an operetta. Towered castles dot the countryside, oxen do the plowing and pull little two-wheeled carts, women work in the fields stacking hay, and the men wear suspendered shorts made of leather and embroidered with silk and gold thread. They wear tasselled socks or socks without ankles. The women's dresses have tight bodices, full skirts, puffy blouses and gay gingham aprons.

One of the war correspondents went to visit Franz Lehar, whose home is not far distant, and found him wearing light gray trousers, a pink waistcoat and a green jacket. It is all very pretty and charming except that now they are hungry. Droves of little children with buckets and baskets hang around the mess kitchens, waiting for leftovers and scraps that are thrown away at the end of each meal. Right now the people in the country have fresh garden stuff to eat, but the winter, and winters to come, look plenty grim to them.

It's another day now. I think I've never finished one of my letters in one uninterrupted sitting. I'm on leave starting right now. I've had my breakfast and now I sit on our sweet little balcony and listen to a gentle rain splatter on the leaves. It isn't going to be a serious rain, fortunately for my leave; and Pollyanna-ish, every vacation needs at least one day for readin', writin' and doing neglected errands.

One of the latter is to go to a tailor where I am going to

have some riding pants made. I have some other material too—some nice tweed which I think I'll have him make up into a suit for me. And I'm just dying for a white wool Bavarian suit like the Lanz of Salzberg stuff they import in America. If my plans materialize, I'll come home well-clothed and won't have to spend the first month fitting myself out as a civilian. I've also made myself a white linen dress out of some hospital sheets we found in a warehouse. It's quite successful, except that it needs washing and ironing all the time and that kind of help is not too plentiful.

Artie! Your books arrived last night—just in time for my week of leisure. Thank you very much. I know I shall enjoy them. When I've finished them, there will be dozens of others who will read them too.

I've stared at the lake now for 15 minutes in search for something to say to fill up this letter. Seem to be fresh out of words and no wonder—on re-reading the letter it sounds like it's padded from the very beginning.

Love to you all,
A

July 10, 1945

Dearest Family:

The last time I wrote, I talked to you about my leave which I had decided to take right here. I'm getting so damn lazy—too lazy to take myself on a vacation. Laziness and the fact that there is so much to do here in the way of sports, made any effort to go away for a week too much to face.

So the first day I had rain and stayed home to write letters and read. The next day was cold and blustery, so I stayed in the

house again. That's the way it continued. Four out of five days were bad. At that point, Eve got sick and I had to go back to work. While I'm not wishing her any bad luck, her illness really saved my neck. At least it saved three days of my leave so that I could postpone it until the barometer read fair. Of those three days, two have been wonderfully warm and sunny, so I have been swimming, boating, and golfing—packed everything into 48 hours. I make it sound like rather a bad deal, but don't waste your sympathy on me because Eve and I have got our business down to a science and we now spend every other day in the office—Eve one day and me the next—with the result we each work about three days a week.

The golf course—a 9-holer—is in pretty good shape now. On my second round I knocked 10 strokes off the first one, so I am eager to go out again. I won't mention the score just yet; it still isn't worthy of publication. The difficulty is to get balls—the same problem we went through in England a year ago. When they opened the course here, there were about 60 balls available, which the Army rented out for each game. They required a deposit of two dollars for each ball. The principle behind that was to make you look for it if you lost it. In 10 days those balls were gone. I fortunately am the proud possessor of 6 brand new balls that Frank Hinman sent me last summer after he heard my wail about balls in England. His balls didn't get to me until after we arrived in France, and I had little hope of ever having another chance to use them. But when we got here, I rummaged through my trunk and found them under the soap—some of the same soap I started out with from the Petesch drug store in Oak Park over two years ago. As you have guessed, those six balls have made me the most popular golfing partner in the ETO.

Some famous people have lived on the little lake, the

Wurm See. King Ludwig, one of the mad kings of Bavaria, had a little castle across the lake from us. One of the more contemporary notables was Dr. Frick, number 10 Nazi, who has a perfectly beautiful house and garden, more modern and more tastefully furnished than anything I have seen since coming to Germany. The doctor, needless to say, is in the hoosegow now. And since Americans have occupied this area, one of our good generals has been living in his menage. Until now, some of our good friends in the Third Cavalry are using it as a kind of club or rest home for their officers. When the General of our Corps decided he didn't want to live there, he offered it to the Commander of the Cavalry. Colonel Polk wasn't too sure he wanted it since he was already quite comfortably situated. But he decided to go look at it. He and some of his officers were inspecting it about 4:00 one afternoon, and as they were sitting in the music room talking it all over and making up their minds, a young man dressed in a swallow-tail coat came into the room and said, "How many will there be for dinner, sir?" The Colonel answered, "Six." And from that time on they've been entertaining elegantly with cooks and maids and the swallow-tailed butler serving the dinner.

I was over there for dinner last night. This has been a strange war. There we sat on the stone terrace with chaise longues, striped umbrellas, a bucket of champagne, and George hovering over us. More champagne for dinner with beautiful fried chicken, fresh garden vegetables which the Army almost never sees, a heaping bowl of lettuce salad, fresh currants with custard, and demitassse. Champagne again after dinner, at which time we drank to the hospitality of Dr. Frick.

I'm a firm believer in the Americans (those that can) treating themselves as handsomely as they can while they're here. They deserve it, Heaven knows. But that kind of living is as unnatural for those tall Texans as the foxholes were a few

months ago. How are we ever going to get ourselves back to an ordinary life? And I include myself in that. I'm kinda afraid to come home, afraid to look for a job—don't want a desk job anyway. What will I do?

All that will come out in the wash, I know. But I can't help thinking about it in relation to myself and a few million other people. About next September, I'll be able to try it all out. I think it will take that long for me to get home. Though I'm starting now to work seriously on my getting out of here. The trouble now is that transportation was closed to Red Cross for some time because of troop movements. Consequently, they have a large backlog that will take some time to get rid of.

My letter to headquarters will go off tomorrow via courier. There is no way I can give you any definite information. So I don't know how to advise Father on his trip to Birmingham to meet me. I would love to have him meet me there if it isn't too hard a trip to make, and if he wants to sweat me out while I flit around Chicago for a while. While I'm seeing Chicago, maybe he could go to McHenry to see his friends. There is really nothing that attracts me there.

Had a nice letter from Mr. Maloney, the Managing Editor of the *Tribune*, assuring me of a job when I was ready to come back. … You can't get away from the fact that they've been darn good to their employees.

Best love to you all,
A.

POSTSCRIPT

By Marjorie Carne

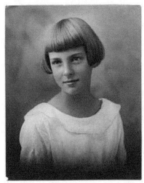

Angela Petesch

May, 1999

Here ends the letters from Angie describing her experiences overseas while serving with the American Red Cross during World War II, 1943—1945.

Angie was discharged from her duties in September 1945, and after a visit with her family in Birmingham and friends in Chicago, she went on to Walnut Creek, California, where her sister Ede and husband, Arthur Wagstaff, were living.

Her prior training at the Chicago Art Institute in the field of metalcraft enabled her to pursue her hobby of jewelry-making in silver and gold, with both precious and semi-precious stones. She opened her own shop in Walnut Creek, where

for five years she displayed a few of her pieces at the Art and Garden Center.

In 1952 she came to Los Angeles where, with Helen Delbar, she opened the new offices of Joseph Bancroft & Sons, textile manufacturers and processors, serving as a Market Representative.

About this time she became associated with the Miss America Pageant as chaperone for some of the beautiful young hopefuls, during which she toured all over the United States.

Angie continued with her hobby of making jewelry and table accessories, such as the "bow-legged salad servers" for friends in Southern California. Her originality and unique contemporary designs prompted her friends and customers to encourage her to create a line of manufactured jewelry. However, she preferred limiting her production to custom designs for friends, with the exception of a few pieces she did for the Men's Department of Bullock's Wilshire and some that were sold from displays at the Los Angeles County Museum of Art and a gallery in Walnut Creek.

Angie retired and lived at Regents' Point in Irvine, California. She celebrated her 92nd birthday on May 16, 1999, shortly before her letters were first published and shortly before she passed away.

~ *Bibliography* ~

The American Red Cross.
 The American Red Cross. *American Red Cross History Hotline*. www.usa.redcross.org: Washington, D.C., 2004.
 American Red Cross History Hotline, Washington, D.C. askmuseum@usa.redcross.org

 Library Collection. *American Red Cross: Hazel Braugh Record Center & Archives*. Washington, D.C. 2005.

 American Red Cross Museum. "American Red Cross Canteens During World War II." redcross.org/museum/history. July 2, 2004.

 Airy, Helen. *Doughnut Dollies: American Red Cross Girls During World War II*. Santa Fe, New Mexico: Sunstone Press, 1995.

 Bremmer, Robert H.; Greenberg, Lucille Stein; Hutchison, Minna Adams. *The History of the American Red Cross. Services in War Against European Axis 1941-1947*. Vol. 13. Washington, D.C.: The American National Red Cross. 1950.

 Cromie, Robert. *Chicago Tribune: Girls Serving Doughnuts Delights G.I.s. Filed From the Field*, October 13, 1944.

 Dulles, Foster Rhea. *The American Red Cross: A History*. NY: Harper and Brothers. 1950.

 Gilbo, Patrick F. *The American Red Cross: The First Century*. NY: Harper and Row.1981.

 Hurd, Charles. *The Compact History of the American Red Cross*. NY: Hawthorn Books. 1959.

 Korson, George. *At His Side: The Story of the American Red Cross Overseas in World War II*. NY: Coward-McCann, 1945.

 Morgan, Marjorie Lee. *The Arc in the Storm: A Personal History of Clubmobiling in the European Theater of War During World War II*. St. Petersburg, Fla.: Hazlett Printing & Publication Inc. 1982.

 Petesch, Angie, *World War II As Seen Through the Hole of a Doughnut*. Self published. 1999.

 www.clubmobile.org. Gasperini, Jim. Clubmobiling History. 2006.
 www.donutdolly.com. Vietnam Donut Dollies Organization. 2006
 www.aerofiles.com/wafs.html. Aerofiles: A Century of American Aviation. 2006.

THE HERO NEXT DOOR™

World War Collection

About the Series

I created The Hero Next Door™ series of war veteran biographies to capture the stories of the every day Americans who lived the horror and honor, the hurt and homesickness, of war—the stories of the humble veterans who live next door to all of us. Our fathers and grandfathers, mothers and uncles, sisters and neighbors ... those men and women, those Heroes Next Door, who served their country well in time of war and returned home to quietly serve their community and family.

Angela Petesch's story is one of those stories. She is a Hero Next Door, one of many millions of veterans who we all know, even if we don't know the stories they often take to their graves. Their stories of sacrifice and service are lost to history, without someone to record them. My own personal experience with that loss gave birth to the original Hero Next Door book when my grandfathers, World War II veterans both, died before I had the time—took the time—to interview them. The loss of those stories of such personal and such historical value inspired me to seek out the stories of others who have sacrificed to protect and build the freedoms we all enjoy and to record them before they,

too, are lost to time. It is our job as those who know, those who love, a Hero Next Door to ensure that their pieces of history do not fade from the American landscape. If you have a Hero Next Door in your life, I encourage you to make the effort to record their story and share it with the next generation.

I am pleased to bring you Angela Petesch's story, with the help of friends—hers and mine—and I look forward to sharing stories of more humble heroes in the Hero Next Door™ Collection.

Kristin Gilpatrick Halverson

HUNTER-HALVERSON PRESS, LLC

2006

MORE TITLES

available through Hunter-Halverson Press, LLC

HUNTER
HALVERSON
PRESS-LLC

115 West Main Street, Second Floor • Madison, WI 53703

info@hunterhalversonpress.com